ARTISTS
AND THEIR
BOOKS

BOOKS
AND THEIR
ARTISTS

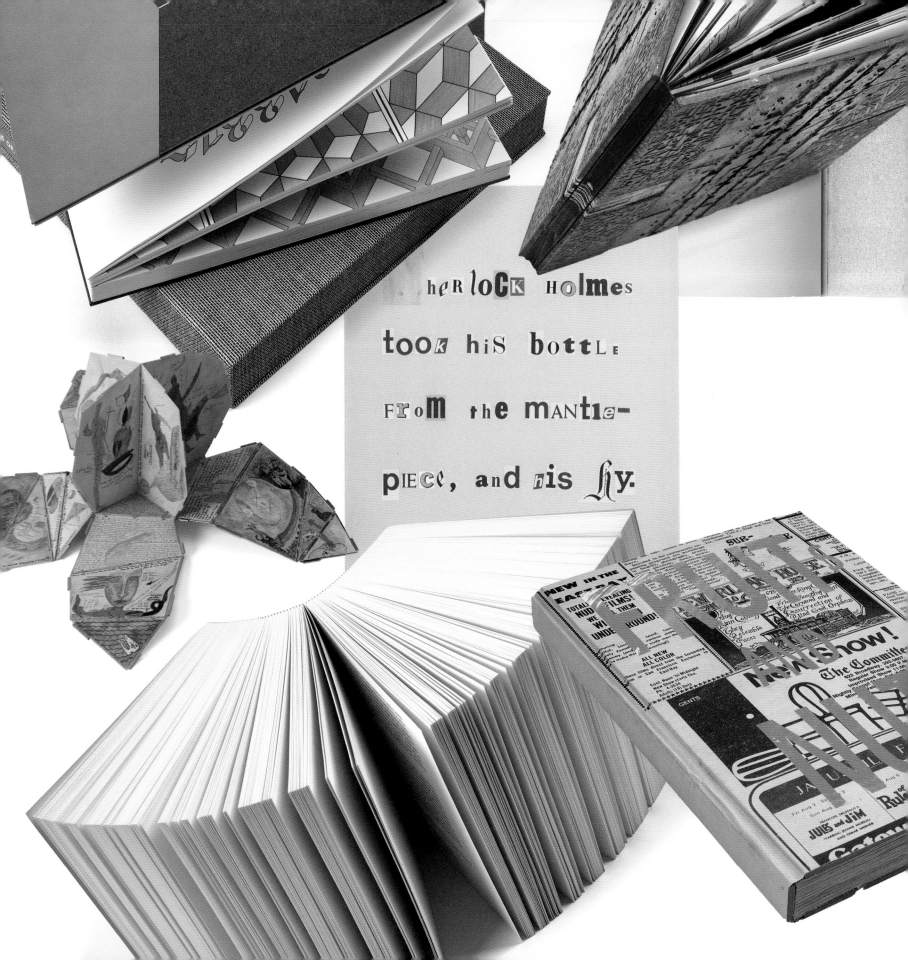

Sherlock Holmes took his bottle from the mantle-piece, and his Sy.

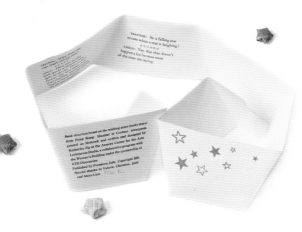

ARTISTS
AND THEIR
BOOKS

BOOKS
AND THEIR
ARTISTS

MARCIA REED

GLENN PHILLIPS

THE GETTY RESEARCH INSTITUTE | LOS ANGELES

This publication is issued on the occasion of the exhibition *Artists and Their Books / Books and Their Artists* on view at the Getty Research Institute at the Getty Center, Los Angeles, from June 26 to October 28, 2018.

The Getty Research Institute Publications Program
Thomas W. Gaehtgens, *Director, Getty Research Institute*
Gail Feigenbaum, *Associate Director*

© 2018 J. Paul Getty Trust

Published by the Getty Research Institute, Los Angeles
Getty Publications
1200 Getty Center Drive, Suite 500
Los Angeles, California 90049–1682
www.getty.edu/publications

Elizabeth S. G. Nicholson, *Project Editor*
Tom Fredrickson, *Manuscript Editor*
Catherine Lorenz, *Art Director and Designer*
Suzanne Watson, *Production Coordinator*
John Kiffe and Christine Nguyen, *Photography*

Distributed in the United States and Canada by the University of Chicago Press
Distributed outside the United States and Canada by Yale University Press, London

Print and color management by iocolor, LLC, Seattle
Printed and bound in China by Artron Art Group

Library of Congress Cataloging-in-Publication Data

Names: Reed, Marcia, 1945- author. | Phillips, Glenn, 1974- author. | Getty
 Research Institute, host institution, issuing body.
Title: Artists and their books : books and their artists / Marcia Reed, Glenn
 Phillips.
Description: Los Angeles : Getty Research Institute, [2018] | Includes
 bibliographical references and index.
Identifiers: LCCN 2017059573 | ISBN 9781606065730 (hardcover)
Subjects: LCSH: Artists' books. | Conceptual art.
Classification: LCC N7433.3 .G48 2018 | DDC 700—dc23
LC record available at https://lccn.loc.gov/2017059573

CONTENTS

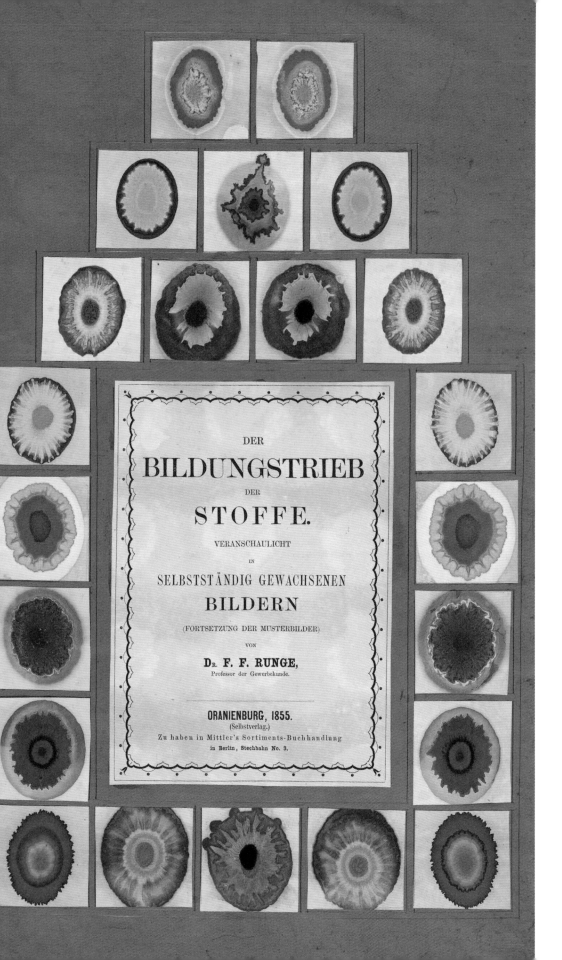

DER
BILDUNGSTRIEB
DER
STOFFE.

VERANSCHAULICHT

IN

SELBSTSTÄNDIG GEWACHSENEN

BILDERN

(FORTSETZUNG DER MUSTERBILDER)

VON

DR. F. F. RUNGE,
Professor der Gewerbekunde.

ORANIENBURG, 1855.
(Selbstverlag.)
Zu haben in Mittler's Sortiments-Buchhandlung
in Berlin, Stechbahn No. 3.

FOREWORD

Artists have long been fascinated and challenged by a revolutionizing invention: the book. In centuries past, they participated in the creation of illustrated books; since the beginning of the twentieth century, many have been inspired to address its form and content through artistic experimentation. It is not easy to define the genre of artists' books, but since its foundation the Getty Research Institute has included them in its rare-book acquisitions.

The diverse forms, techniques, materials, and content of artists' books are important aspects of art historical creativity, yet the medium has not yet been fully integrated into either the history of art or the history of the book. Earlier rare books, prints, and archival ephemera reveal how artists designed books, creating letterforms, graphics, page designs, and bindings. Artists used books to preserve their sketches, notes, and recipes. Occasionally, they collected these in albums or created personal collections, like mini-museums on paper. Albrecht Dürer published stylishly designed artistic treatises. Such early illustrated books, prints, and related formats—*vues d'optique*, *leporelli*, and pop-up paper theaters—can be seen as precursors of artists' books in the modern and contemporary period. Direct relationships between artists and their creations disclose a very different history from that of commercial publishing.

In the twentieth and twenty-first centuries artists became more radical in their inventions, still experimenting with the concept and the object book. Many artists have used the book to convey a creative narrative that parallels their work as painters, sculptors, printers, or photographers. They express their imagination by taking advantage of the continuous process that turning pages allows, telling a story by provoking a perceptual and aesthetic rather than a logical reading experience. Some artists have gone further, creating objects that bear meaning beyond words and printed language but that still connect to the tool we use daily at work or for enjoyment.

Artists' books trigger surprise, curiosity, and enchantment. We are astonished when we open a book and do not find paper sheets and printed lines of words but pages that are cut out and reveal, through their turning, the structure of a city. We are amazed if the pages of a book are replaced by rare fabrics. Sometimes books, lines, and words are part of larger ensembles, boxes of diverse materials that represent or replace an autobiography in written form.

This volume and an associated exhibition of artists' books, conceptually structured and carefully curated by Marcia Reed and Glenn Phillips, is intended to show the range of ingenious and thoughtful ways artists embed ideas about books into their work. It is hoped that the book and exhibition will encourage further exploration in this field of research, still rather neglected by current art historical discourse.

Thomas W. Gaehtgens
Director
The Getty Research Institute

THE BOOK IN GENERAL:
SOME NEW DEFINITIONS

MARCIA REED

Years ago, a CalArts student attending a Getty Research Institute (GRI) seminar on artists' books declared, simultaneously aggressively and possessively, "I don't read, but I make books." I have never forgotten this wonderful (in all senses) and maybe not even conscious statement of the greater question. It just about sums up the variety of roles that books and reading play today and the perspectives from which they can be viewed. Of course, this student *did* read, but not in the "old way," and the books he made were probably not traditional books but new takes on the venerable medium.

By the end of the twentieth century, predictions of the book's demise had become cliché; decades into the twenty-first century, books are still very much with us. If anything, their status as icons symbolizing erudition, cultural cultivation, and hipness has only increased. Rather than shriveling up to accommodate old-style stereotypes, the idea of the book has effectively expanded. By now most people understand that a book can be not only text on paper but also a coherently conceived work that is published in one or many formats. It can be transmitted electronically, absorbed visually or audibly, and preserved on a shelf, a tablet, a memory stick, or in the cloud. No longer a passive medium, it can be written, read, and circulated participatively—sometimes interactively. In short, the book is far from dead. Rather, it is a lively and contested concept that is frequently visualized or produced as a work of art, pointedly demonstrating its cultural significance.

What's happened to books has parallels in art. Just as books are no longer all rectangular or square, like stock trade editions, at the same time art is not just an oil painting on canvas or a monumental figurative sculpture. Those tired definitions no longer work. In fact, there is now a capacious creative space that extends beyond old-fashioned ideas that artworks are made to be viewed standing respectfully still in a museum gallery and books are made to be read quietly holding them in your hands. A more productive way to think about both contemporary art and artists' books is to consider their sources and histories: Who makes them and why?

Given the book's malleability and long history, and given its inherent pleasures and promising potential, it is only natural that artists should find the form attractive. The resulting works—artists' books—bridge traditional genres, leaning toward the concerns of art and away from the modes of commercial publishing. Often created to document processes of art, actions, or performances, they are purposely less than well organized, sometimes intentionally unedited, reflecting the events, installations, or exhibitions to which they relate. In view of the long intertwined histories of creating art and designing books, artists' books can arguably be seen as ranking among the most significant recent developments in both fields.

Making books has never been just about the texts, because as works on paper, books possess an essential materiality. Indeed, artists have long been engaged with book illustration and design, following a path begun by medieval and Renaissance artists—

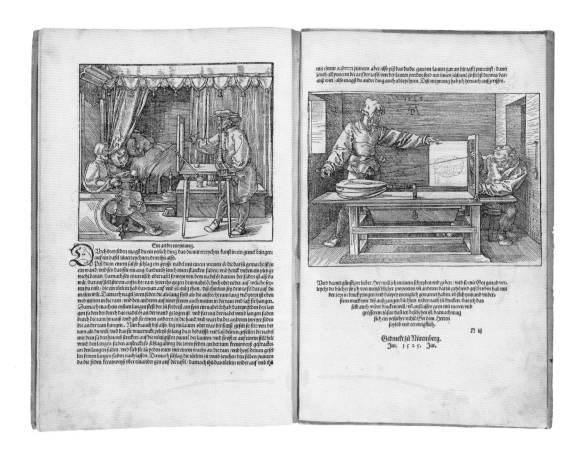

calligraphers, illuminators, and binders—whose inventive uses of paper and vellum, inks, leather, and wood continue to appeal to museum viewers and to inspire artists. We tend to think that our own era has purchase on innovation and are genuinely surprised by the artistic presentations of complex ideas in earlier books like the *Mira calligraphiae monumenta* (1561–96) (see fig. 2). This calligraphic model book was originally created in 1561–62 by the Croatian-born court secretary to the Holy Roman Emperor Ferdinand I, Georg Bocskay. His masterful array of writing styles demonstrates how shaped letters can be carriers of expressive content. Thirty years later, Joris Hoefnagel was commissioned by Ferdinand's grandson, Emperor Rudolph II, to illuminate Bocskay's virtuoso writing samples; he filled the pages with lively creatures and botanical subjects.

As the practices of printing—letterpress and graphic arts—spread throughout Europe, artists found more ways to bring the worlds of books and art together. Experimenting with old and new methods

at the beginning of the sixteenth century, Albrecht Dürer published treatises on perspective and proportion in thoughtfully designed volumes that employed old and new techniques—woodcuts, etching, engraving—even illustrating how artists work. His treatise *Vnderweysung der Messung* includes diagrams and shows the instruments used to obtain accurate proportions in the making of images (see fig. 1). Dürer published his woodcut series *The Life of the Virgin* in book form in 1511. These prints had circulated individually over the previous decade with Latin verses by the Benedictine monk Benedictus Chelidonius on the verso of each sheet. This was a departure from earlier illustrated books, which integrated image and text on the same or on facing pages, or they simply inserted prints as double-page spreads. Dürer's print formats made it possible to hold and/or collect single sheets with text and image or to acquire them all in an illustrated book.

In the mid-eighteenth century, the erudite Venetian Giovanni Battista Piranesi came to Rome

Fig. 1 | Albrecht Dürer (German, 1471–1528), *Vnderweysung der Messung,* Nuremberg, 1525. Woodcuts. GRI 84-B7142.

Fig. 2 | Joris Hoefnagel (Flemish, 1542–1601), *Mira calligraphiae monumenta*, Vienna, ca. 1591–96. Watercolors, gold and silver paint, and ink on parchment. J. Paul Getty Museum, Ms. 20, fols. 15, 118.

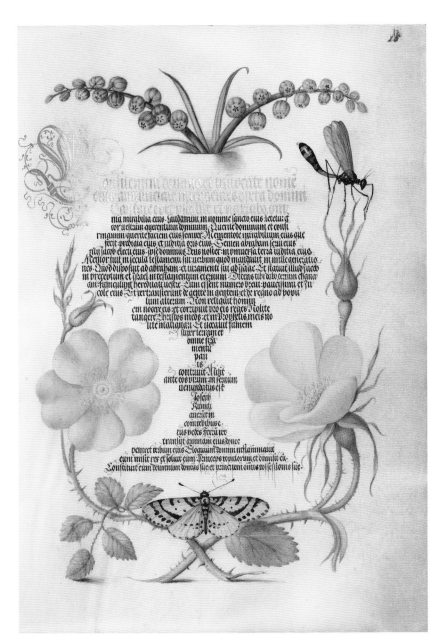

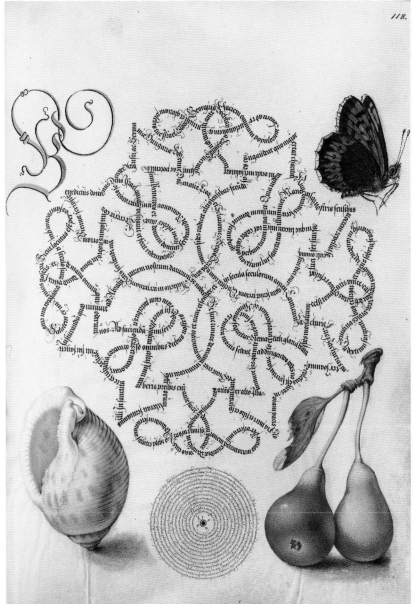

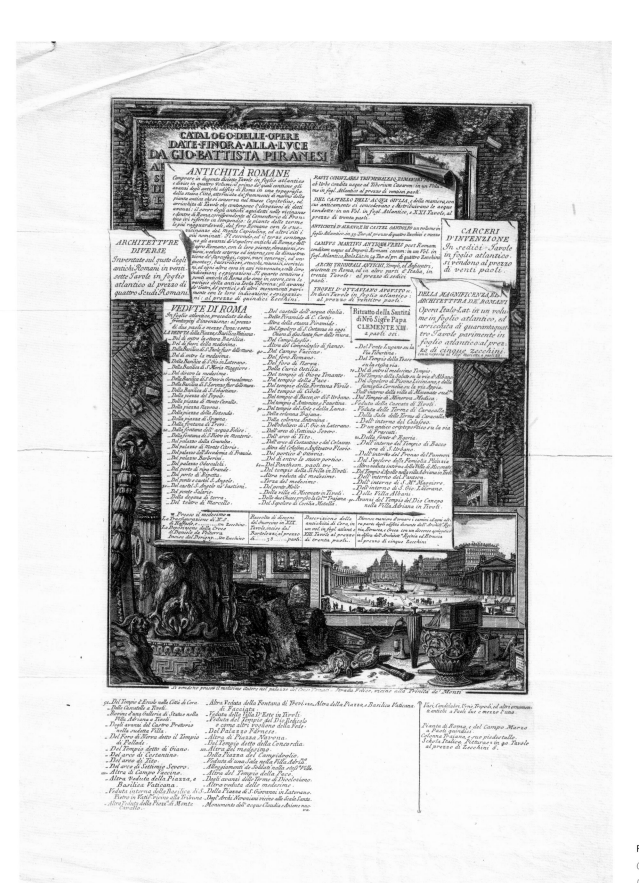

Fig. 3 | Giovanni Battista Piranesi (Italian, 1720–1778), *Catalogo delle opere date finora alla luce da Gio Battista Piranesi*, Rome, 1775. GRI 89-B18453.

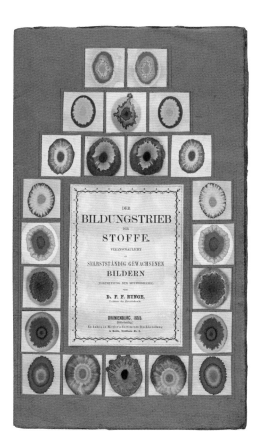

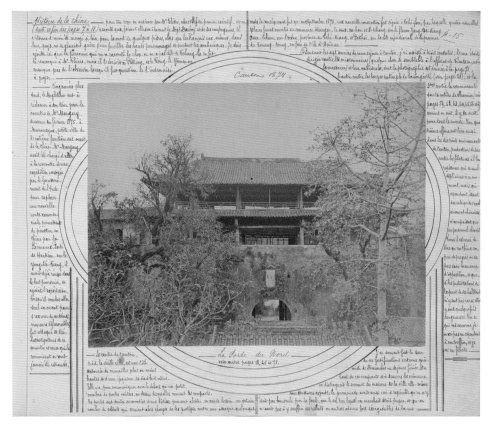

Fig. 4 | F. F. (Friedlieb Ferdinand) Runge (German, 1795–1867), *Der Bildungstrieb der Stoffe,* Oranienburg, Germany, 1855. GRI 2990-556.

Fig. 5 | *Canton, 1878, La Porte du Nord* from *Chine-Japon photographic album,* assembled by G. Prat (French, act. 1878–96), 1878–96. GRI 98.R.14.

and trained with the renowned publisher of Roman views Giuseppe Vasi. Piranesi's training as an architect and his deep passion for Roman archaeology was expressed in graphic works created for the fashionable aristocrats who sampled the culture of France and Italy on the Grand Tour (fig. 3). Piranesi's single-sheet catalogues of available works have a bulletin board quality, illustrating featured titles with trompe-l'oeil post-its. The catalogues were continually updated, with space left for additions at the lower edge of the print. Like Dürer, Piranesi saw books both as texts illustrated by prints and as bound volumes that compiled single prints. Collectors could assemble a library of luxury folios on the grandeur of Rome, making them feel like refined bibliophiles, or they could select a few favorites from Piranesi's nearly one thousand prints as connoisseurs of the medium.

In her catalogue on the role of prints in early modern intellectual history, Susan Dackerman explained how artists helped natural philosophers and historians not only to visualize their discoveries but also to participate in a more active way, presenting experiments and even simplified devices, such as sundials, to cut out and use in prints.[1] Illustrated books offered scientists a flexible format that could be altered according to the demands of the content. In a stunning example of a highly artistic presentation of science, the chemist F. F. Runge in 1855 published his pioneering experiments on generating color in a specially produced book filled with chromatograms (fig. 4). Although it is certainly not an artist's book, it would be difficult to argue that it is not a beautiful and unusual book perfectly expressing its subject—not unlike artists' books of the next century.

These days when we talk about books, we tend to define and compartmentalize them as if they were solely commercial productions, like modern trade books, failing to see their cultural functions. Yet books have never been *just* printed books. They have long been an elastic, inclusive category. Think of the idiosyncratic and hermetic compilations documenting esoteric subjects such as alchemy and botany, among

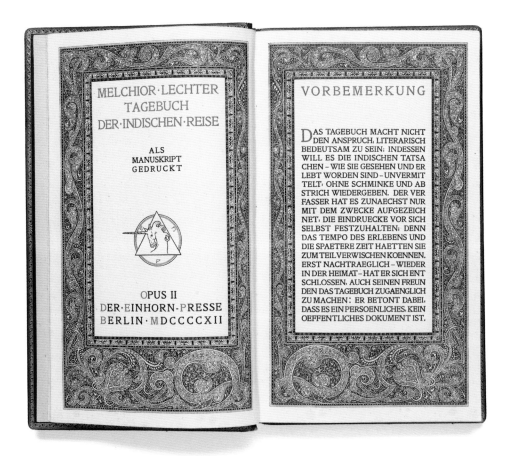

the many fields that have their amateurs, aficiona-
dos, and adepts. Highly personal photo albums that
document travel, such as that of the collector G. Prat,
who framed his photographs with extensive notation
(fig. 5); sketchbooks; notebooks; diaries; and scrap-
books collecting memories, clippings, and recipes are
some of the most precious and meaningful books in
our possession. These works have been effectively
left out of narratives of book history, sidelined by the
narrow canons that privilege printed books. Recogni-
tion of the varieties of books—witnessed by essential
elements in their design and content—serves to
broaden definitions of books and demonstrates the
significant place of art in their history and production.

A more inclusive and heterogeneous history
of the book highlights the vital alliance of art and
creative publishing. As the nineteenth century turned
toward the twentieth, this trend accelerated with
the rise of the Symbolist and Aesthetic movements,
whose artists produced books featuring original
prints, and small presses specialized in literary works

with artistic page layouts. In another travel account,
this one published by the Einhorn-Presse, decorated
pages were designed by the author and designer
Melchior Lechter for his journal of India. Evoking
Lechter's impressions of Indian art, the pages
resemble ornamental bas-reliefs framing the beauti-
fully set typography (fig. 6). Only at the end of
the nineteenth century was this connection articu-
lated by calling artistically designed books or those
illustrated with graphics "books of artists." Whether
conservative—looking back to medieval manu-
scripts—or avant-garde, these books marshaled
design and materials as expressive sources. Choices
of paper, font, and printing technique—increasingly
using color for texts and images—were essential
elements in conveying the theme of a book.

Modern artists' books took a variety of forms,
but most could be seen as one of two principal types.
One was the luxury edition, the *livre d'artiste* or *livre
de peintre*—closely related to the fine art for which it
was the paper ambassador. Parallel to print portfo-

Fig. 6 | Melchior Lechter (German, 1865–1937), *Tage-
buch der indischen Reise,* Berlin: Einhorn-Presse, 1912.
GRI 44-44. Gift of Dr. Richard A. Simms.

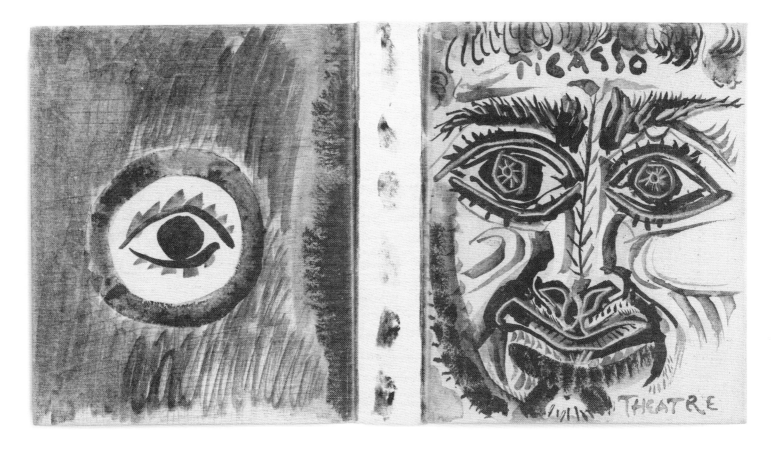

Fig. 7 | Pablo Picasso (Spanish, 1881–1973), ink and watercolor drawing on fabric binding of a presentation copy of Douglas Cooper, *Picasso Theatre* (New York: Abrams, 1968). GRI 860384.

lios, these illustrated books were intended to promote artists' works, allowing their art to circulate beyond the gallery. Texts sometimes crept onto the pages of these volumes, but even though they might have been important literary works or classics, they were clearly secondary elements.[2] Throughout the twentieth century, *livres d'artistes* continued to be published and collected as prestigious editions, often with special bindings and personalized embellishments by the artist, such as the cover created by Pablo Picasso for the critic Douglas Cooper's copy of *Picasso Theatre* (fig. 7). The dust cover of the published edition is based on this sketch.

The second type of artists' books are those conceived, designed, and made by artists themselves explicitly (if not exclusively) as autonomous creative endeavors. Such books and graphic art created by the early twentieth-century avant-garde movements can legitimately be seen as forerunners to today's artists' books, particularly in their antiestablishment goals. Artists and writers associated with Expressionism,

Cubism, Futurism, Dada, and Surrealism employed increasingly innovative designs for expressive books. Notable examples at the GRI include Sonia Delaunay and Blaise Cendrars's *La prose du Transsibérien et de la Petite Jehanne de France* (Trans-Siberian prose and little Jeanne from France; 1913), a small package of poetry and bursts of color that astonishes the viewer as it unfolds in twenty-one double sections. Ardengo Soffici's *BÏF§ZF+18 Simultaneità e Chimismi lirici* (BÏF§ZF+18: Simultaneity and lyrical chemistry; 1915) (fig. 8) is designed to shock from the moment its collaged cover and strange title are glimpsed, as are the "metal books" of the Italian Futurists: Filippo Marinetti and Tullio d'Albisola's *Parole in libertà futuriste: olfattive tattili termiche* (Futurist freedom words: olfactory, tactile, thermal; 1932) and Albisola's *L'anguria lirica* (The lyrical watermelon) of the following year, illustrated by Bruno Munari. In our own time, Mirella Bentivoglio's *Litolattine* (1998; p. 40), with its Coke-can pages, is an obvious homage to these projects. Turning the truculent pages of

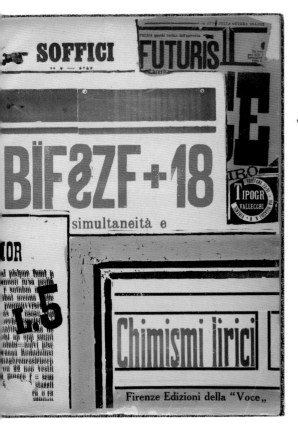

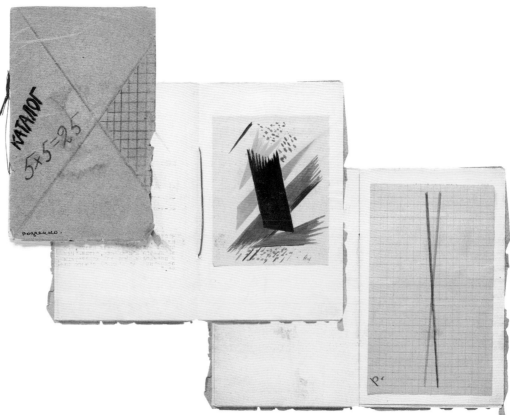

these industrial-quality books, which stick, creak, and scrape, it becomes crystal clear that these volumes aren't intended to function in traditional ways. These are books that make noise. Long before Marshall McLuhan, artists were aware that the medium is the message.

In the early 1920s, Russian artists designed a handmade catalogue of selected graphics for a Moscow exhibition titled *5 x 5 = 25*. This traveling exhibition on paper was created by, among others, Alexander Rodchenko and Lyubov Popova (fig. 9). In the next decade Marcel Duchamp began to produce successive versions of his *boîtes* (boxes), miniature portable museums that allowed his works to be collected and circulate. His 1934 work *La mariée mise à nu par ses célibataires, même* (*The Bride Stripped Bare by Her Bachelors, Even*) included facsimiles of archival documents relating to the larger work of the same title. Duchamp's *boîtes* appeared in successive editions from 1938 to the 1960s, as well as a mailbox (*Boîte Alerte: Missives Lascives*) designed for the

1959–60 Exposition Internationale du Surréalisme (fig. 10). In turn, Duchamp's boxes became models for later works, such as George Maciunas's *Fluxkit* (1964) and, more recently, *DOC/UNDOC: Documentado/ Undocumented Ars Shamánica Performática* by Guillermo Gómez-Peña and Felicia Rice (2014; p. 94).

These avant-garde projects and the artists' books that followed throughout the twentieth century are very different from modern or contemporary deluxe editions, as Johanna Drucker argued in *The Century of Artists' Books*.[3] Artists' books were increasingly understood as freestanding works of art presenting ideas or animating literary works with all the complexity of creations in other media. They could be beautiful and/or provocative; in avant-garde movements, permission was granted for books to become more expressive in their materiality, more meaningful, and less pretty. Inspired by the manifestos of earlier aesthetic (and political) movements and acknowledging the increasingly conceptual and theoretical nature of postwar art, text came to play a larger role

Fig. 8 | Ardengo Soffici (Italian, 1879–1964), *BÏFŠZF+18 Simultaneità e Chimismi lirici*, Florence: Edizioni della "Voce," 1915. GRI 1568-453.

Fig. 9 | Alexander Rodchenko (Russian, 1891–1956), cover (left) and leaf 8, *Line Drawing* (right), and Alexandra Exter (Russian, 1882–1949), leaf 7, *Plane and Color Construction* (center), *5 x 5 = 25*, Moscow, 1921. GRI 85-B4938.

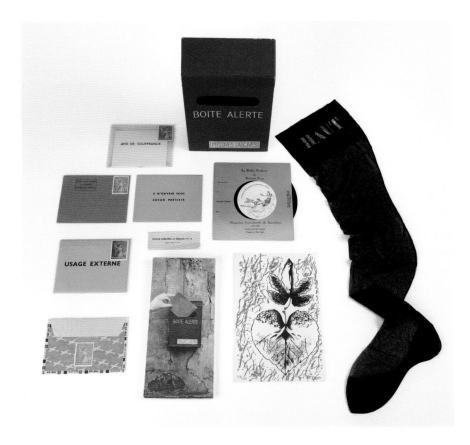

in the artist's book—just as it did in other artistic media: think of the paintings of Cy Twombly, Glenn Ligon, and Ed Ruscha; installations by John Baldessari and Raymond Pettibon; or the latter's single sheets. Mimicking and occasionally serving as posters, flyers, pamphlets, periodicals, and newspapers, these works are frequently vehicles for social and political commentary, just as broadsides and leaflets always have been used to agitate and talk back. They were often produced on a shoestring, employing artisanal or notably economical techniques like mimeograph and photocopy, sometimes by choice, sometimes out of necessity, often acknowledging sources in and sympathies with less privileged classes.

For all their overlap with other artistic media, artists' books today are recognized as a unique and significant genre. There are still debates about their proper place: Is it the library or the museum? In some museums, they are moving from library stacks into curatorial vaults; private collectors enjoy having them on their coffee tables. In a few instances, artists'

books are fetching enviable prices on the art market. Rare is the historical exhibition that does not include them at present.[4] It is a form—flexible, portable, tactile, and meaningful—that only seems to grow in popularity. As the title of this volume indicates, some artists work exclusively with books, having dedicated themselves to the format. Other artists create them when a project calls for it, when their work needs to be documented, or when they want to do something only a book can achieve.

All books, including artists' books and extending into electronic and online editions, can benefit from more expansive definitions. But what has been missing in discussions of artists' books is consideration of certain essential elements. First, the writing, often poetry, is treated cursorily if it is noted at all; oddly but also dismissively, library cataloging of artists' books almost never mentions their subjects. How the text is composed or presented is likewise rarely mentioned, yet it can be of critical importance.[5] For example, in Paul Éluard's *Facile* (1935), photographs by Man

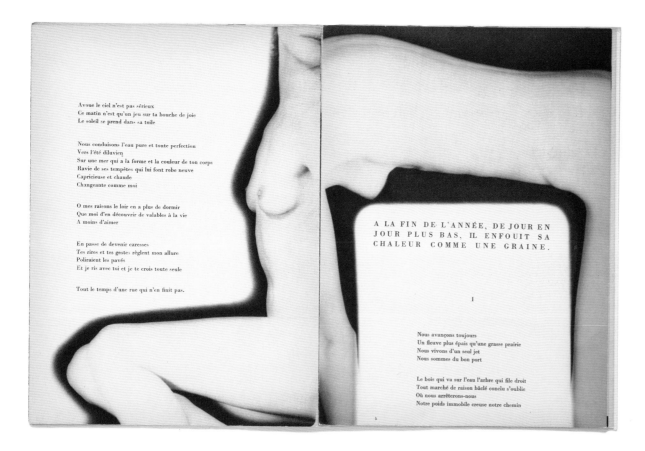

Ray of the nude body of the poet's wife, Nusch Éluard, seem to flow across folded pages. Éluard's words loop around and frame her limbs and torso on loose pages that can be rearranged for alternative viewings (fig. 11). Unsurprisingly, the viewer's gaze tends to rest on iterations of the body rather than being drawn into reading or discussing the words. Similarly in contemporary art, how text is composed or depicted in an artwork or installation is almost never mentioned. Have you ever considered the fonts in Ed Ruscha's paintings or thought about the immediacy and neediness of the jagged cursives on Raymond Pettibon's single pages?

The alternative appearances of various artists' books—which should make the reader ask: Exactly what kind of book is this?—are often treated as if they were simply ornament and craft, rather than intentional design choices suited to particular and purposeful subjects. The caution is: Don't overlook the specific design and intentions of texts and books in artworks, and be sure to give similar considerations when reading the texts in artists' books.

Don't miss the book in general! Far more attention should be paid to the familiarity and convenience of the book, no matter the specific format. What social and cultural assumptions underlie its continued, apparently welcome presence, especially the ways in which books inhabit so much of contemporary art? We might benefit from observing the subtle combination of calligraphy, images, and presentation in Asian art and books, which combine artistically presented texts and images. With textile mounts and elaborate boxes, scrolls are made to be revealed as they are unrolled. They are objects to be discovered—opened, held, and read—a bit like Marcel Duchamp's *boîtes*! In similar ways, contemporary artists' books give parallel significance to the materiality and the seamless interconnections of viewing and reading.

Fig. 11 | Paul Éluard (French, 1895–1952) and Man Ray (American, 1890–1976), *Facile,* Paris: Editions G.L.M., 1935. GRI 84-B22293.

Collecting Artists' Books

The foundation of the GRI's artist's book collection came from Jean Brown, a self-educated aficionado who spoke of herself as a librarian and archivist. She and her husband, Leonard, lived in Springfield, Massachusetts, and became interested in collecting Dada and Surrealism at the time of a series of Société Anonyme exhibitions organized by the patron Katherine Dreier and Marcel Duchamp at the Springfield Art Museum in the late 1930s.[6] Jean was proud to know Duchamp, who—along with John Cage and Robert Motherwell—was a touchstone for her. The Browns' collecting was guided by the Documents of Modern Art series published by Wittenborn; Jean owned every volume, and she annotated her copy of *Dada Painters and Poets* by Motherwell with the titles in her collection.[7]

After Leonard passed away in 1971, Jean repaired to the Shaker Seed House in rural Tyringham, Massachusetts, said to be where the Shakers had printed their seed envelopes. There, building on the collection she and Leonard had assembled, Jean reinvented herself as a collector of Fluxus and contemporary artworks, occasionally dipping into Viennese Actionism, Situationism, Happenings, performance art, and, most notably, mail art and artists' books. She recognized the connections and overlaps among these characteristically twentieth-century genres of works on paper. An ever-evolving installation, archive, and library, the Shaker Seed House was a welcoming, creative space for Jean and the artists and writers who visited her.

Collectors have key insights and instincts. They are motivated by a need to know and see more, and—most important—an almost irrational passion for collecting. Jean Brown assembled her archive intuitively, connecting with artists and then remembering those artists through their works. Her methods were social, personal, and engaged. Although she was a customer of Wittenborn Art Books in New York, her collecting was not driven by art dealers, as artists' books barely made a blip on the art world radar in the 1970s and early 1980s. And she did her homework: George Maciunas spent considerable time in Tyringham, guiding Jean's collecting and building cabinets for her collection. Sitting at her desk on the second floor of the Shaker Seed House, looking out onto the woods, she wrote letters and updated the 3 x 5 cards, folders, and notebooks in which she cataloged her collection. Jean acquired books, archives, and documents concerning the processes of some of her favorite artists, such as Benjamin Patterson, Ian Hamilton Finlay, Ray Johnson, and Dick Higgins, all of whom made books (fig. 12). She saw her collection as a network, and one of her great pleasures was having artists and others visit the Shaker Seed House, creating new work amidst the Shaker furniture and Fluxus objects, keeping the collection alive.

In 1985, two years after its establishment, the GRI acquired the Jean Brown Archive, principally for its Dada and Surrealist holdings. What fascinated and challenged me, a rare book and print curator trained in early modern art history, were the more than four thousand artists' books in the collection. What were they? How did they fit into our collections? In seeking answers to these questions, it seemed like a good idea to connect with Jean Brown. I visited the Shaker Seed House several times in the late 1980s and 1990s and enjoyed many lengthy, enthusiastic, and highly informative conversations with Jean. Her strategies became the template for my own explorations into the vast field of artists and books. Jean's collecting by way of connecting was an approach that made sense for the GRI.

The GRI's collection does not propose a canon of the *best* artists' books; rather, it traces the diverse

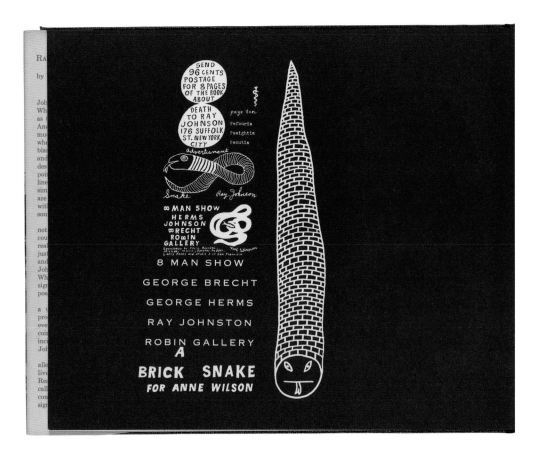

history of artists' engagement with books. These projects may communicate subjects in novel ways through innovative designs and formats or document an ephemeral artwork, preserving some sense of a performance, an installation, or an exhibition. They establish how significant a part of contemporary art literature as well as artistic production these books are. Given the prevalence of artists' books in twentieth- and twenty-first-century art of all genres, the Getty's holdings are an intentionally diverse mash-up.

Museums are not agents of the avant-garde, but rather institutions that collect, document, and provide information. They often do not seem to know what to do with artists' books after they acquire them. Should they be protected and preserved as the irreplaceable works of art they often are? Or should museum visitors be allowed to read, touch, and interact with these volumes as intended? This is an important part of the GRI's access for artists' books, all of which can be viewed in its Special Collections reading room. In contrast, museums might appear to embalm books,

entombing them in vaults. It is ironic that the sensible, yet quite strict, protocols of museums have made it difficult to truly experience the innovative and challenging books artists and presses have created.

A primary aim of *this* book is to express the vivacity of artists' books by sharing them with you. This necessarily selective presentation brings together renowned artists and less well-known small presses and book artists. It includes more than a hundred postwar works that trace the trajectory of this complex art form as it has intersected with nearly every major movement in modern and contemporary art. Often enigmatic and open-ended, these hybrid works agitate against exclusive categories and question the compartmentalization of artists and art by genre. Indeed, artists' books have succeeded in challenging the authority of collecting categories and the compartmentalization of the art establishment, and they are not well served by simple summaries or pat descriptions. Perhaps that is why relatively few such collections have been published to date. Accordingly,

Fig. 12 | Ray Johnson (American, 1927–1995), *The Paper Snake,* New York: Something Else Press, 1965. GRI 90-B9374.

our responses to these varied works move beyond simple glosses and inventories of features to embrace more wide-ranging and impressionistic readings that present artists' books within a larger context and pay full tribute to their manifold material, visual, and literary qualities.

We hope this encounter with artists' books encourages you to give them the attention they so richly deserve. Please come to see and read them at the GRI or at another institution. Ultimately, with this book we aim to shed light on how strongly the idea of books—collecting them and reading them—permeates contemporary art and culture. In other words, just when you thought the book was dead, it is more alive than ever!

NOTES

1 Susan Dackerman, ed., *Prints and the Pursuit of Knowledge in Early Modern Europe* (Cambridge, MA: Harvard Art Museums; New Haven, CT, and London: Yale University Press, 2011), 19; cf. Suzanne Karr-Schmidt, "Georg Hartmann and the Development of Printed Instruments in Nuremberg," in this same volume, 268–79.

2 See, for example, Eleanor Garvey, *The Artist and the Book, 1860–1960, in Western Europe and the United States* (Boston: Museum of Fine Arts, 1972); and Elizabeth Phillips and Tony Zwicker, *The American Livre de Peintre* (New York: Grolier Club, 1993).

3 Johanna Drucker, *The Century of Artists' Books* (New York: Granary Books, 1995). A maker of artist's books herself, Drucker assembled a prodigious compilation documenting artists' engagement with books from the early twentieth-century avant-garde on, with particular emphasis on the postwar period. The book was Drucker's answer to Riva Castelman's *A Century of Artists Books* (New York: Museum of Modern Art, 1994), which focused on *livres d'artistes*.

4 Two examples of recent exhibition catalogues including early twentieth-century artists' books are Vivien Greene, *Italian Futurism, 1904–1944: Reconstructing the Universe* (New York: Guggenheim Museum, 2014); and Anne Umland and Cathérine Hug, *Francis Picabia: Our Heads Are Round so Our Thoughts Can Change Direction* (New York: Museum of Modern Art, 2016).

5 The rare example that shows how to read artists' books is Renée Riese Hubert and Judd D. Hubert, *The Cutting Edge of Reading* (New York: Granary Books, 1999).

6 The Société Anonyme was an organization founded by Duchamp, Man Ray, and Dreier that sponsored art exhibitions, publications, lectures, concerts, and other cultural endeavors.

7 Robert Motherwell, ed. *Dada Painters and Poets: An Anthology*, Documents of Modern Art, vol. 8 (New York: Wittenborn, 1951).

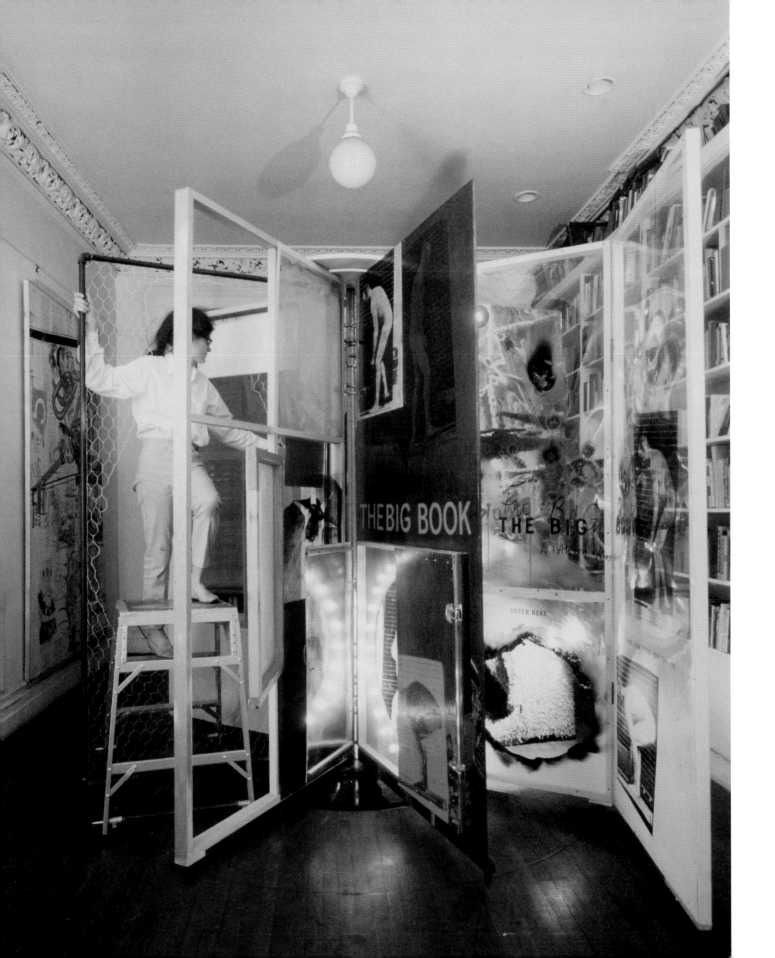

REDISCOVERING THE RADIUS OF THE DISCOURSES, OR DAVID ANTIN'S "POLITICS OF THE ARTIST'S BOOK"

GLENN PHILLIPS

One nice evening, sometime around 1967, the artists Alison Knowles and Dick Higgins held a party at their home. The attendees encompassed some of the most interesting creative minds active in the New York art world at the time, including the composer John Cage; artists Eleanor Antin, Emmett Williams, and Philip Corner; poet and critic David Antin; and media theorist Marshall McLuhan, famous for coining the phrase "the medium is the message." Beyond socializing and conversation, Knowles needed some help in assembling *The Big Book*, a massive artist's book whose scale might more closely recall a sculptural installation or even a miniature piece of domestic architecture (fig. 13). *The Big Book*'s "pages" were eight feet tall and composed of materials such as plywood framing and chain-link fencing mounted on a turnstile-like support. Each page opening formed a sort of room, and people could physically crawl from one part of the book to another through large holes and passages between the pages. Moving through the book was in many ways like moving through a house: there was a kitchen with a stove, a bedroom, a telephone, and even a toilet, as well as a library filled with other artists' artists' books.

More than a decade later, in 1978, David Antin would recall *The Big Book* and this party when giving a talk at the Los Angeles Institute of Contemporary Art on the occasion of *Artwords and Bookworks*, a landmark exhibition–turned–interactive library featuring well over one thousand artists' books and mail artworks by more than six hundred artists.[1] Surrounded by this overwhelming evidence of both the popularity and vitality of artists' books for contemporary artists, Antin gave a wide-ranging (and sadly unpublished) talk that delved into artists' books as a distinctive medium that could accomplish distinctive goals within artistic communities.[2] Of *The Big Book*, Antin noted, "The pages had places where you could cook a meal, where you could read smaller artists' books, where you could lie in the grass, where you could listen to music—the pages were filled with delight.... You could settle down and really live with this book.... It had a place to make coffee, it had a place to sleep, it had a food supply."[3] Antin was using Knowles's book as one of the more extreme and impressive examples of a primary goal the artist's book can accomplish, which is to give the idea of the book an "opportunity to live differently."[4] Just as Modernist painters and poets had ruthlessly tested and expanded every conceivable notion of their respective media, book artists too had stretched every physical and conceptual limit of what a book might be.[5]

This formal and physical expansion of the book is one of the most materially interesting and surprising aspects of artist's book production over the past fifty years, but in Antin's formulation it is not the most radical. Instead, Antin focused on the most easily dismissed aspects of artists' books—perhaps even their most easily criticized qualities—as their most vital or even revolutionary traits: their lack of wide distribution, the relative smallness of their edition size, and their sometimes difficult or esoteric subject matters, which can at times seem fully closed and insular to those not "in the know." Antin referred to

Fig. 13 | Alison Knowles (American, b. 1933), *The Big Book*, 1967. Photo: Peter Moore.

this as a limited "radius of intelligibility," which he saw as inherent to any "true" discourse composed of a knowledgeable community of participants based upon shared knowledge and debate. For Antin, a limited radius of intelligibility was a positive and desirable trait because "a discourse cannot be conducted across infinite space."[6] Any attempt to do so was not a real discourse but rather a one-sided transmission: a broadcast, like television or radio, or, in Antin's view, the distribution model of the commercial book publishing world.

Antin was asking his audience to think of artists' books not in relation to the somewhat larger field of art publishing but in the context of the vastly larger field of publishing in general. When we think of books in these broader terms, the first images that might come to mind are paperback novels and other commercial publications that are inexpensive and readily available at booksellers and online retailers. Compared to these products, artists' books present something of a paradox. On the one hand, artists' books are purported to represent the most advanced and current ideas about bookmaking, often challenging the very notion of what a book can be. At the same time, there is something retrograde about the artist's book: with their small edition sizes and often deluxe or handmade qualities, many artists' books share traits with medieval illuminated manuscripts, a precursor to the modern book that is as much a portable artwork as it is a container of transmitted knowledge. Such rarities are far removed from mass-market books, products designed to reach large numbers of people at low cost. Even within the more limited world of art publishing, books such as exhibition catalogues, scholarly publications, or even this very volume are designed to strike a balance that might optimize the ratio between audience and cost: if texts can be a bit more general and less academic,

more people may be interested in the book; if the number and quality of illustrations can be kept within reason, more people may be able to afford the book. Most books, therefore, exist as a compromise, a series of accommodations that settle a text into a general set of physical parameters that can maximize portability and ease of distribution and minimize costs for everyone involved.

Artists' books try to forgo these accommodations and focus instead on specific and local concerns. This is true both in terms of the design and production of the book (which as a limited-edition or even unique item likely features far fewer compromises than a mass-market book), but also in terms of audience itself. Rarely has an artist's book been created with a large mass audience in mind, even if the books might have a large *art* audience in mind. Antin illustrated this idea in his lecture with a thought experiment: imagine that Ed Ruscha's 1968 book *Nine Swimming Pools and a Broken Glass*—a simple compendium of ten photographs exactly as described in the title (fig. 14)—is suddenly stocked in the checkout line at Vons grocery stores:

> Let's say by some enormous trick, we presented the issue to Vons. We said to Vons, "Look, you don't know what you got here, you got basically a best seller.... Clearly everybody will recognize the sleazy romanticism of Los Angeles as soon as they open that book, and they will be delighted and amused.... The glamour of Los Angeles— which is as thin as a color slide of a swimming pool—will be immediately apparent, and it will delight and irritate everybody simultaneously, and it will sell to everybody in Los Angeles, Pasadena, Eagle Rock. Our people in Long Beach will rush to buy it, because they will want swimming pools like that.... People in Northern California

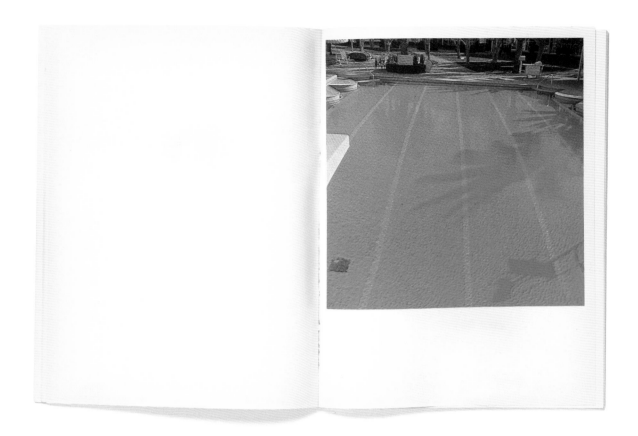

Fig. 14 | Ed Ruscha, *Nine Swimming Pools and a Broken Glass*, 1968. See pp. 160–61 [9].

will say 'Oh that's what those weird southerners would like to live like.' They will look at it scornfully and buy them in Berkeley, all over Berkeley you will see people…carrying copies of the swimming pools of Ed Ruscha, opening them up and laughing and saying 'Oh, Southern California, it's all skin and sun….'"

Do you expect that? No. You don't even expect anybody to pick up that book. As soon as it appears in a supermarket, between the *TV Guide* and the *Daily Examiner*, it'll be there, somebody will open it up, and then close it.[7]

Antin's example was particularly poignant, given that Ruscha's books present perhaps the biggest success story in the history of the medium: printed economically and (originally) priced modestly, they could almost blend in with the other books at a bookstore. By 1978 *Nine Swimming Pools and a Broken Glass* was on its second printing, with a total print run of 4,400 copies. Yet even with this rather blockbuster level

of distribution (in artist's book terms), it is absurdly incongruous to imagine the book a true mass-market success. Nor, however, is it necessary to do so. Mass printing and distribution is only one—optional— quality of the book, among a plethora of others.

By separating the notion of the book from the notion of mass marketing and distribution that has so often dominated the business of publishing, one can see another possibility—an "opportunity to live differently"—for books that adhere more closely to local communities and ideas. Consider, for instance, another project by Alison Knowles, called *The Identical Lunch*. The project began in 1969 not as an artwork but simply as an observation by Knowles's friend Philip Corner that she tended to eat the same lunch every day at her local eatery, the Riss diner in Chelsea. At Corner's suggestion, Knowles began to think of the lunch as a sort of performance with a "score" ("a tuna fish sandwich on wheat toast with lettuce and butter, no mayo and a large glass of buttermilk or a cup of soup") that could be shared and performed

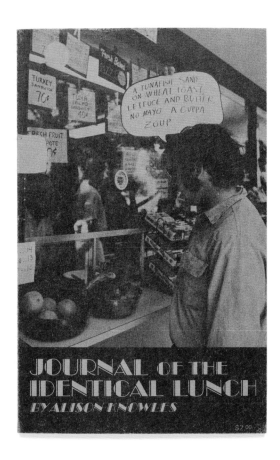

by friends, who could then record their own observations about the experience. During the first phase of the project, Knowles's repeated and supposedly "identical" performances in fact produced a multitude of variations, not only because of changing restaurants and soup specials and varying degrees-of-doneness of toast, but also through the social negotiations of her collaborators (Can I have rye toast? Can I have coffee?) and their own creative approaches to interpreting the score. George Maciunas at one point performed the score by placing the tuna sandwich and a large glass of buttermilk into a blender, surprising perhaps even himself when the resulting mixture turned out to be a tangy, cool, and refreshing cream of fish soup. In 1971 Knowles gathered documentation from some of these lunches and observations from her collaborators and published a small artist's book, *Journal of the Identical Lunch* (figs. 15 and 16). Meanwhile, unbeknownst to Knowles, Corner had begun his own approach to the project, in which he set out to try every single option on the Riss diner's extensive menu—a project that was unexpectedly complex given the large number of combinations of items on offer and a complicated system of changing specials and even secret menu items. Corner published his own artist's book called *The Identical Lunch* in 1973 (fig. 17).

At first glance, both projects can seem absurd—or mundane beyond any point of interest. Yet somehow the projects also go to the heart of the artistic experience. Within the controlled environment of these scores, the projects become about *looking*, about careful observation, about heightening one's perceptions of the world around us. Corner's *Identical Lunch* becomes a touching portrait of the denizens of this tiny corner of New York City in the tradition of Edward Hopper's *Nighthawks*. Likewise, Knowles's project becomes a study in social interaction and friendship, a basis for shared experiences and mutual reflection. What began as a simple observation from one friend to another over lunch in 1969 has seen its radius of intelligibility steadily expand. Nearly fifty

Figs. 15 and 16 | Alison Knowles (American, b. 1933), *Journal of the Identical Lunch*, 1971. GRI 91-B35085.

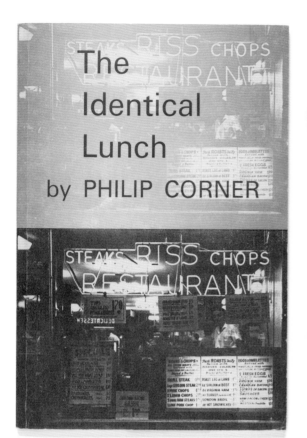

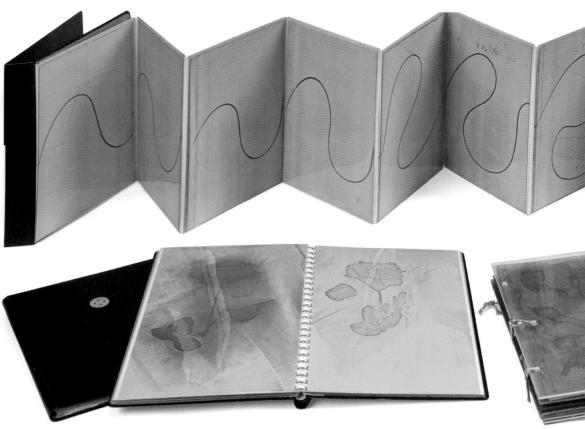

Fig. 17 | Philip Corner (American, b. 1933),
The Identical Lunch, 1973. GRI 94-B16117.

Fig. 18 | Barbara T. Smith, Coffin series, 1965–66.
See p. 174.

years later, Knowles's *Identical Lunch* has continued to be revived as a performance work, both by the artist herself and by countless other participants who have brought their own interpretations to the piece.

Sometimes it can be precisely the humble origins of a work, the seeming smallness of its initial radius, that lends a work its power. When in 1965 Barbara T. Smith leased a Xerox machine—then a cutting-edge technology—and installed it in her Pasadena dining room, she had no fully formed plans beyond knowing that she wished to be a professional artist and that her efforts in this area had so far been met with rejection. Unhappy in her role of suburban housewife, Smith began to experiment with the Xerox machine, turning it into an ersatz printing press. She eventually used her own body, images of her children, and common household objects to produce a stunning series of Xerox artworks—including a series of thirty-two unique artist's books that she called Coffins, partially in reference to her father's profession as a prominent mortician (fig. 18). At the time Smith produced the

works, she was working largely in isolation and had not yet attended graduate school, and the sea change that would be caused by feminist artists in Southern California was not yet even a ripple. When the works were exhibited in 2013, more than four decades after their last public presentation, they appeared to many as a revelation—powerful and authentic expressions of Smith's own experience and precursors to the profound transitions that would take place both in Smith's life and in the culture at large in the ensuing years. All this from a project in an edition of one whose publisher and press was a rented Xerox machine.

David Antin's positioning of artists' books in opposition to mainstream mass-market publishing is significant in that it places artists' books at the center of an artistic avant-garde that flourished in the 1960s and whose roots continue to nourish a great deal of artistic activity today. By the 1970s the heart of this movement was often seen as Conceptual art, video art, and performance art, endeavors whose (at the

time) radically noncommercial products challenged the notion of art as a high-end commodity. These practices, too, were developed in direct opposition to the mass media. Early video art, for instance, bore almost no relationship to the fast-paced conventions of commercial television, and the ability to create personal media, whose messages differed substantially from the corporate-controlled messages of broadcast television and Hollywood, was significant not only for video and performance artists but also for feminist artists and nearly every other social-protest movement of the era. Given that so many Conceptual and performance artists were also regularly producing artists' books during this era, the connection should come as no surprise, yet artists' books have rarely been given the same prominence within historical accounts of the 1960s, 1970s, and beyond. Looked at within a wider context of opposition to mass media, these practices also placed U.S. and Western European artists in dialogue with artists from other regions of the world—such as Latin

America, where artists including Clemente Padín in Uruguay (p. 138), Cecilia Vicuña in Chile (p. 192), and Anna Bella Geiger in Brazil (fig. 19) were using artists' books as well as video and performance to produce their own forms of personal media that stood in stark contrast to the mass-media outlets that were tightly controlled by government and military forces within their home countries. Examining contemporary art practices across the past five decades, we see that even in the era of globalism, hypercommodification of the art world, and electronic distribution networks that bypass traditional channels of communication, many artists still use artists' books as an arena for formal and material experimentation as well as a forum for political, personal, and at times quite humble communication. Chris Burden's *Coyote Stories* (p. 56), for instance, presents a rare occasion when the artist incorporated autobiographical details in a work, even though so much of his early practice had depended directly on his own body. Likewise, William Wegman's *Field Guide to North America and to Other*

Fig. 19 | Anna Bella Geiger (Brazilian, b. 1933), *Passagens,* 1975. GRI 2693-230.

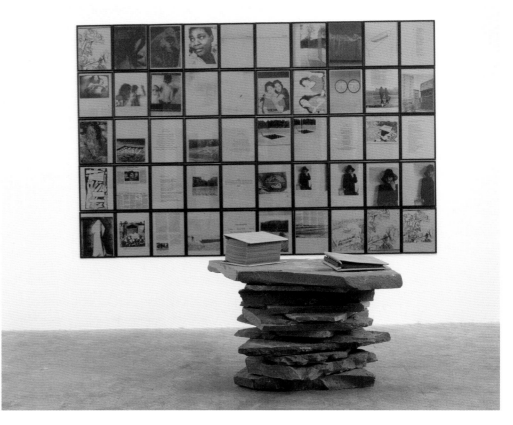

Regions (fig. 20) presents glimpses of the artist's summer life in Maine with only rare appearances by the adorable Weimaraner dogs that have dominated so much of his artistic practice.

While many artists (a great number of them featured in this publication) have devoted their practice solely to the production of artists' books, it is significant to note that a number of artists whose careers have primarily been forged within other media have also carried out a sustained practice of creating books, often throughout the course of their career. This is true not only of luminaries such as Ruscha (pp. 158), John Baldessari (p. 34), Dieter Roth (p. 154), and Richard Tuttle (p. 186), but also for younger artists like Tauba Auerbach (p. 32), Andrea Bowers (p. 48), and Christopher Russell (p. 164). For these artists, books often represent signposts for their working series, with each new investigation in one medium leading to corollary experimentation with books. With Bowers, for instance, each new series of drawings arises from intense rounds of research and

fieldwork, and her artist's books often allow her to preserve and distribute archival materials, oral histories, and other physical and visual components that have driven and inspired the larger series. In some cases, Bowers devises double lives for her books, creating works that can not only be perused by turning pages but also, in some cases, be unbound and transformed into sculptural gallery installations. The two thick volumes that compose *Sentimental Bitch*, for instance, contain not only a nearly complete run of the 1985–89 zine *Bitch: The Women's Rock Newsletter with Bite* but also a series of fifty images that can be removed from the books, framed, and hung on the wall while the books themselves are exhibited on slabs of blue stone (fig. 21).

Such display strategies speak to one of the greatest challenges facing the public presentation of artists' books, both in museums and within catalogues such as this one: the books are interactive and meant to be handled, as is any book, yet there is no adequate way to reproduce them or exhibit

Fig. 20 | William Wegman, *Field Guide to North America and to Other Regions,* 1993. See p. 198.

Fig. 21 | Andrea Bowers (American, b. 1965), *Sentimental Bitch,* 2002. GRI 2813-878.

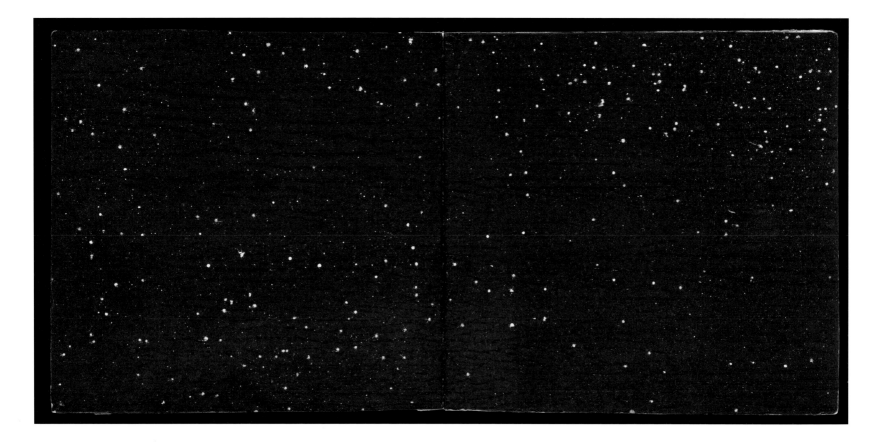

them to a large public without reducing them to a
static and therefore severely limited presentation.
The artist's book collection at the Getty Research
Institute (GRI) is open and free to use for researchers,
although handling of some of the most fragile works
is restricted. And yet this limitation, though unfortu-
nate, can also lead to some of the best experiences
of artists' books. The GRI frequently hosts tours and
classes, which can be wonderful occasions to present
these works within small social settings. On more
than a dozen occasions now, I have had the pleasure
of showing Anselm Kiefer's small but spectacular
unique artist's book *Die berühmten Orden der Nacht,*
delicately turning its pages for a group of visitors or
students. The book begins with a series of gelatin
silver prints showing sunflowers near Kiefer's studio
in Barjac, France. As the pages turn, visitors begin to
realize that the photographs also contain handwriting
and lines of ink. They are stellar coordinates, linked to
stars and constellations. As the book proceeds, the
camera moves in on a single sunflower, enormous

and bursting with seeds. The camera zooms closer
until, at last, the seeds completely fill the page. Then,
the book shifts from photography to painting. The
final twelve pages of the book are made of stiff card-
stock, thickly layered with black paint, surprisingly
physical, heavily textured, and splattered with specks
of white. It is a depiction of the night sky, each page
identical and yet infinitely varied (fig. 22). Without
fail, people gasp at the transformation, and the feel-
ing in the room shifts: the radius has just expanded
immensely—from the backyard to the cosmos itself—
just by turning a page.

Fig. 22 | Anselm Kiefer, *Die berühmten
Orden der Nacht,* 1996. See p. 110.

NOTES

1 *Artwords and Bookworks*, curated by Judith Hoffberg and Joan Hugo, ran from February 28 to March 30, 1978, at the Los Angeles Institute of Contemporary Art before traveling to Artists Space, New York; the Herron School of Art, Indianapolis; and the New Orleans Contemporary Art Center. See Judith Hoffberg and Joan Hugo, *Artwords and Bookworks: An International Exhibition of Recent Artists' Books and Ephemera* (Los Angeles: Los Angeles Institute of Contemporary Art, 1978).

2 Audio recordings of this talk are preserved in the David Antin Papers at the Getty Research Institute, Los Angeles. The talk was recorded on two devices. The first, better-quality recording, is on two tapes, one labeled "The Artist's Book" (C47), and one labeled "The Politics of the Artist's Book" (C84). The second, poorer-quality recording, also on two tapes, is labeled "The Radius of the Discourses" (C49–50). For the purposes of this essay, subsequent references to this talk will be cited as "The Politics of the Artist's Book." Antin often reworked the transcripts of his talks into a hybrid of essay and poetry called "talk pieces." To the best of my knowledge, this talk was not published, although it is possible that portions of it were integrated into another talk piece or that ideas from the talk were integrated into a piece by another name. Thanks to Eleanor Antin for sharing her memories of the party Alison Knowles held to help assemble *The Big Book*.

3 Antin, "The Politics of the Artist's Book."

4 Ibid.

5 See, for instance, the entries for James Lee Byars (p. 60), Dieter Roth (p. 154), and Buzz Spector (p. 180) in this volume.

6 Antin, "The Politics of the Artist's Book."

7 Ibid.

VARIOUS ARTISTS' BOOKS

DENNIS ADAMS

(American, b. 1948)
Recovered—10 on 10, Adams on Garanger, 1993
Brussels: Maîtres de forme contemporains

Bold and disturbing are the words to describe *Recovered—10 on 10, Adams on Garanger*. Produced in an edition of ten, each book includes a unique portrait of a defiant Algerian woman from the series *Femmes Algériennes,* photographed by Marc Garanger in 1960. While stationed in Algeria with the French army during the Algerian War of Independence, Garanger, who personally opposed the occupation, was asked by his commanding officer to document local people for reasons of "terrorist control." His portraits, particularly those of Algerian women who were required by the commanding officer to unveil themselves, revealed the naked anger, resentment, and passion of a people under colonial rule striving to regain their liberty. The images gained wide acclaim and caused no little controversy when they were published in Europe.

For this work, Adams chose ten of Garanger's portraits of unveiled women and placed one on the inside back cover of each copy. He designed the front cover and text block as half pages; thus the women are veiled as they peer at the viewer. Opening the front cover, we are confronted by our reflection in a mirrored page and become participants, and by turning the pages, we engage in the act of re-covering the women whose head scarves had been forcibly removed. Ten pages of photographs taken by Adams document dilapidated social housing projects on the outskirts of French cities, many of them occupied by Algerian émigrés. Powerful images of crumbling buildings force the viewer to confront some of the ways colonial and postcolonial policies and attitudes continue to make their mark on the fabric of human existence. (FT)

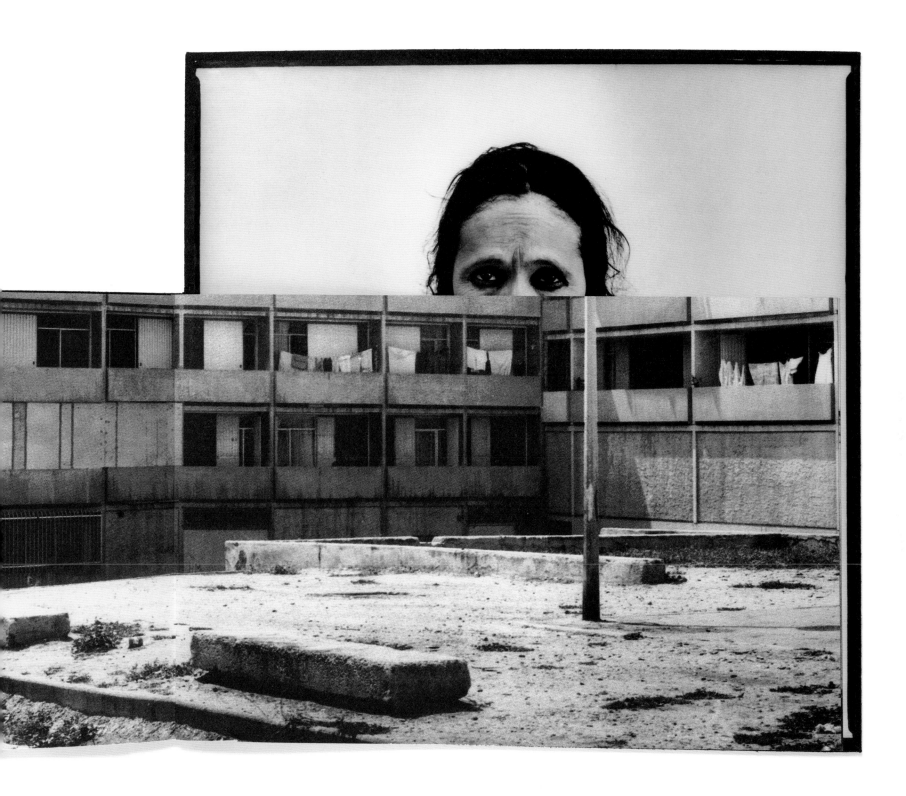

NOBUYOSHI ARAKI

(Japanese, b. 1940)
Xerox Photoalbums (ゼロツクス写真帖), 1970

When he made the *Xerox Photoalbums*, Araki was not yet a celebrity maker of photo-novels, with more than four hundred titles to his name. Rather, he was still a salaryman working at the Tokyo-based Dentsu advertising agency, at the time the world's largest. In his off hours, though, the company photocopiers became his de facto publishers for the *Xerox Photoalbums*, a projected twenty-five–volume set in an edition of seventy (perhaps in commemoration of the year of their creation). While they all sport the same anonymous black cover with traditional thread binding, the books vary greatly in format—from long oblongs to small notebooks—and content, which ranges from Araki's own photography, including a few of the titillating images for which he became famous, to found images from the mass media (including photos of a TV documentary on the atom bomb) to doodles and handwritten notes. A number of the albums feature images from Expo '70, the world's fair in Osaka, for which, not coincidentally, Dentsu was handling advertising. Most intriguing, perhaps, are the volumes in which Araki exploits the full range of the photocopier's capacities. Thus, in volume 7, *Eros in Tokyo* (東京はエロス), the photographer pushes the photocopier's tendency to flatten contrast so that the image grids of Tokyoites become almost solarized. And in volume 20, *Love Letter Book* (恋文帖), the entire work consists of the same found commercial photograph of a woman repeated over and over, with some pages blank and others only half formed, allowing the accidents of production to determine the flow of the book. As a group, these albums offer a playful—and historic— example of what can result when artists get their hands on new technology. (JT)

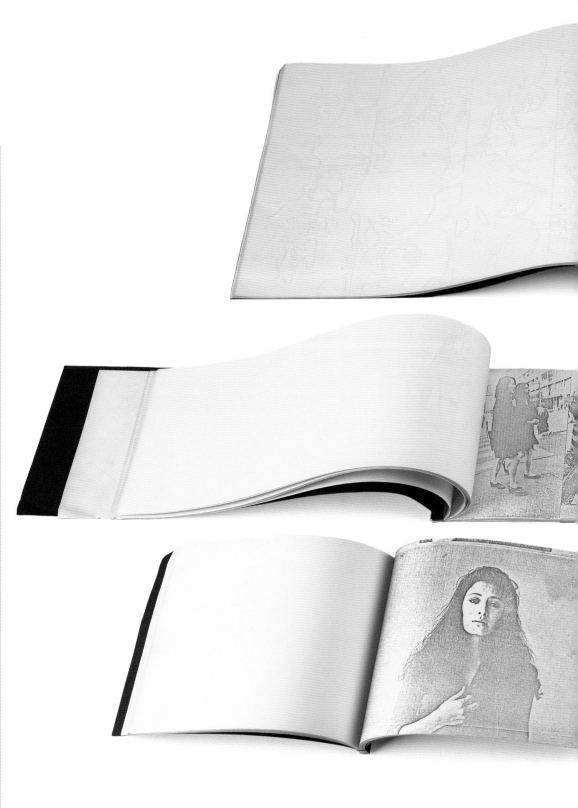

"Where Bigger Meets Better"

American Megazine

HEALING TEMPLE

THE AGE OF AQUARIUS

6

LISA ANNE AUERBACH
(American, b. 1967)
American Megazine # 2: The Age of Aquarius, 2014

Known for her apparently homespun artworks, especially knitted ones that give radical meanings to traditional home economics, Auerbach publishes perspectives on how we live now on sweaters, rugs, and wallpaper as well as the printed page. Years ago, she circulated a zine, *American Stuccolow,* about life in Los Angeles—verifying that there are indeed friendly neighborhoods within this notoriously impersonal city. In this magnum opus, a five-foot-tall "mega" zine, she presents street views of psychics' parlors, familiar sights to all who drive around LA. The artist photographed these small enterprises at dusk and dawn, documenting evocative names displayed on kiosks, houses, and storefronts. The psychics' signage is big and cheerful, encouraging us to think that the contemporary sibyls inside know something about the bright future we all hope for.

Reading *Megazine* necessitates a time, a place, and a second person. This is assisted reading, begun by lifting the book onto a table large enough for the double-page spread. As pages flop and flow, the reader stands for maximum legibility. In addition to highlighting the omnipresence of psychics in the city, perhaps Auerbach's primary narrative is about America, and how we seem always to think that extra-large must be better. In this case it's true: reading slowly with friends and colleagues is fun! (MR)

TAUBA AUERBACH

(American, b. 1981)
Stab/Ghost, 2013
Paris: Three Star Books

It is only one hundred pages long, but flipping through *Stab/Ghost* from cover to cover feels like a trip down infinity lane. That is mainly because its contents are silk-screened not on paper but on "250 micron Lexan," a clear polycarbonate sheet. While one might expect to be able to judge a transparent book *through* its cover, *Stab/Ghost*'s first frontal image—a dense web of interlocking skeins in black, yellow, green, and blue—is deceptive. The act of turning its pages, especially when the book is seated on its custom light table, reveals an ever-evolving perceptual puzzle: what one sees depends on the angle of viewing, and dots that appear on one sheet soon smear into distant space. That the book was produced by Auerbach, an artist born to designer parents, should be no surprise. From the beginning of her career she has worked at the intersection of design, mathematics, and science, frequently exploring systems of communication, including various alphabets, Morse code, and even semaphore signals. Her books have charted the possibilities of the codex form and sometimes include three-dimensional pop-up constructions that seem impossible to have materialized from flatness. In *Stab/Ghost*, the information contained within its pages never quite solidifies but nevertheless remains quite haunting. (JT)

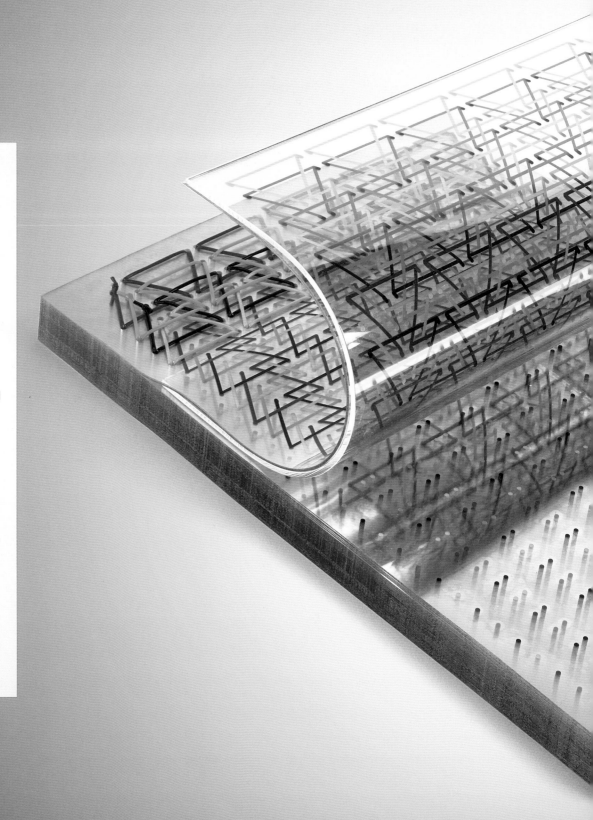

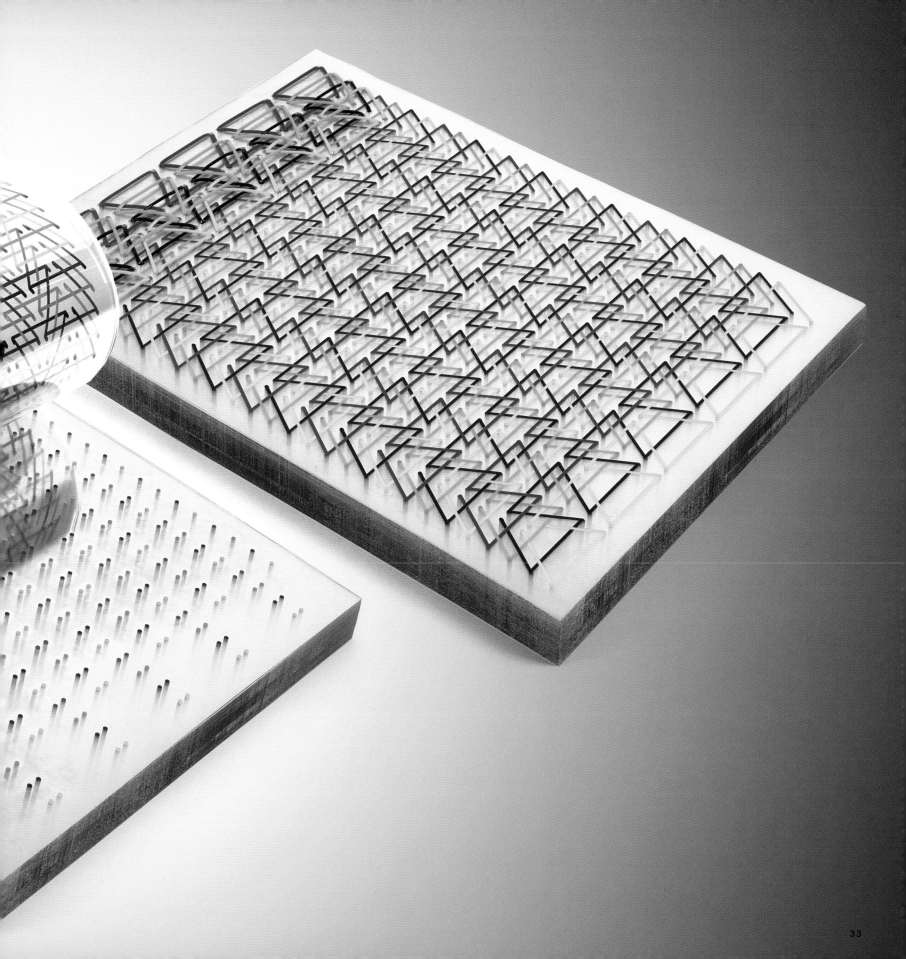

JOHN BALDESSARI

(American, b. 1931)

Throwing Three Balls in the Air to Get a Straight Line (Best of Thirty-Six Attempts), 1973

Milan: Giampaolo Prearo/Galleria Toselli

Drawing a line is one of the most fundamental and traditional artistic skills. Here, Baldessari playfully turns this skill on its head by leaving the line making partially up to chance, as he tosses three orange balls in the air and tries to photograph them when they most resemble a straight line. Twelve photo-lithographs document the orbs suspended in different configurations, hovering like planets against a cloudless blue sky. These otherworldly spheres coalesce into straight lines in some of the photographs, while in others they refuse such an order. Hints of the work's California setting—the tops of palm trees, for example—appear on some pages, while others render sublime orange abstractions against a deep blue ground.

The artist's simple game reveals his broader interest in systems and playing with confining, arbitrary rules to create a work. The book documents the "best of thirty-six attempts," the number of exposures in a standard roll of 35mm film. Not only is the titular feat documented by Baldessari then, but the mechanics of photography itself are written into the book, registering and revealing the chance occurrence of each moment captured. The book asks us to consider the "line" created by the three balls—a drawing traced on a clear sky by light, lens, and film—humorously provoking questions about photography's status as fine art. (ZG)

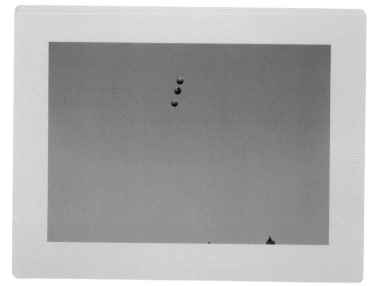

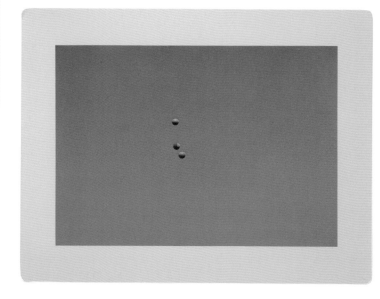

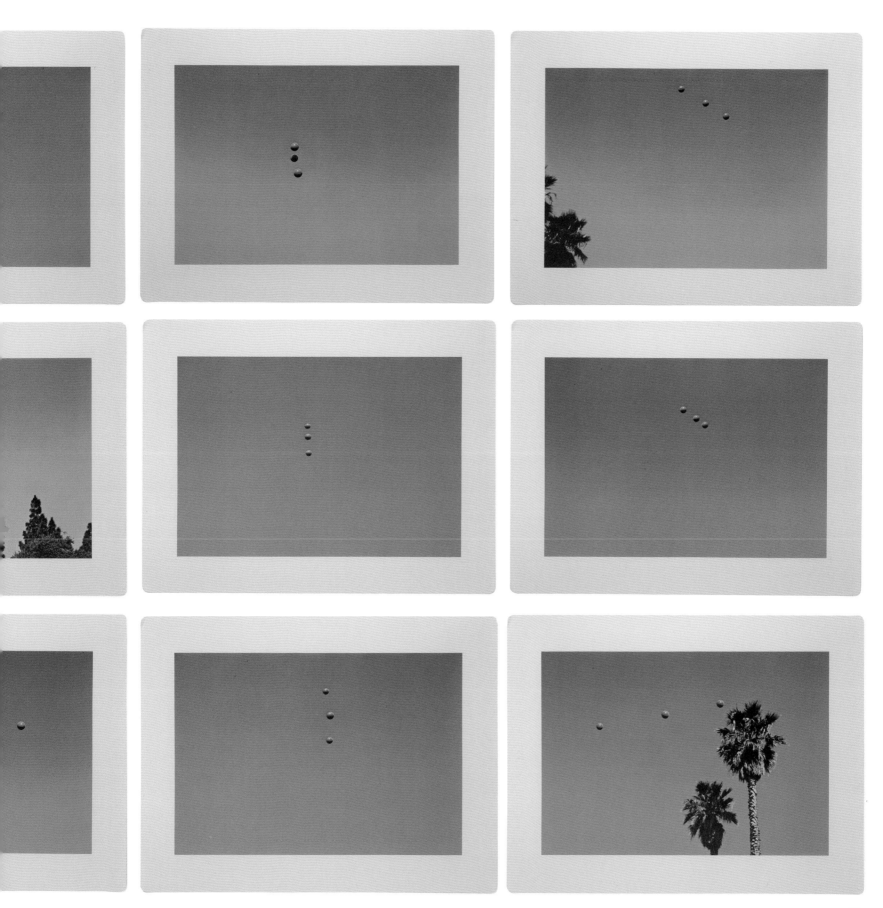

MIROSŁAW BAŁKA

(Polish, b. 1958)
Entering Paradise, 2003
Santa Monica, CA: Edition Jacob Samuel

Artists' books are ideal vehicles for recording memories of travel and impressions of faraway places. Before he came to stay with the master printmaker Jacob Samuel, Bałka had never been to California. Astonished by the culture and the beauty of the beach in Santa Monica, he knew he was in some kind of paradise—a floating world—but still Bałka had reservations. On this book's cover, the artist's name hovers like a mirage over a horizon created by a slight coloration in the vellum cover. The book's etchings record the lingering trace of footprints on printing plates. A poem by Bałka tells the story of the project. (MR)

Eden not lost, yet
Eden, not yet lost
entering Eden
entering Paradise

on a sunny day in Santa Monica
Sunday the 6th of April 2003

on the corner of Bay and Main
on the sidewalk in front of Pandemic
on benches facing the Pacific Ocean
on the parking lot below the palm trees
on the stairs near the chess players

we asked 12 (twelve) homeless men
for their footprints

We offered to pay them.
They accepted.

They took off their shoes
tired, dirty, stinking, full of pain
their feet
touched the shining copper plates
their feet
rocked back and forth
leaving an impression.

For one afternoon they entered Paradise
(booze, grub, booze).

A refreshing breeze came from the ocean.

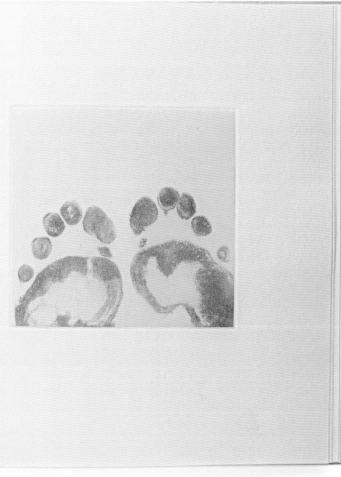

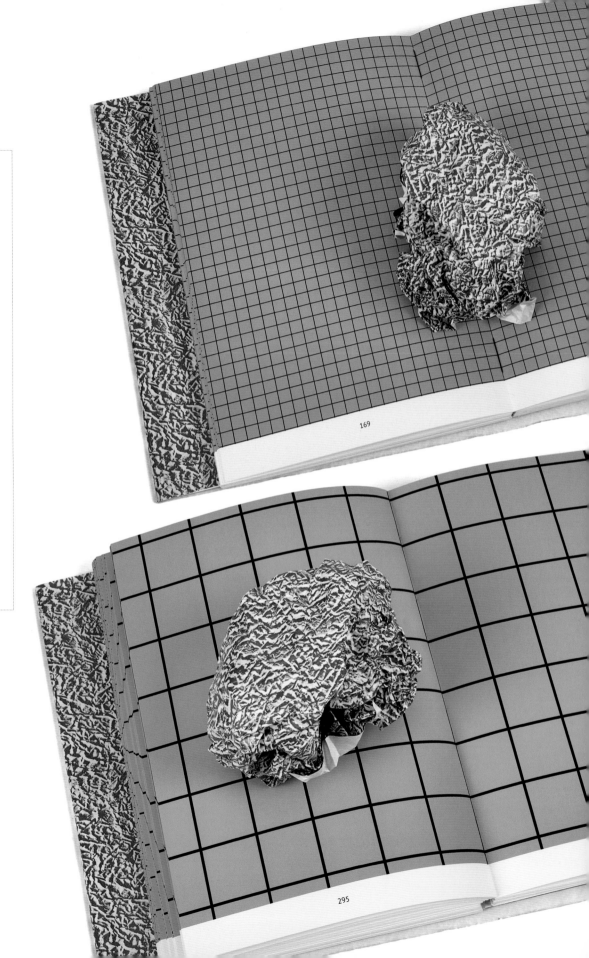

ANA DIAS BATISTA
(Brazilian, b. 1978)
Livro das escalas, 2015

This book is an invitation to play—literally—with scale, perception, and geography. *Livro das escalas* (Book of scales) engages the viewer in an interactive landscape. The pages contain grids, similar to cartographic records or scientific catalogues, that vary in size throughout the book, shrinking toward the center and then expanding again. The volume has a paper jacket printed with the texture of stone. When the jacket is crumpled, it becomes an object to be placed on the pages of the book. Superimposed on successive grids, the same object seems to take diverse forms, such as a stone, a hill, an island, a mountain, or even a continent; it appears to change scale without really being modified.

Throughout her artistic production, Batista singles out everyday objects, playing with their shapes and natures. Her arrangements often involve operations such as resizing, duplication, mirroring, reversal, and reiteration. With her work, she aims to investigate the conditions under which meaning is constructed, often creating sculptural pieces that play with scale. (IA)

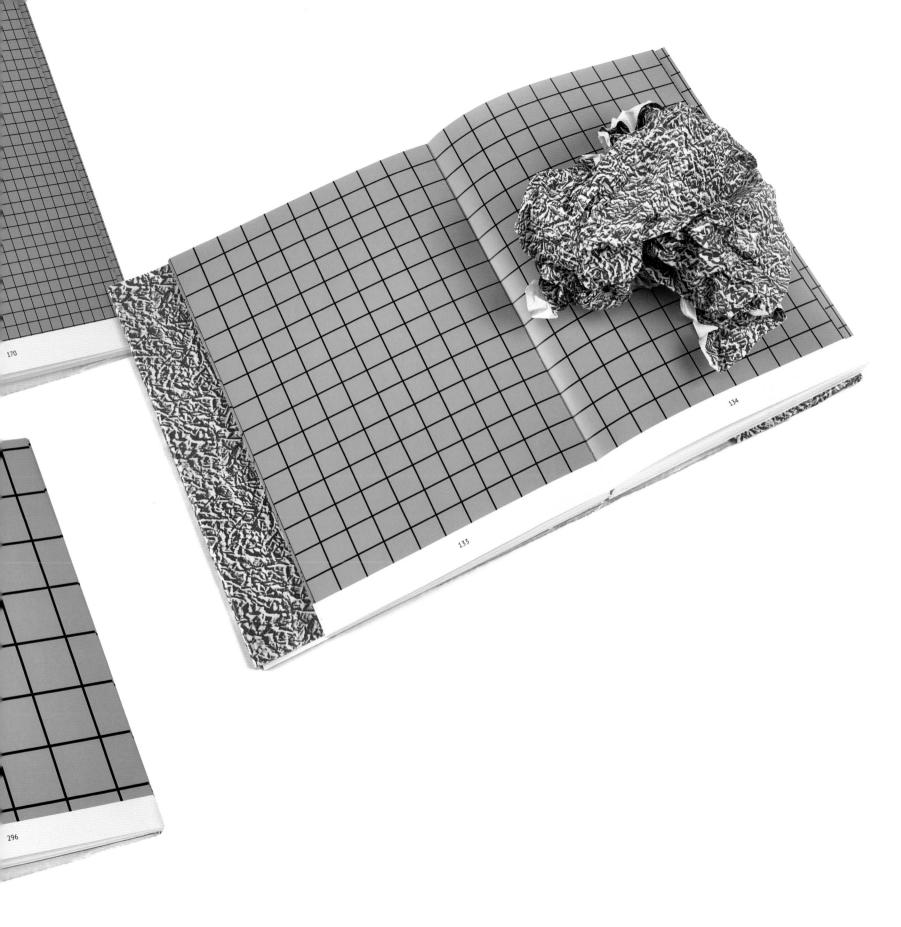

170

296

133

134

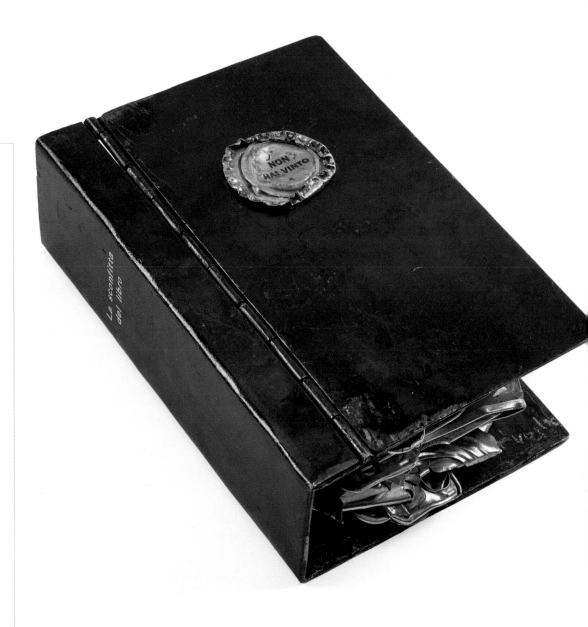

MIRELLA BENTIVOGLIO

(Italian, 1922–2017)

Litolattine, 1998

Litolattine—a made-up word for "lithographed tin cans"—is composed of eight flattened Coca-Cola cans functioning as pages, bound together by two bolted rods and secured inside a blackened steel enclosure. A crushed bottle cap that reads in laconic Italian *"NON HAI VINTO"* (You did not win) is mounted on the book cover as a precious emblem. Like its crushed-can pages, this book seems like a found object, the by-product of a consumer society in which litter on the streets ends up smashed under the wheels of the hectic metropolitan traffic of Rome, Bentivoglio's home.

The title *"La sconfitta del libro"* (The defeat of the book) is inscribed on the book's spine and questions conventional book media just as surely as the pages it contains. Here, every element of the traditional book—cover, pages, emblem—has been replaced by Bentivoglio with metal objects originally produced for mass consumption, evoking both a bygone pop-culture era and the onset of pervasive corporate globalization.

Litolattine offers a witty, end-of-the-century tribute to the iconic metal books by Bentivoglio's forebears Filippo Marinetti and Tullio D'Albisola.[1] These Futurist artists, who rejected the weight of past pedantry and advocated the destruction of libraries, embraced the innovative metal-based technologies of the modern age, which, with the roaring engines of cars and planes, stood for newly conquered speed and freedom. (IP)

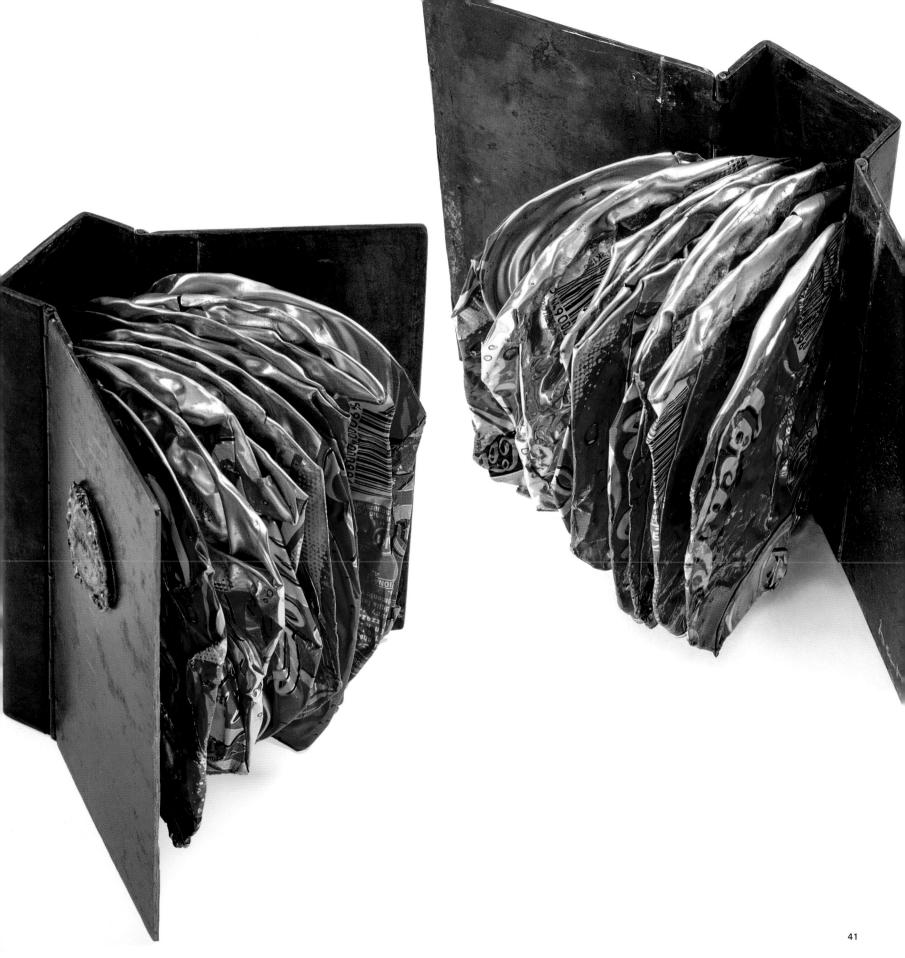

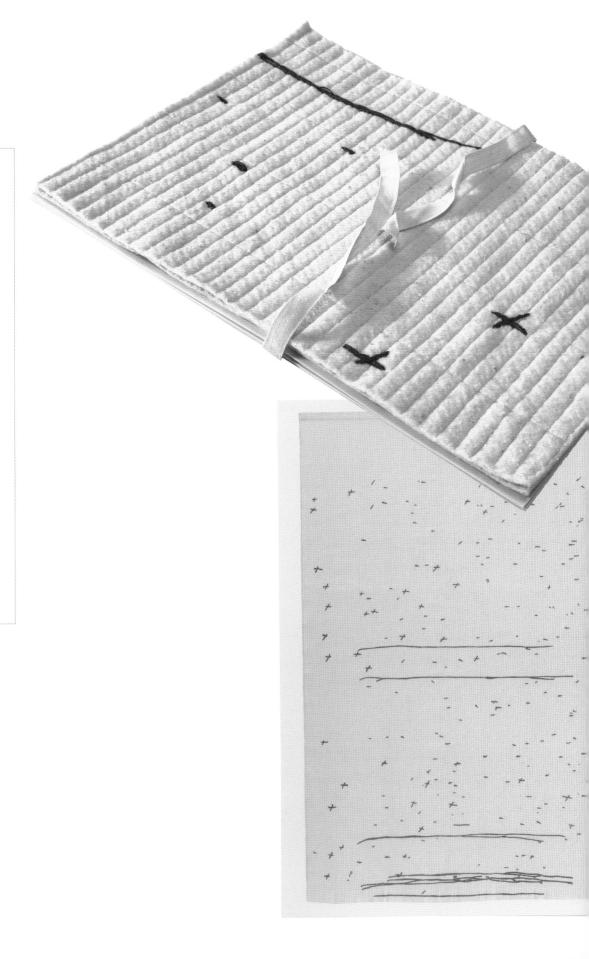

JEN BERVIN

(American, b. 1972)

The Dickinson Composites, 2010

New York: Granary Books

What would Emily Dickinson have thought of artists' books? In this work—and in *The Gorgeous Nothings: Emily Dickinson's Envelope Poems,* edited with Marta Werner—Bervin aims to answer this question by assuming the role of Dickinson's contemporary fabricator.[2] Instead of focusing on the poet's words, Bervin has lifted the punctuation marks and spaces from Dickinson's manuscripts and restaged them on textiles and as thread work on large-scale quilts. By framing Dickinson's art in the context of craft, Bervin hit a historically gendered trifecta: Dickinson's eccentric way of writing poetry on scraps of paper; embroidery, notably on samplers; and quilts, a supremely American craft form created in communal quilting bees or circles that were vehicles for country-style communication. In Bervin's hands, handiwork seems a perfect way to think more expansively about Dickinson. "The pleasures and challenges" of her poetry "are impossible to ignore," said poet Dan Chiasson. "Letters are sounds, so too are spaces between the letters, the margins and gaps."[3] (MR)

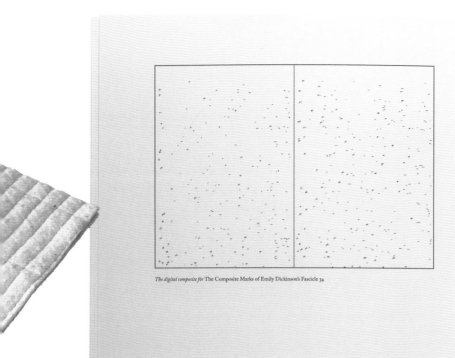

The digital composite for The Composite Marks of Emily Dickinson's Fascicle 34

I wanted to map Dickinson's marking system, to visibly reverse its omission. Using scans of Franklin's *The Manuscript Books of Emily Dickinson: A Facsimile Edition,* I made digital composites of the patterns that form when all of the + and – marks in a single fascicle remain in position, isolated from the text, layered in one composite field. The fascicles from which I made composites showed clearly identifiable shifts in the size, frequency, and distribution of the marks.

The first time I saw the manuscript punctuation markings, I thought they looked like electron clouds in and around the poems. I felt that the dashes might need to be seen in relation to the + marks, that they both weigh in the balance—a sort of temporal space out (–), space in (+) the poem. I am inclined to understand both these marks and the variant words as carefully chosen and integral to her poetics, however private. I've come to feel that the specificity of the + and – marks in Dickinson's work are aligned in energetic relation with a larger gesture that her poems make as they enter, exit and exceed the known world. They go vast with her poems. They risk, double, displace, fragment, unfix, and gesture beyond—to loss, to the infinite, to "exstasy," to extremity.

The embroidered works I made are quite large to convey the exact gesture of Dickinson's individual handwritten marks. Each quilt is 6 x 8 feet (1.83 meters x 2.44 meters), made from a sheet of cotton batting backed with muslin. I selected the batting because it looked like magnified paper; the muslin gives it strength. On each quilt, I hand-sewed a vertical center line (a stand-in for the folio fold) and then machine-sewed a subtle ground of lines that replicate those of the ruled paper and/or light-ruled laid paper. I transferred the digital composite marks onto the batting with a projector and pencil, and embroidered them with red silk thread—red because it consists of the longest wavelengths of light the human eye can see.

The Dickinson Composites are mends of omissions, samplers of "a system of Aesthetics – / Far superior to mine" (Poem 137). I wanted to visually reassert the vital presence of the omitted marks, to raise questions about them. Choosing to circumvent what seemed like an intractable editorial situation, I tried to make something as forceful, abstract, and generously beautiful as Dickinson's work is to me.

4

5

SANDOW BIRK

(American, b. 1962)

American Qur'an, 2005–14

The Qur'an is the book that shapes the worldview of more than one-fifth of humanity, yet it is relatively little known in the United States. California artist Sandow Birk, mindful of the ongoing conflict among the three Abrahamic faiths, created *American Qur'an* to ask a critical question: "What does this holy book have to say to Americans?"

Between 2005 and 2014, Birk illustrated all 114 suras (chapters) of the Qur'an with dazzling beauty. The boldness of this undertaking cannot be underestimated. In the Muslim world, the Qur'an is considered the literal word of Allah. The human figure is rarely depicted; Arabic is the true language; and no one, certainly not a non-Muslim, is invited to make changes. Yet Birk laid a graffiti-inflected English script over colorful full-page depictions of contemporary American life, creating tension between the mundane and the mysterious. He did not shy away from a transgressive point of view for an American: in a post-9/11 world, Sura 1 ("The Opening") shocks with an aerial view of downtown Manhattan. In the final leaf of the book, with Suras 113–14 ("Daybreak" and "Mankind"), Birk, a surfer himself, presents the surprise of a parking lot at dawn with surfers readying their boards for a new day on the water.

The three Abrahamic faiths share a common origin story, which Birk addresses in Sura 20c ("Ta Ha") in his original, provocative way: Adam and Eve, along with the serpent and apple, stand in a lush garden, which itself exists on a soundstage surrounded by the machinery and personnel of filmmaking. Thus, Birk frames the shared religious story of mankind's fall within the setting of contemporary secular storytelling, making *American Qur'an* a kind of ultimate metatext. (SB)

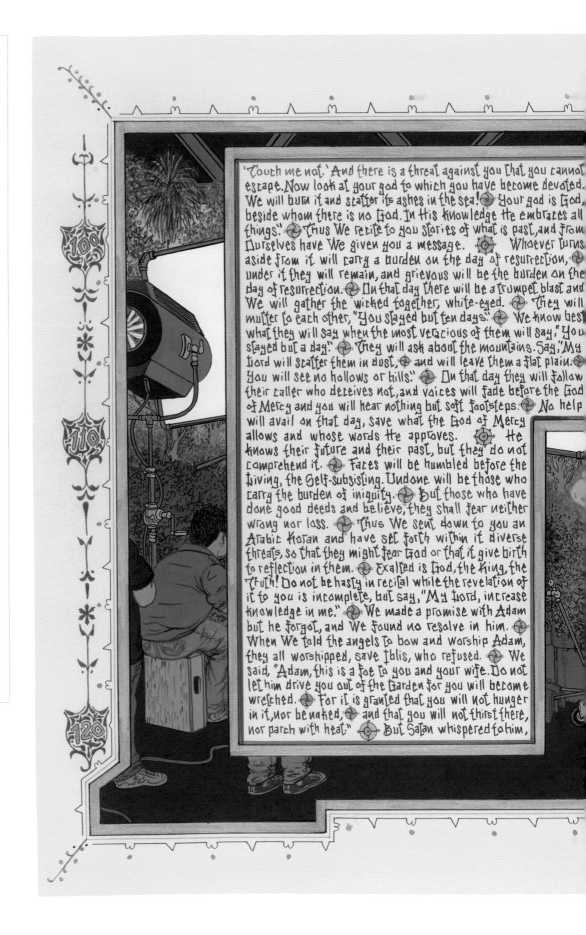

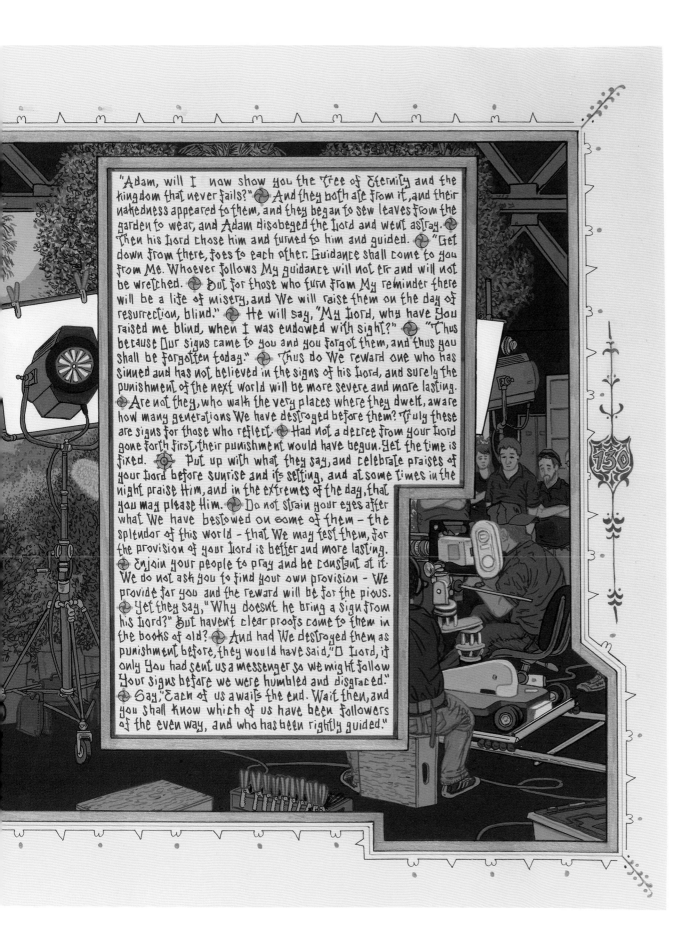

"Adam, will I now show you the Tree of Eternity and the kingdom that never fails?" And they both ate from it, and their nakedness appeared to them, and they began to sew leaves from the garden to wear, and Adam disobeyed the Lord and went astray. Then his Lord chose him and turned to him and guided. "Get down from there, foes to each other. Guidance shall come to you from Me. Whoever follows My guidance will not err and will not be wretched. But for those who turn from My reminder there will be a life of misery, and We will raise them on the day of resurrection, blind." He will say, "My Lord, why have You raised me blind, when I was endowed with sight?" "Thus because Our signs came to you and you forgot them, and thus you shall be forgotten today." Thus do We reward one who has sinned and has not believed in the signs of his Lord, and surely the punishment of the next world will be more severe and more lasting. Are not they, who walk the very places where they dwelt, aware how many generations We have destroyed before them? Truly these are signs for those who reflect. Had not a decree from your Lord gone forth first, their punishment would have begun. Yet the time is fixed. Put up with what they say, and celebrate praises of your Lord before sunrise and its setting, and at some times in the night praise Him, and in the extremes of the day, that you may please Him. Do not strain your eyes after what We have bestowed on some of them – the splendor of this world – that We may test them, for the provision of your Lord is better and more lasting. Enjoin your people to pray and be constant at it. We do not ask you to find your own provision – We provide for you and the reward will be for the pious. Yet they say, "Why doesn't he bring a sign from his Lord?" But haven't clear proofs come to them in the books of old? And had We destroyed them as punishment before, they would have said,"O Lord, if only You had sent us a messenger so we might follow Your signs before we were humbled and disgraced." Say,"Each of us awaits the end. Wait then, and you shall know which of us have been followers of the even way, and who has been rightly guided."

TO OBSERVE
WITHOUT
CONFUSION

Vol. 1

Memory: The Hand

KEN BOTNICK
(American, b. 1954)
Diderot Project, 2015
St. Louis: emdash

For many of us, encyclopedias were our first serious books. Parents purchased a set for homework; door-to-door salesmen pitched their value; grocery stores offered them to customers, who collected one volume at a time. Yet, unless we are scholars of the eighteenth century, we no longer read or need encyclopedias; they are unwanted fossils from the ruins of twentieth-century libraries.

Although the ideal of a single authoritative source is passé, Ken Botnick has taken the encyclopedic concept as his subject in this elegantly choreographed consideration of *Encyclopédie, ou dictionnaire raisonné des sciences, des arts et des métiers,* published in France between 1751 and 1772 and edited by Denis Diderot (1713–1784). Botnick montages images and text from entries in the *Encyclopédie,* creating two-dimensional sculptures that open up space on dense pages. These are printed in black, gold, silver, and transparent varnish on multiple papers (eight pounds' worth!)—a process requiring that the paper be run through the press 220 times.

This work reminds us that the word *project* can also mean *propel*: it is as if the DNA of Diderot's *Encyclopédie* has been blasted forward, like disassembled projectiles hurtling across the space of the pages. Botnick has designed a neo-post-Enlightenment-style volume, one appropriate to the eighteenth-century ideal of gracefully packaged knowledge as well as in tune with our own open-ended, nonspecific moment. It bids a nostalgic farewell to a time when we thought we knew what we could know. (MR)

ANDREA BOWERS

(American, b. 1965)
Labor Is Entitled to All It Creates, 2012
Los Angeles: Susanne Vielmetter Los Angeles Projects

At once a book, an archive, and a sculptural-installation-in-waiting, Bowers's hefty volume presents a snapshot of Southern California workers' rights movements during the Occupy Wall Street era. The book is an assemblage of printed ephemera from every active nonprofit labor rights organization that Bowers could find in Los Angeles in 2011–12 gathered into a large binder. These flyers and pamphlets are divided into a number of thematic sections separated by brightly colored Colby poster stock and featuring script by the artist. The rainbow-hued dividers form their own side tribute to the Colby Poster Printing Company, a family-owned print shop that shut its doors in 2012 and whose bold styling and fluorescent inks marked an unmistakable California street style for more than sixty years.

The book is beautiful on its own, and its inherent activism becomes "activated" as Bowers disassembles its contents, photocopying the flyers and displaying them on folding tables for the public to take away. Presented in this form, the book's contents stretch to more than sixty feet of material and refer to the common method of distributing literature at rallies and protests. Collectively, the project is not only a portrait of Southern California rights movements in 2012 but also a portrait of Southern California itself, with the mixture of languages, communities, and industries addressed in the flyers forming its own representation of the strikingly diverse interests and struggles of working people throughout the region. (GP)

TERRY BRAUNSTEIN

(American, b. 1942)
[1] *Shorthanded*, 1995
[2] *Shorted*, 1996
[3] *Shortsighted*, 1996

Braunstein channels Max Ernst and introduces him to Betty Crocker in these absurdist re-creations, stiff visions worthy of mid-century popular magazines. For this series she took three copies of a vintage book entitled *Shorthand,* altered their covers to reflect her titles, and collaged onto their pages images from other sources. Braunstein prefers pictures that already have a history, selecting them purely for their visual qualities and not caring about their original meanings. She tends toward nostalgia and domestic subjects, but she extracts them from their comfort zones with her scissors. Her apparently childlike cuttings are a kind of amputation that leads to alienation; Braunstein captures the mundane and makes it strange. She frequently pastes the pages of her books together, closing off the possibility of reading in any conventional sense and obliterating the investigations or narratives of previous authors. By allowing only certain openings into these cosmetically enhanced volumes, Braunstein directs us to read old images in new ways and to consider the layers of meaning embedded therein by author, publisher, and artist. (MR)

[1]

SHORTSIGHTED

SHORTED

SHORTED

SHORTED

I do not we do not believe

I do not see they do not

I do not know they do not know

to mean it may be what to do

to know at any to draw

[2]

[3]

MARCEL BROODTHAERS

(Belgian, 1924–1976)
Un jardin d'hiver, 1974
London: Petersburg Press; Brussels: Société
des Expositions

Broodthaers's book purports to reproduce pages
from a printer's catalog showing six typefaces: Onyx,
Palace Script, Times Roman, Rockwell, Perpetua Bold
Italic, and Univers Bold Condensed. This selection
of fonts attests to Broodthaers's interest, rooted
in his background as a poet, in the communicative
capacity of typefaces and the impact of the printed
word. Each reproduction is repeated between two
and four times, in no apparent order. The artist's
inclusion of color plates of exotic birds sourced
from nineteenth-century ethnobotanical engravings
stands out among these stock pages. Broodthaers
had included these prints of tropical birds in the
installation version of *Un jardin d'hiver* (A winter
garden) at the Palais des Beaux-Arts earlier in 1974.
The publishers included a note describing the book
as a commentary on this installation, which Brood-
thaers characterized in his native French as a *décor*
(meaning interior design or film setting). Several ele-
ments referred to the design and interior decoration
of late nineteenth-century European greenhouses
and conservatories: potted palms, ironwork chairs,
and engravings of exotic plants and animals. Winter
gardens provided spaces of leisure for an emergent
middle class primed to enjoy the unfamiliar flora and
fauna that colonial expansion had delivered from
distant, exotic lands. Broodthaers was particularly
attentive to how such institutions presented art and
style to a growing bourgeois audience navigating
new domains of public and private space. Contrast-
ing with the multifaceted address of his large-scale
décor, Broodthaers's book engages his audience in
the intimate, handheld space of reading. (DC)

PALACE SCRIPT
SERIES 429

14 point★ 5 lbs. A 6 a 40
The Art of Fine Printing is to Arrange Type so as to produce a Graceful and Orderly Page that puts no Strain on the Eye

18 point★ 5 lbs. A 4 a 20
The Art of Fine Printing is to Arrange Type so as to Produce a Graceful and Orderly Page

24 point★ 5 lbs. A 3 a 12
The Art of Fine Printing is to Set Type so as to Produce a Graceful and

30 point★ 5 lbs. A 3 a 15
The Art of Fine Printing is to Arrange Type so as to Produce a

36 point★ 10 lbs. A 3 a 12
The Art of Fine Printing is to Arrange Type so as to

42 point 10 lbs. A 2 a 5
The Art of Printing

Founts include Suitable Spaces and are Sold at a Special Rate

A B C D E F G H I J K L M N O P Q R S T U V W X Y Z £ 1 2 3 4 5 6 7 8 9 0 / £ £ a a
a b c d e f g h i j k l m n o p q r s t u v w x y z . , : ; ' ' ? ! ()

Mc Mc Mc t t t t
These extra characters are available in 14, 18 and 24 point only
153

UNIVERS BOLD CONDENSED
SERIES 694

6D on 7 point 5 lbs. A 75 a 150
THE ART OF FINE PRINTING IS TO ARRANGE TYPE so as to produce a graceful and orderly page that

7D on 8 point 5 lbs. A 70 a 140
THE ART OF FINE PRINTING IS TO ARRANGE type so as to produce a graceful and orderly

8D on 9 point 5 lbs. A 60 a 120
THE ART OF FINE PRINTING IS TO arrange type so as to produce a graceful and

9D on 10 point 10 lbs. A 90 a 190
THE ART OF FINE PRINTING IS TO set type so as to produce a graceful

10D on 11 point 10 lbs. A 80 a 130
THE ART OF FINE PRINTING IS to arrange type so as to produce

11D on 12 point 10 lbs. A 60 a 120
THE ART OF FINE PRINTING is to arrange type so as to

12D on 13 or 14 point 10 lbs. A 50 a 100
THE ART OF FINE PRINTING is to arrange type so as

14D on 16 point 10 lbs. A 35 a 65
THE ART OF FINE printing is to arrange type

18D on 20 or 24 point 10 lbs. A 20 a 40
THE ART OF FINE printing is to set

22D on 24 point 10 lbs. A 14 a 27
THE ART OF fine printing is

28D on 30 point 10 lbs. A 8 a 16
THE ART of fine printing

36 point 10 lbs. A 5 a 11
THE ART of finest

48 point 20 lbs. A 6 a 12
The Finer Arts

ABCDEFGHIJKLMNOPQRSTUVWXYZ&£1234567890
abcdefghijklmnopqrstuvwxyz.,':;-?!()
180

15

NANCY BUCHANAN
(American, b. 1946)
Fallout from the Nuclear Family, 1980

The ten volumes that form Buchanan's *Fallout from the Nuclear Family* present an intensely personal look at the dynamics of Cold War America through an examination of the artist's own father, Louis N. Ridenour Jr. A nuclear physicist, Ridenour had been invited by Robert Oppenheimer to join the Manhattan Project but opted instead to go to Europe and work on radar technology. He later became an outspoken critic of nuclear weaponry as well as an amateur playwright and fiction writer. Ridenour died suddenly in 1959, when Buchanan was still young. Two decades later, Buchanan returned to Ridenour's professional and personal papers and began sifting through them in an effort to make sense of her father's life and the political history of an era that propagated a looming threat of nuclear war.

Working with an early version of a Xerox color copier, Buchanan copied selections from her father's papers and organized them into ten sections that offer a loose narrative of his life. She then inserted a variety of framing and interpretive interventions that add her own perspective to the story. Inserted throughout the volumes are red pages containing Buchanan's own historical research on the era. A series of blue tissue pages contain excerpts from audio interviews that Buchanan conducted with her father's associates. Other pages contain cutouts that frame striking or significant excerpts from the archival pages behind them. As a whole, *Fallout from the Nuclear Family* constructs a portrait of how secrecy, overzealous governmental security, the growth of the military-industrial complex, and anticommunist tactics were reflected in the life, thoughts, and actions of one individual, his family, and the nation at large. (GP)

CHRIS BURDEN

(American, 1946–2015)

Coyote Stories, 2005

Santa Monica, CA: Edition Jacob Samuel

This compilation of twenty-seven unbound leaves in a wooden box was produced collaboratively by the Los Angeles–based Burden and the master printer Jacob Samuel. Originally handwritten on lined legal pads, Burden's suspenseful narratives parallel his performances in their intense, personal focus. He writes about camping in tents and vans and sleeping under the stars as he built his house and made his life in Topanga Canyon, seemingly always under sur-veillance by coyotes, the signature urban predators of Los Angeles. Burden records a series of sightings and momentous encounters with the scavengers, who play their traditional role as shape-shifters and tricksters. Emblematic illustrations drafted by Burden show the simple objects described in his stories: crushed potato chips, the favorite knives the coyotes stole, and the blue wallet they marked like dogs, leaving a strong-smelling message.

 Burden is best known for his innovative work in early performance and installation art in the 1960s and early 1970s, which was sometimes documented in published books. Those books were more detached, with Conceptual social critiques and commentary, making *Coyote Stories* an unusual departure for Burden. Yet its gripping narrative and violent climax embody characteristic twentieth-century themes, juxtaposing man in his most macho mode with an idealized nature. In an almost cinematic updating of Jack London's *Call of the Wild*, Burden's tales tell of extreme conditions, events that transcend the normal physical limits of men and an-imals, heroic behavior, and survival—or death. (MR)

4. Blue Wallet

In 1985, Nancy and I were coming home from the beach and decided to stop and pick up supplies at the Topanga Market. I gave Nancy my wallet and waited in the car for her. Several days later I asked her for my wallet. It was nowhere to be found. I assumed it had been dropped in the parking lot and was lost. Nancy wondered aloud if perhaps it had been put down at our campsite and stolen by a coyote. Since this was a blue nylon surfer wallet, this idea seemed to me a lame excuse for her having lost my wallet at the market. Two months later upon returning from a trip to Washington D.C., I woke early to take a pee in the bushes. My eyes spotted a blue glimmer deeper in the brush. I wanted this to be my wallet, but my rational mind told me it was probably a piece of trash. Foraging deeper into the brush to investigate, I realized that indeed it was my wallet lying on the ground at the confluence of 4 or 5 coyote trails. Every time a coyote passed by my wallet, it peed on it.

Coyote Stories

Chris Burden

Edition Jacob Samuel

Santa Monica

2005

MICHELE BURGESS
(American, b. 1960)
BILL KELLY
(American, b. 1948)
Repair, 2006
San Diego: Brighton Press

In its elegant Japanese silk portfolio with bone closures, this book juxtaposes exquisite production and beautiful damage. Kelly's reflective poems are inserted among Burgess's manipulated and painted photographs of sculptural fragments and crumbling monuments. The damage is done. Images are corroded, rusted, and abraded. The strong colors—red and orange, brown and gray—express the effects of decay, rot, rust, war, fires, floods, and simply life in the material world.

Burgess and Kelly reflect on the intentions and practices of conservation—memorializing fragments, making or re-creating monuments. We accept that ancient structures are damaged beyond repair; we admire and aestheticize them, rather than unceremoniously discarding them like dishwashers that no longer work. This book uses the language of conservation to question the authority of our artistic tastes and our judgments about condition and treatment. The word *repair* at first makes us think of shoes or furniture, but it has expansive meanings that unfurl the longer we consider them. *Repair* means to fix, renew, or make functional again, but it also means to return, retreat, or get out of the fray. This book asks a question: does *repair* mean to fix up or to move away to some safer place? (MR)

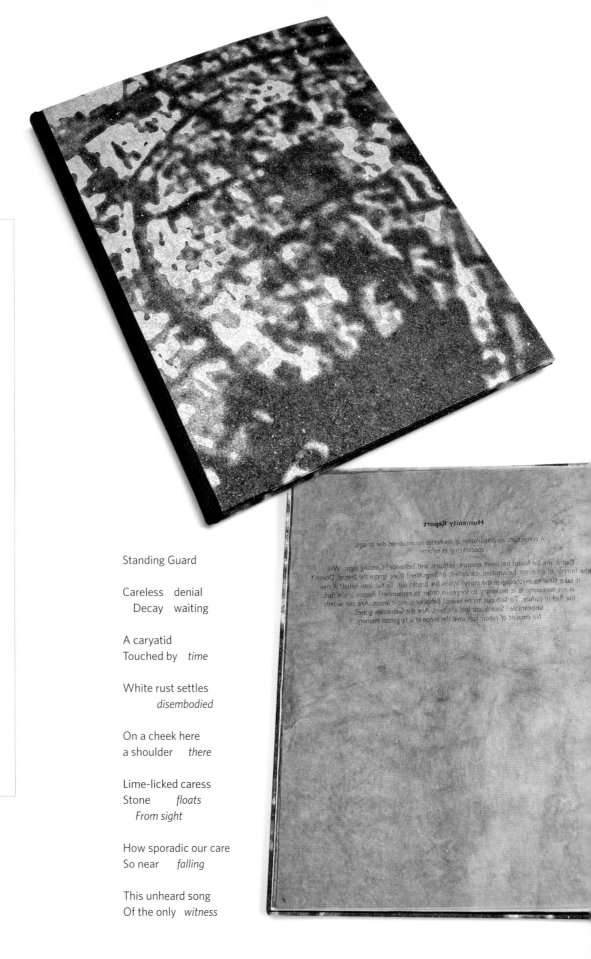

Standing Guard

Careless denial
 Decay waiting

A caryatid
Touched by *time*

White rust settles
 disembodied

On a cheek here
a shoulder *there*

Lime-licked caress
Stone *floats*
 From sight

How sporadic our care
So near *falling*

This unheard song
Of the only *witness*

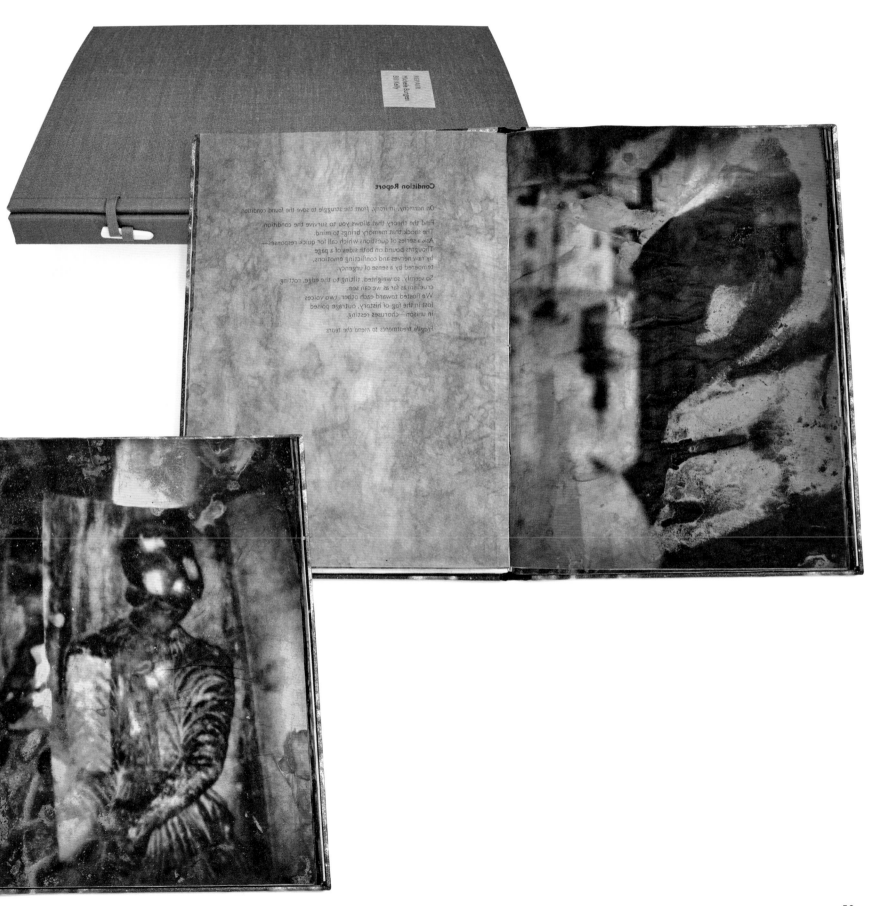

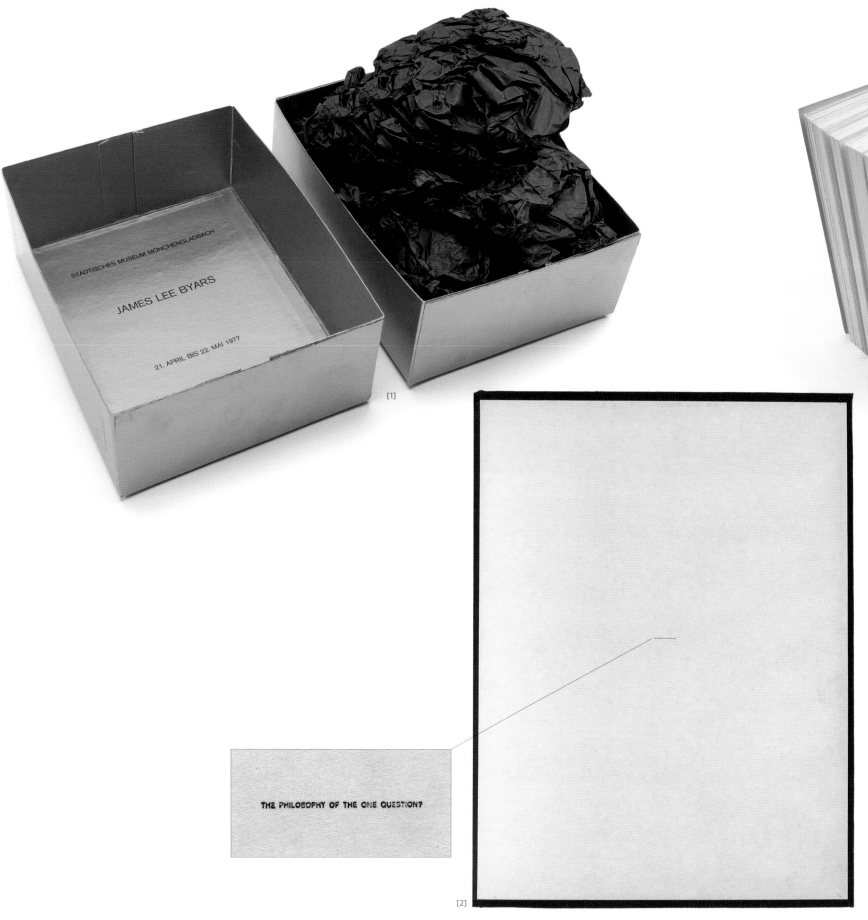

STÄDTISCHES MUSEUM MÖNCHENGLADBACH

JAMES LEE BYARS

21. APRIL BIS 22. MAI 1977

[1]

THE PHILOSOPHY OF THE ONE QUESTION?

[2]

[3]

JAMES LEE BYARS
(American, 1932–1997)
[1] *TH FI TO IN PH*, 1977
Mönchengladbach, Germany: Städtisches Museum
[2] *The One Page Book*, 1972
Cologne: Michael Werner
[3] *Gold Dust Is My Ex Libris*, 1983
Eindhoven, Netherlands: Stedelijk
Van Abbemuseum

The art of James Lee Byars ranges from monumental sculptures in marble to the most fleeting acts of performance, but a fascination with language, print, and books runs throughout his career. For Byars, the act of reading—or attempting to read—could be a perceptual experience and a mode of philosophical searching, and many of his works aim to slow readers down, if not stop them altogether. His art often stretches the definition of a book to its outer limits and openly challenges the form.

Gold Dust Is My Ex Libris—also known as "the cube book"—presents the book as sculpture: nearly two thousand pages, mostly blank, form a block. Yet hidden among those pages are the components of a small exhibition catalogue containing images and texts about Byars's work, all printed on the recto. Nearly impossible to read like a normal book, engagement with this work becomes a process of searching, flipping, and trying to find the content held within.

The One Page Book goes to the opposite extreme, reducing the book to a single page bound in hardcover. The page might at first appear to be blank, but it contains a six-word text at its center written in type so small that it is difficult to read without a magnifying glass: "the philosophy of the one question?"

TH FI TO IN PH pushes the notion of a book even further. Presented as a gold box, it contains no book at all but rather a large crumpled piece of black tissue paper, almost too large to fit. The title page is printed inside the box's lid; an essay is printed on the inside bottom of the box; and the tissue paper, when carefully unfolded, reveals small gold letters: TH FI TO IN PH. This is an abbreviation for Byars's overall artistic method, "The first totally interrogative philosophy," an unending series of questions with answers that are never in plain sight. (GP)

JOHN CAGE

(American, 1912–1992)
Mushroom Book, 1972
Lithographs by Lois Long (American, 1918–2015)
Text by Alexander H. Smith (American, 1904–1986)
New York: Hollanders Workshop

"Hunting is starting from zero. Not looking for,"
said John Cage. In 1962 he founded the New York
Mycological Society with Lois Long and others.
Mycology—the study of fungi—was a lifelong pas-
sion; just as Cage explored the aleatory aspects of
music, he drew an analogous relationship between
chance and mushroom foraging. *Mushroom Book*
calls upon the reader to become such a hunter, one
who forages words and images across the field of
a book's pages.

 Its structure follows some given patterns: on
ten separate folded folios, ten life-size illustrations
of mushrooms by Long are accompanied by botani-
cal descriptions written by Alexander H. Smith. The
illustrations are printed using chromolithography,
sumptuously rendering the deep, rich colors of each
specimen. Atop each of the mushroom illustrations
lies a semitransparent sheet of Japanese paper
on which are printed texts: diary entries, cursory
statements, quotes from Henry David Thoreau's
Journal, aphorisms, stories, poems, and recipes
written by Cage and others. A robust textured blue
fabric portfolio holds the folios. Maps of mycologi-
cal explorations are accompanied by similarly varied
texts on the outside of each folio "written in stone,"
Cage's reference to lithography's use of a stone
plate. The placement of each element in this book
was determined by the *I Ching*. As Cage explained:
"This enables one, if he wishes, to hunt for a partic-
ular text in a given lithograph, just as he might hunt
for a particular mushroom, late summer or fall, in a
forest." (ZG)

in Connecticut
in the lAir
afterNoon, nobby and j
frequenTly
went to tHe woods.
he'd hike Ahead
Rapidly
(to gEt exercise, i
suppose).
i walked
sLowly
not wanting any tUngs
to eScape my notice.

on sUndays,
soMetimes
Beth, becky and suki
wOuld
come aloNg with us.
eAch
Then (nobby too)
had
a bag or a basket. on sUch
family occaSions, nobby covered no
more
ground than
the rest of
us.

A-ki. (from *Solo for Voice*
60)

react against complex
structures and
heaviness.
(E. L. Wheelwright and Bruce McFarlane)

However, I came to no
longer feel the need for
musical structure. Its absence could,
in fact, blur the
distinction between art
and life. An individual can hear sounds
as music (enjoy living) whether or not he is at a
concert.

having this experience
today, one has it as Daniel did in
the Lion's Den. Many forces, competitive
self-interest and devotion to efficiency
among them have brought mankind *and the earth
itself* to the edge of
oblivion.

Three species are included here. They all lack
a ring on the stalk. . .though a veil is
present.

KEY TO SPECIES
1. Cap brick-red; common on oak
 logs and stumps, usually until
 late in the fall
 Naematoloma sublateritium
1. Color of cap orange-cinnamon
 to yellow or olive 2
2. Cap orange-cinnamon to tawny
 Naematoloma capnoides
2. Cap and gills yellow, becoming
 olivaceous
 Naematoloma fasciculare
 (Alexander H. Smith)

Quriet asserts
that it is better raw than cooked
and that its sweet milk affords an agreeable drink
for the botanist in the warm
days of summer.
(Charles H. Peck)

Make a book that's edible.

. . the earth itself to the edge of
oblivion. Total destruction can be
averted and a change for
the good of all men
may be made, but it
will require selfless intelligence
and cooperative energetic work.

Flore
alynatigUs
champigNons
ouvreGa
prÍx.

As we were leaving the airport
Morris said: First
thing's to take a ride on the lake. I
said, "What for? Mushrooms don't grow on
lakes." Years later, Ted's voice came over
the water: Mushrooms! Rowing out,
filled canoe with *pleuroti*.

iiMarmürkel
:Oigiisnen
kähuR
Cm.
kollakasHall
tumEdamato
lnLedamato
aLumimes
sern·As

Eräldatud
jalaSt
Cm,
vürsuseU,
vaLviult
tippsuEiga,
rohtsNud
aprillisT
mAim.

Since *Tarzetta* is the oldest of
these three generic
names, the choice of one of these
species as the lectotype of
Tarzetta would lead to
the abandonment of either *Stromantinia* or
Geopyxis, both
widely used generic names.
This led Rifai (1968) to favor the
conservation of *Geopyxis* over
Tarzetta, and to
Dumont and Korf's decision to accept
Tarzetta over
Stromantinia (*Mycologia* LXIII:
1084, 1971).

shell-shape.
(Henry David Thoreau)

lost.

When we first moved to the
country we were seven friends: Paul and Vera,
David and M.C., Karen and
David Weinrib and I. Paul and Vera stayed in
Gurneville while houses were being built. The
rest of us lived in the farmhouse
on the land. After
seventeen years only David Tudor and
Karen remain. All the
couples have split up.

Tibti
seRisega
peemüTiga
Cm.
conkeUsbesnd
eOr
vedAýsitheenkad
hOredalt
·Monikord
noguwAlt

kunl
eRäldataud.
valdjacheesUkas:
kollakasprunNikut,
kUlse
eM.

"becauSe
of iTs
shaggy appeaRance
and dull cOlor
it has Been
nicknamed
the oLd man
Of the woods."
its new naMe,
academicallY speaking,
is *floUcopus*
goes oHearing
doeSn´t accept the new name.

loiS and i
disagree abouT
its desiRability
as fOod. she likes it
Because
"It
Looks like
A prune but tastes like
a Clod
of Earth." sari also likes
it
very mUch.
She makes a pickle out of
it.

Cantharellula umbonata (Fr.) Singer

Pileus 1·5(7) cm broad, broadly conic with margin incurled at first, expanding to plane or nearly so and with a small conic pupilla or umbo, finally shallowly funnel-shaped, edge even to short sulcate-striate, surface dry to moist (scarcely hygrophorous), appearing glaucous, at times rivulose, grayish to dingy bluish-gray or developing olive or vinaceous-brown tones. Context thin, soon whitish, odor and taste not distinctive, where bruised often stained reddish.

Lamellae decurrent, close, narrow, usually dichotomously forked, separable from pileus trama, whitish to pale yellowish, staining dull vinaceous where injured, edges often ± blunt.

Stipe 1·5-6 cm long, 3-6 mm thick above, equal or tapered either way, often pointed at base, often surrounded by copious mycelium, becoming hollow, surface pruinose to fibrillose-striate, pallid or colored grayish-avellaneous (paler than cap).

Spores 7-10 x 3-4 μ, narrowly elliptic to subfusiform, white in deposit, hyaline under the microscope, amyloid, smooth. Basidia 4-spored. Pleurocystidia absent. Cheilocystidia absent. Pilear cuticle of appressed hyphae with some finely incrusted pigment on the walls. Clamps present.

Habit, habitat and distribution: Gregarious to scattered in patches of hair-cap moss (Polytrichum) especially, along roads and borders of woods or on waste land, late summer and fall, common. It also occurs on beds of conifer needles.

Observations: It is rated as edible but I have yet to find a collector who is using it. It is an attractive fungus in an odd sort of way for I know of no other species which truly resembles it. Very pale colored variants are sometimes encountered.

Panellus serotinus (Fr.) Kühner

Pileus 2.5-7(10) cm broad, 2-4 cm from margin to base, more or less fan-shaped, margin at first incurled, glabrous, viscid, color varying from green to olive and at times toned purple-drab, sessile. Context pallid, pliant, odor slight, taste mild to bitterish.

Lamellae crowded, attached to a basal tubercle, narrow becoming broad and then close to subdistant, pallid to ochraceous, the margins often darker ochraceous.

Spores 4-5.5 x 1-1.5 μ, allantoid in profile, cylindric in face view, amyloid, thin-walled, smooth, white in a deposit (but gill edges may stain paper yellowish). Basidia 17-22 x 3-4 μ, 4-spored. Pleurocystidia 35-64 x 6-12 μ, often with yellow content, in H₂O fusoid-ventricose, fusiform to clavate, some with incrustations over apex, some with yellow content in H₂O, hyaline in KOH. Cheilocystidia 40-60 x 6-12 μ, resembling pleurocystidia. Pilear cuticle gelatinous, with an overlying turf of clavate to elongate cells. Clamp connections present.

Habit, habitat and distribution: Usually imbricate or gregarious on dead wood of various hardwoods, late in the season widely distributed in North America and Europe.

Observations: I have always regarded this species as an indicator that the mushroom season is approaching the end, since it reaches its peak after the heavy fall crop is on the wane. It shows some interesting variations, one of which is a brilliant orange-ochraceous tubercle and young gills, the color being caused by the pigment in the cystidia. A second extreme almost lacks these colors. A second series of variations concerns the pilear color—green to olive shading into dull violet drab, causing the uninitiated collector (and some who think they are initiated) to believe they have a different species. The artist has shown the typical form here. Lastly, the spore deposit is white; reports of a yellow deposit should be rechecked. The gill edges in the violaceous drab pilei may be near wood brown instead of ochraceous.

SOPHIE CALLE

(French, b. 1953)
La fille du docteur, 1991
New York: T. Westreich

Known for her controversial projects that challenge decorum, Sophie Calle creates artworks that often straddle the line between photography, literature, and performance art. Calle first came to prominence in the 1980s with works that seemed to present shocking intrusions into the privacy of strangers. In *Suite Vénitienne* (1980), she followed a stranger on the street in Paris, and, upon learning that he was traveling to Venice, followed him for two weeks, tracking his movements like a detective and publishing her findings as an artist's book. For *The Hotel* (1981), Calle took a job as a hotel maid, using the opportunity to search through and photograph guests' belongings.

La fille du docteur (The doctor's daughter) presents two separate narratives, allowing readers to draw their own conclusions about how the stories may or may not be related. Attached to the left side of each spread are a series of sixteen facsimile cards, each congratulating a local doctor (Calle's father) on the birth of his daughter (Calle herself). On the right, a series of photographs show Calle as she progressively performs a striptease and appears to fall unconscious. The experience of opening and reading the cards, filled with hope and well-wishes for the future, presents a stark contrast with the photo-narrative of "Sophie" behaving in a manner that most parents do not imagine for their daughter. What lies between these two extremes speaks volumes, as the reader is left to imagine a family dynamic around the little girl Sophie, what she could have been, and the social ramifications of what she may have become. (GP)

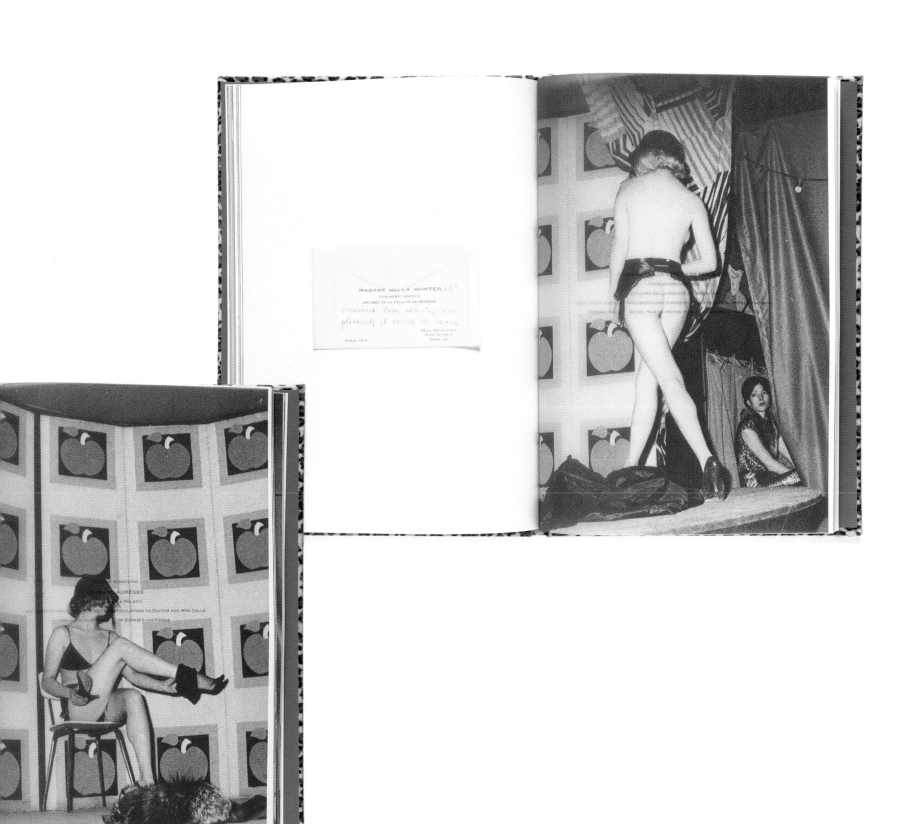

CAROLEE CAMPBELL

(American, b. 1936)

The Persephones, 2009

Text by Nathaniel Tarn (American, b. 1928)

Sherman Oaks, CA: Ninja Press

When the Greek goddess Persephone was abducted by Hades, the king of the underworld, she became queen of that realm. Yet she returns perennially to this world, personifying spring and denying death with flowers and newborn creatures. Evoking nature's recurring processes, this book looks as if it has been buried and unearthed, an effect achieved with sumi ink sprinkled with salt. Poems numbered and called "The Persephones" are printed inside heavy cream-colored paper folders. There is almost no color, just that of paper and clouds of carbon-colored ink. As the folios are opened, they seem to emerge from a deep, dark sleep.

Most of the original editions of *The Persephones*, a 1974 collection of poems by Nathaniel Tarn, were lost in a fire. Tarn revisited and revised the poems for this edition; their reappearance is itself like a rebirth, made slightly difficult by the need to pull goat parchment covers from a slipcase and open stiff folders to reveal the poems within. Awareness of matter slows things down, takes time, makes noise. The physical qualities and visual density of the leaves enhance the experience of reading. (MR)

Who is to sing of brothers and sisters in love,
daughters mad for their fathers, mothers for their sons,
as he leads her upward thru the banks of darkness
son of heaven and deep earth, baptized of the underworld,
looking back at her all the time, afraid to look forward,
 she whose name means forever,

 like a ship on the ocean into the dispersal of the wind
 all sails abreast
 fallen like a man into death
into the great arms of her beauty, his wrists cut and shredded
blood lapsing out like the hours, gone into time, gone weightless,
 measureless,
beyond grieving and remembrance
 seemingly dispossessed...

 thru all the towns of the dead
 in the poverty of his time,
 of his becoming,
 of his arrival
among thickening shades:
 stepping out from the crown with his
swift feet
 become a god instead of a mortal
 singing all music,
 reading all knowledge

and fallen / fallen / fallen
 like a kid
 into milk.

KEN CAMPBELL

(British, b. 1939)

Tilt: The Black-Flagged Streets, 1988

Campbell's books are vehicles for spiritual themes, and their content is unconditionally cosmic. Corporeal metaphors energize them, and death and violence lurk in their pages. Campbell's texts or poems frequently concern a spectral presence, hovering within innovative formats and abstract designs; in this instance, the cover evokes black square pavers, while words inspired by a maritime wreck remain opaque and illusive.

Inspired by a statue of a Hindu deity in the Rietberg Museum in Zurich, the dancing doll representing the goddess Shiva seems to hurtle through the pages of *Tilt*, her dislocations heightened by Campbell's use of irregularly shaped covers to upset the usual rectangular field of viewing. The angular cover and slightly goofy slant of the text make you want to tilt your head while reading the book. The artist adds a nice touch in having the goddess resemble a space alien, bridging ancient traditions of an inner sacred realm and the outer space of modern science fiction.

Campbell is notably successful in making his material come alive inside our heads. His technical prowess and compositions of words and images mimic thought processes as we obsess over ideas and experiences, compulsively sorting and re-presenting them. His books are often like dream sequences; words offer clues, but they are purposely not specific. Everything about each of Campbell's books—scale, shape, paper, colors, images, words, reproductive technique—is bound to the subject at hand, though we may not immediately recognize how it all works. (MR)

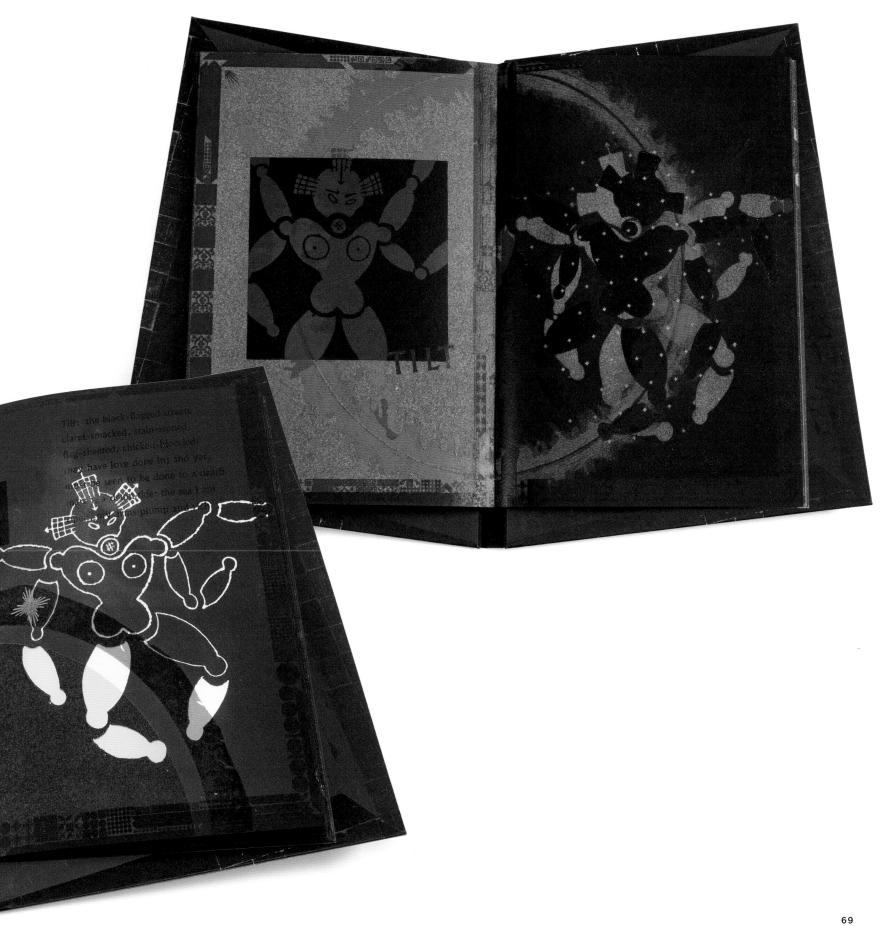

DESEN PERTO

MENOS

AUGUSTO DE CAMPOS
(Brazilian, b. 1931)
Colidouescapo, 1971
São Paulo: Edições Invenção

One of the founders of the international concrete poetry movement, Augusto de Campos launched the literary magazine *Noigandres* in 1952 in collaboration with his brother, Haroldo, and the poet Décio Pignatari. The title was a word of intentionally complex etymology derived from Ezra Pound's *Canto XX* and alluding to a poem by the twelfth-century French troubadour Arnaut Daniel. Augusto's *Poetamenos* (Minuspoet), a series of poems written in 1953 and published in *Noigandres* in 1955, introduced concretism to Brazil and made dramatic use of colored fonts to create melodies of optical-acoustic words.

In the 1960s Augusto experimented with one-word poems, recasting them in different formats, colors, and media. This book-poem—whose title is the Portuguese translation of the neologism "collideorscape" from James Joyce's *Finnegans Wake*—combines two or more words to create a new "word-formation" on every unfolded page. A veritable kaleidoscope of shifting meanings, *Colidouescapo* is accompanied by a "(Tentative) Glossary" that helps identify the seven "original words" that form the book's portmanteaus—such as "Desesprezo" = "Desperate + Despise"—and sends the reader hunting for words that may or may not exist in the book.

Wrapped in a shiny red dust jacket, *Colidouescapo* lacks a spine. It is not bound, nor is there a fixed order to the pages. The instruction to "refold the paper and mix the pages at your will to yield new words" draws inspiration from the indeterminacy of the American composer John Cage (p. 62), whom Augusto greatly admires. Not only does Augusto randomly disperse one-word neologisms across the pages, he also upends the defining features of the book as medium. (NP)

ULISES CARRIÓN

(Mexican, 1941–1989)

Arguments, 1973

Cullompton, UK: Beau Geste Press

Conceptual artist Carrión humorously interrogates the structure and content of books and the literary devices used by authors and playwrights. The titular exchanges in *Arguments* are indicated only by the names of the participants, with no reference to the actual content of their disagreements. The distinctly Anglophone names are arranged in various configurations on each page of the book, leaving the reader to wonder about the substance of the disputes. Indeed, as the "arguments" play out across the gridded field of the typeset page, the book increasingly becomes about the materiality of the text itself, with Carrión adding symbols such as the ampersand or violating the names themselves—as when, for example, "Marion" becomes "Mar()ion"—resulting in ever more complex exchanges.

Produced by the artist-run Beau Geste Press from its farmhouse in Devon, *Arguments* was a truly collaborative effort, with offset printing by Felipe Ehrenberg (p. 80), layout by David Mayor, and typesetting by Terry Wright. Its rich vermillion cover and variety of colored pages reflect the press's predilection for using a range of paper stocks in its productions. In 1975 Carrión founded the bookstore Other Books & So in Amsterdam and enjoyed an ongoing collaboration with the press. On the last page of *Arguments* a semitransparent sheet reads, "My name is Ulises. What's yours?"—a rhetorical invitation to the reader to enter the space of the book. (ZG)

ANNE CARSON
(Canadian, b. 1950)
KIM ANNO
(American, b. 1958)
The Mirror of Simple Souls, 2003
St. Joseph, MN: One Crow Press (Literary Arts
Institute of the College of St. Benedict)

The work of the poet and classicist Anne Carson
often hovers on the border between scholarship and
something else. This perhaps makes her the ideal
person to adapt the work of Marguerite Porete, a
fourteenth-century French mystic who was burned
at the stake for heresy—for writing a book that
hovered on the border between orthodoxy and
something else. This adaptation takes the form of
a handmade opera libretto, the dialogue between
Marguerite and her inquisitors mirroring the dialog-
ic style of her condemned treatise.

 The art and design were created by Kim Anno,
an artist known for her own boundary-crossing work
across multiple media. Anno's collaboration with
Carson negotiates the space between textuality and
orality, desire and death, clarity and mystery. Here,
text overlaps with fragmented musical notations
and defaced, murky photographic images that grad-
ually give way to an abstraction that effaces mean-
ing. In places, blind-stamped text obscures Carson's
poetry, and the final image is a ghostly stamp on a
white page. Marguerite's writings were concerned
with a desire for God that transcends subjectivity, a
search for something beyond the self. This annihi-
lation of the ego ultimately echoes the desire of the
artist and author to sublimate themselves within the
work itself. (RK)

M: Jealous he is truly!
 For he has stripped me
 from myself
 absolutely
 and placed me in divine pleasure without my

Defecta
dubia
perniciosa est
Quis scit?
Nemo scit.
Ratio non est.

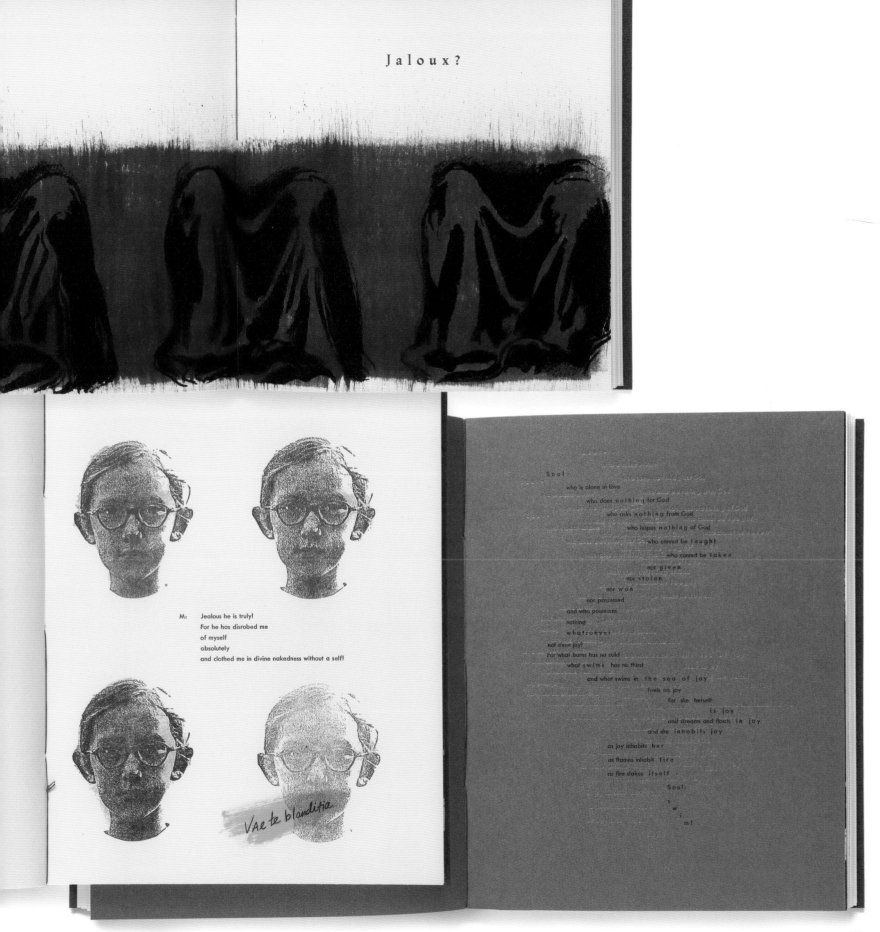

Jaloux?

M: Jealous he is truly!
For he has disrobed me
of myself
absolutely
and clothed me in divine nakedness without a self!

Vae te blanditia

Soul:
who is alone in love
who does nothing for God
who asks nothing from God
who hopes nothing of God
who cannot be taught
who cannot be taken
nor given
nor stolen
nor won
nor possessed
and who possesses
nothing
whatsoever
not even joy!
For what burns has no cold
what swims has no thirst
and what swims in the sea of joy
feels no joy
for she herself
is joy
and streams and floats in joy
and she inhabits joy
as joy inhabits her
as flames inhabit fire
as fire slakes itself –
Soul:
s
w
i
m!

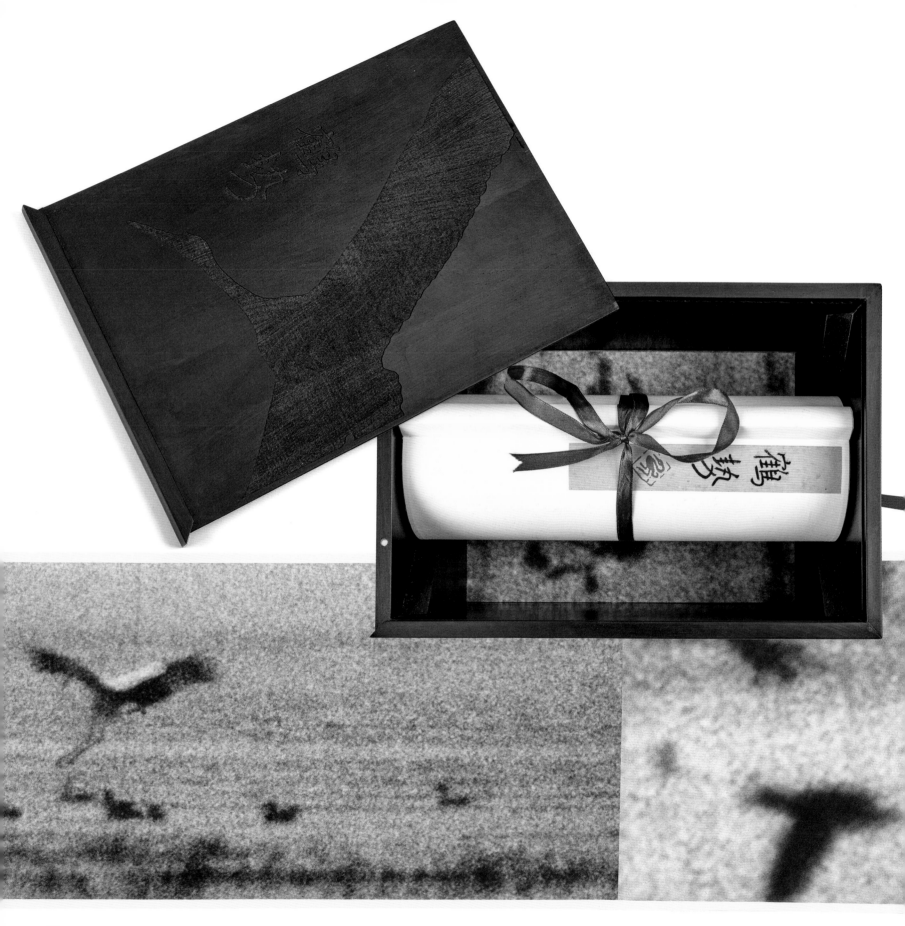

MICHAEL CHERNEY
(American, b. 1969)
Twilight Cranes, 2008

Twilight Cranes lies nestled in a delicately hand-crafted wooden box. Once opened, a scroll of subtly sparkling paper is revealed. It unfurls into an exceptional artist's book more than forty feet in length, implicitly recalling a traditional Chinese scroll and drawing us into its own expanse of time and space. The process of unrolling reveals a motif: the silhouette of a crane, at first seemingly solitary against the grainy background, then followed by more of its kind. As we move through the scroll, the graceful birds form a scattered siege (or sedge, both formal terms for a flock of cranes). The scroll consists of several prints of uniform width but varying lengths, building a panorama of changing horizons. The degree of sharpness changes as well; some birds are clearly delineated while others disappear into a blur of abstract form.

The prints prove to be enlarged details from photographs Cherney took at Poyang Lake, China's largest freshwater reservoir. This important habitat for migrating cranes has recently been endangered by accelerated industrialization. Taking advantage of the absorbent, blotting quality of *xuan* paper, traditionally favored by Chinese scribes and artists, Cherney created distorted, painterly images that produce a conspicuous visual noise; like layers of pollution, the graininess prevents a clear view of the landscape. In form and content, this piece speaks to the enduring influence of Chinese artistic and literary traditions on Cherney, who has scattered his ghostly cranes, symbols of longevity, in the twilight between ancient Chinese customs and the present. (LC)

SIMON CUTTS

(British, b. 1944)
Fo(u)ndlings, 1978
London: Coracle Press

A cardboard box of tags comprising the labels (also known in museum parlance as tombstones) for an "exhibition of found art," this modest catalogue, held in its plain brown stapled coffin, reveals the radical self-sufficiency of a small press like Coracle. Founded in 1975 by the poet Simon Cutts, and named after a compact boat for one person with no keel, mast, or rudder, the press was guided by the concept that a book could stand alone—staking out space both architecturally and virtually—and navigate out into the world. A book of poems might be conceived as an art object; gallery labels can become an exhibition space for words. *Fo(u)ndlings* features succinctly described familiar objects chosen by Cutts's colleagues. The items' status is notably enhanced by their selection for display. This copy made its way to collector Jean Brown's Shaker Seed House in Massachusetts (see Marcia Reed's essay in this volume) and is inscribed on the outer box: "R.I.P. Anonymous for Jean Brown [by the artist] Trevor Winkfield 8/9/79." (MR)

fo(u)ndlings
1978

fo(u)ndlings
1978

Patrick Hughes 1977

Andrew Holmes

Jonathan Gili

d'un Soupir.

brass

brass

are only after your money.

Your brain versus ours

A SPUR OF **THE**
ATLY LENGTHENED
MPTED RETRO
THE FORM OF **A**
DIARY, BY *Felipe Ehrenberg.*
ESPERANDO QUE SE ENTIENDA
en cualquier idioma. THIS
IS ALSO A wild **SHOT** in the
DARK. SALUD A MI AMIGO DE
HACE TANTO **TIEMPO**, SALUD~
TO STEPHAN LEVINE. 1973

LEFT LIFELESS ! RIGHT FIRST TIME!

FELIPE EHRENBERG
(Mexican, 1943–2017)
Pussywillow: A Journal of Conditions, 1973
Cullompton, UK: Beau Geste Press

Felipe Ehrenberg moved to Devon, England, in 1968 and founded Beau Geste Press in 1970 together with fellow Mexican artist Martha Hellion and the British artist and art historian David Mayor. The press published artists' books for an international community, using unconventional printing techniques and creating text-and-image pieces linked to the practices of Conceptual art.

It was in Devon that Ehrenberg first learned of pussy willows, a kind of tree that bears soft, fuzzy buds. He liked the musicality of the words and used them to title this work. *Pussywillow* examines Ehrenberg's collecting activities by presenting a compilation of odd materials drawn from his archive: photocopied and altered photographs, family pictures and erotic images, newspaper clips related to the US involvement in Chile's coup, collages, calendars, a poem, notes from the artist's diary, book chapters, and drawings. The book intends to demystify the figure of the artist by presenting what Ehrenberg accumulated rather than what he produced, thus playing with the notion of collecting as a tool to define the identity of an individual. Printed on brown wrapping paper, the book bears a stamp that reads, "This book is the color of our skin," thus addressing the artist's Mexican heritage. As he put it, *Pussywillow* was produced "from that nothingness in which imagination goes out to hunt." (IA)

OLAFUR ELIASSON

(Danish, b. 1967)
Your House, 2006
New York: Library Council of the Museum
of Modern Art

Weighty questions come to mind immediately upon
hoisting this unwieldy block of a book from its plain
cardboard box. Why is it titled *Your House,* when
its laser-cut interiors are based on Eliasson's house
in Copenhagen? Shouldn't it be called *My House*?
Are you supposed to be the artist's guest, and if so,
where is the host?

Though he is not present, Eliasson is letting
you in, welcoming you with this publication. And as
a suitably polite guest, you come in and admire the
incredible intricacies of how the openings in the text
block open up into interior spaces, both recto and
verso, as you page through the hefty tome.
This is no flip book. The experience demands time,
energy, and attention. Turning the oblong pages,
you learn a new way of reading or viewing, unlike
reading words on a page or looking at art illustrated
in a book or hung on a wall. Books are meant to
record, to illuminate, to entertain. At the end of this
volume, do you know more? Maybe not, but you're
very relaxed. *Your House* offers a meditative passage
through a major paper monument. Perhaps it might
be nice to live there in some alternative spatial
dimension. (MR)

TIMOTHY C. ELY

(American, b. 1949)
Hollow House, 2015

It is not surprising to learn that Ely's first interests included UFOs, science fiction, comics, and alchemy. His first book, created sixty years ago, was a cookbook that gathered recipes from his mother and her friends into a one-of-a-kind work that, like a book of alchemy, collected and shared secrets. *Hollow House* is an alchemical laboratory. Employing abstract symbols, inscrutable and illegible writings, numbers, formulas, and traces of tools, Ely depicts an overview of knowledge that is perceived and applied but never synthesized or complete. Taking the apparatus of learning and the constructs of science, his art is to present evidence and truth as beautiful details, fragments, ultimately mysteries.

Ely describes his art as "deep paper," a notion that underscores the importance of his materials: heavy Arches paper, pencil, ink, watercolors, occasionally ground stones, metals, botanicals, and dirt. While his books retain traditional shapes—a way for Ely to acknowledge the earlier history of the book—their conventionality ends there. There is a distinctive lack of one essential element: letterpress. For in the end these are works of art. Each two-page spread is a single work, part of a sequence. We proceed through the book as we would through a church, passing stained glass windows as we approach the altar. Within painted covers and specially designed bindings, the book is a structure made to house Ely's elegant and oblique shards of knowledge. Neither explicated nor parsed, they recall W. H. Auden's description of poetry as "the clear expression of mixed feelings." (MR)

BARBARA FAHRNER

(German, b. 1940)

The Philosopher's Stone, 1992

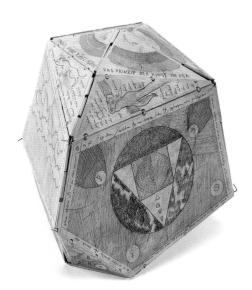

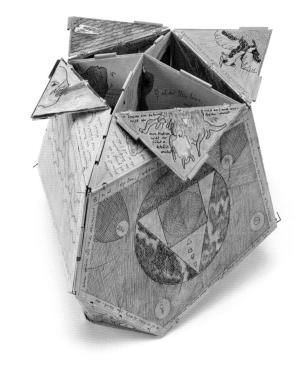

Not a book, but drawn from books, this angular paper egg holds nuggets of age-old wisdom, revealing them as it is deciphered, cracked open, and slowly unpeeled. Fahrner created her unique polygonal work in the context of a latter-day cabinet of curiosities—the Herzog August Bibliothek, a sixteenth-century ducal library in Wolfenbüttel, Germany. Instead of designing a divinely proportioned geometric figure, she composed an awkwardly shaped piece that tantalizes viewers who want to discover what's inside. Too late, they realize that taking apart is easy, putting back together is painstaking and will take hours, especially if they have failed to keep track of the specific locations of master binder Daniel Kelm's pins. This is really an object lesson that entices and entertains, then frustrates.

Fahrner appears to be thinking about reading and viewing—struggling for interpretations and easy answers, wishing for translations of the German and Latin texts. The truth is that wisdom is always difficult to obtain. This work riffs on sixteenth-century "books of secrets," which held recipes for medicines and paints, techniques that aided domestic routines of life and work, and alchemical formulas—to say nothing of the secret of the philosopher's stone itself, the decidedly unphilosophical but deeply cosmological method for turning lesser matter into gold. These unpretentious manuals—like this ungainly but unforgettable object—proffered their wisdom, moralities, and mysteries from the depths of a workman's pocket or apron. (MR)

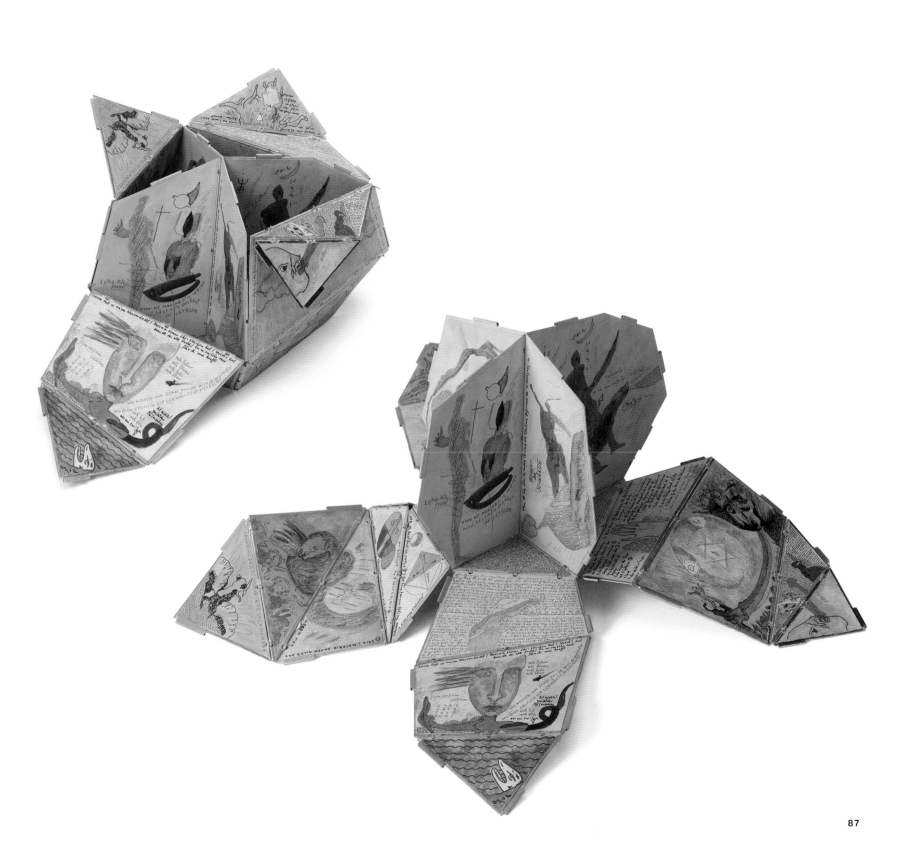

[1]

HANS-PETER FELDMANN

(German, b. 1941)
[1] *14 Bilder*, 1971
[2] *1 Bild*, 1970
[3] *45 Bilder*, 1971
[4] *11 Bilder*, 1969

Bound in plain greenish-gray cardstock, the books in Feldmann's *Bilder* (Pictures) series consist entirely of black-and-white photographs. The Conceptual artist produced some three dozen different booklets of varying sizes, each containing images of a particular subject. Like file folders or dossiers, the covers bear the word "BILDER" or "BILD" and the artist's last name in heavy block type along with a numeral indicating the number of pictures contained within—for example, seven family photos, fourteen mountains, six soccer players, one image of pyramids, forty-five pairs of shoes. About half of the pictures were taken by Feldmann, with the remainder collected from posters and postcards. The artist selected the pictures based on the ordinariness of both subject matter and printing technique. He resists being called a photographer, insisting that his works are not photographs but simply *pictures*.

Feldmann emphasized accessibility in producing these editions. Originally trained as a painter, he discovered that photographic reproductions could communicate his pictorial ideas in a much more practical and expedient way, and he began working with them in the late 1960s. He produced one thousand copies of each edition of *Bilder,* regarding them as simple and inexpensive consumer goods. They were not meant to be collected as works of art, and thus he deliberately chose not to sign them. The booklets were given as gifts and used as invitations to his exhibitions, and no single recipient was to obtain a complete set. (DC)

[2]

[3]

IAN HAMILTON FINLAY
(Scottish, 1925–2006)
Poem with 3 Stripes, ca. 1963
Dunsyre, UK: Wild Hawthorn Press

Concrete poet and artist Finlay intriguingly referred to this "booklet" as a "hand-knotted, I mean knitted poem" in a letter to the American poet Emmett Williams.[4] Finlay offered to make Williams his own copy, explaining that he had made only fifteen so far. The knowledge that he produced each example of this book himself greatly enhances our understanding of its construction and meaning, as he more typically collaborated with artists on publications, combining his poetry with commissioned designs. The presumably small number of copies may explain why *Poem with 3 Stripes* has gone unmentioned in bibliographies of works published by Finlay's celebrated Wild Hawthorn Press.

 Two bold stripes of red and blue add color to the white cover. The third stripe resides within, a thick green band applied to the right end sheet that remains visible throughout the act of reading. Each black page features a single monosyllabic word punctuated by a period and pasted on the recto in a different position. A reduction of language to its most essential, Finlay's poem masterfully engages our senses of sight, sound, taste, and touch. The Getty Research Institute's copy of this rare production, "knitted" together by the poet and initially a gift, bears a handwritten inscription from Finlay to a friend, the British author Lesley Lendrum: "*To Lesley with love from Ian, 7 August 63.*" (CA)

MAX GIMBLETT
(New Zealander, b. 1935)
The Gift, 1992

"Transformative" is a word often used to describe complex and demanding works requiring elaborate explanations. Yet it equally applies to this deceptively simple series of ink drawings on paper presented in a red linen box with pink and orange ribbon ties. Made while Gimblett was a Getty associate, *The Gift* was his donation to the Getty's Special Collections—hence the title. A beautiful box holding small, intensely colored paper sheets, it is a simple gift, like the Shaker song. For the Shakers, creativity came uncultivated, not as individual artistic genius, rather as a spiritual bestowal. According to Gimblett's good friend Lewis Hyde, creativity is "the gift we long for, that gift, that when it comes, speaks commandingly to the soul and irresistibly moves us."[5] We could add the conventional wisdom that good things often come in small packages. The first page of this work instructs us to "Go drink tea." Very good advice. Gimblett thought that was all you needed to know as you lifted each leaf meditatively and simply enjoyed its concentrated, restorative dose of color. (MR)

GUILLERMO GÓMEZ-PEÑA
(Mexican, b. 1955)
FELICIA RICE
(American, b. 1954)
DOC/UNDOC: Documentado/Undocumented:
Ars Shamánica Performática, 2014
Video by Gustavo Vazquez (Mexican, b. 1954)
Text by Jennifer A. González (American, b. 1965)
Sound by Zachary James Watkins (American, b. 1980)
Santa Cruz, CA: Moving Parts Press

Addressing what it means to be documented, this box was inspired by the earlier boxes of Marcel Duchamp but is far more complicated. It's not only an assembled collection made to travel and cross borders, but truly a vehicle of communication, with taped audio clips by its artists, sounds, and lights that encourage direct engagement with what's in the box: push the buttons to hear the sound clips, don the *lucha libre* (Mexican wrestling) mask.

The heavy decorated metal box is more like a truck toolbox than Duchamp's valise. Those earlier boxes were filled with works on paper or plastic, while this one is lined with fake leopard skin, fur, and deluxe fabrics. Open, it becomes an altar filled with objects: mirrors, cosmetics, money, and toys. The genius of the box is that it attracts with glitz, bright colors, texture, and trinkets. The case holds a book in a metallic red slipcase—a fancy-car color—with a fake leopard-skin cover. Within its pages, Gómez-Peña's texts on the immigrant experience are printed in hard-to-read, disorienting, irregular lines of text. While the boxes of Duchamp and George Maciunas's *Fluxkits* of the 1960s are collections objectified, Rice and Gómez-Peña have created a world in a box that hinges on what is known or accepted—that is, DOC(umentado); and the scary foreign territory of what we don't know and thus distrust—i.e., UNDOC(umented). "Just as I became an immigrant one day, you yourself might be one in the future." (IA & MR)

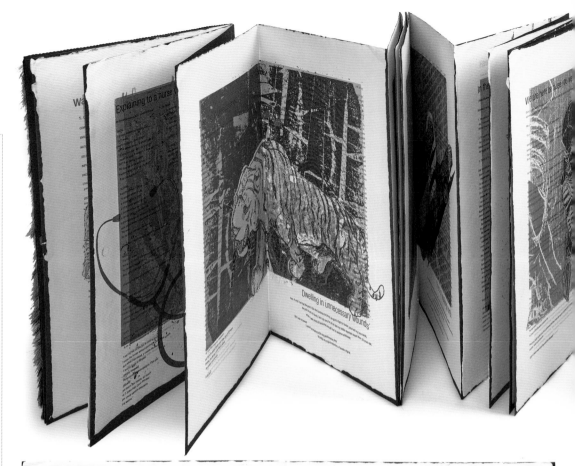

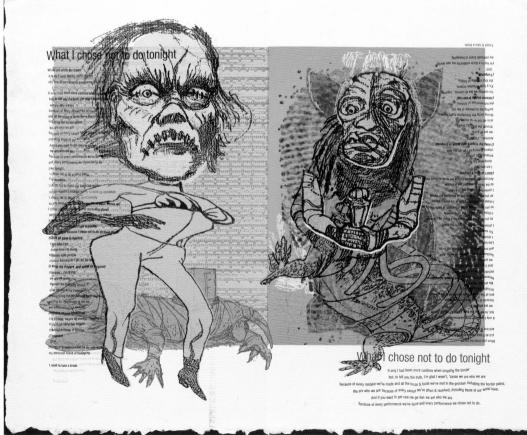

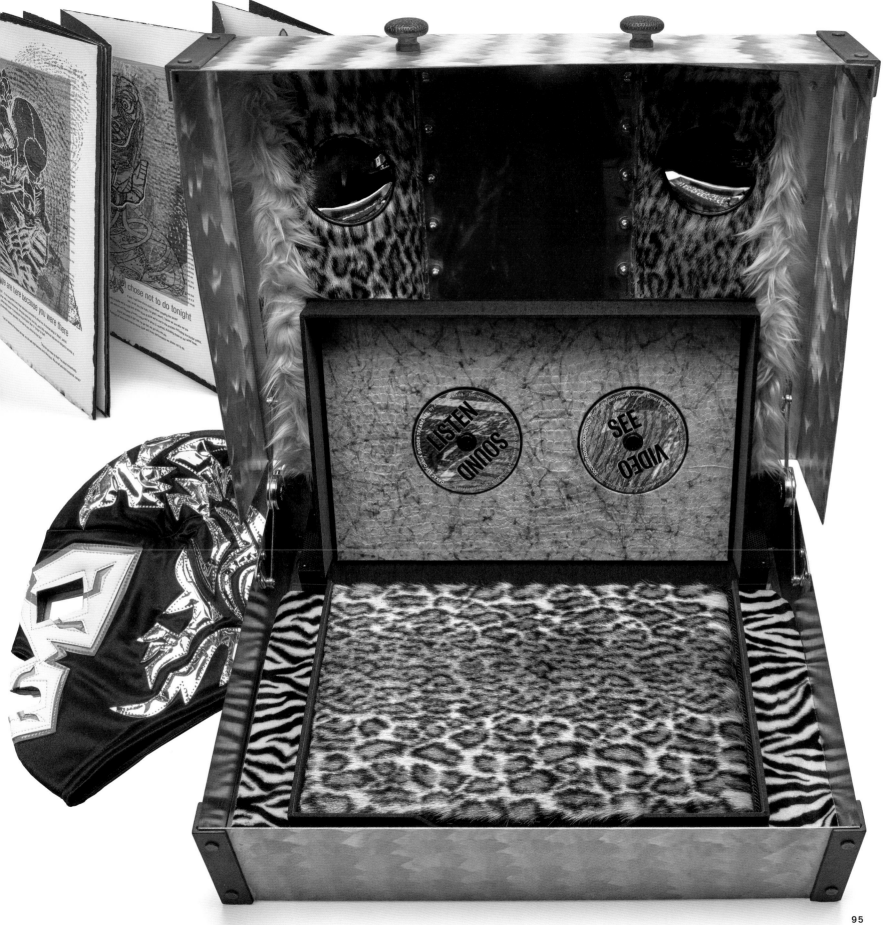

WALTER HAMADY

(American, b. 1940)

Hunkering: the last gæbberjabb[296] number eight and ix/xviths or aleatory annexations or odd bondings or fortuitous encounters with incompatible realities or love, anguish, wonder: an engagement or a partial timeline of sorts or bait and switch or finally, a pedagogical rememberance[27], 2005

Mount Horeb, WI: The Perishable Press

With their run-on titles, jumbled words, and seemingly random collections of content, Hamady's *Gabberjabs*—a series of eight books created from 1973 to 2005—anticipated the blabbering, chattering, and jabbering aesthetic of blogging and tweeting long before the Internet. The artist distills our popular culture into collages of images, words, and a considerable amount of what could be called clip art and dingbats. Like an embedded alien, Hamady seems to be able to read the signs of our world and hear the cackle of our communication.

These macaronic texts blend English; the Lebanese of Hamady's family; the languages of waves of European immigrants to the northern Midwest: German, Scandinavian, French (he is "Voltaire the Hamaedah"); and barely noticeable Arabic script. Hamady craftily includes all the special characters and diacritical marks of these various tongues, because for him, the strange and exotic are good things. In this stew of signs—or chowder of words— even the shapes of letters and punctuation marks are important, coming across like home-brewed vocalizations from mid-century America. Yet for all their visual variety, sound is key to these works, because Hamady's words—especially the hard-to-read ones—sound great when read aloud. (MR)

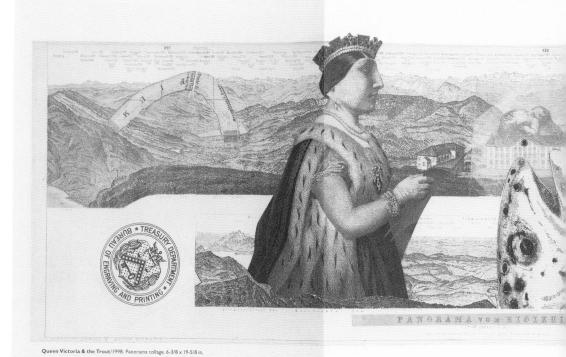

Queen Victoria & the Trout/1998. Panorama collage. 6-3/8 x 19-5/8 in.

ROBERT HEINECKEN

(American, 1931–2006)

Time: 150 Years of Photojournalism, 1990

Trained as a printmaker and graphic artist, Heinecken took the skills he mastered in these media and used them to challenge the definition and boundaries of photography. He called himself a "visual guerrilla" and a "paraphotographer" in acknowledgment of his unconventional methods and ever-evolving Conceptual outlook. Though he founded the photography program at the University of California, Los Angeles, in 1963 and was one of the most prominent instructors in the nation for the next three decades, Heinecken rarely used a camera to shoot a straight photograph. More often he repurposed commercial and pornographic images as his source material. His dedication to teaching and artistic expression is perhaps best reflected in the words of Marshall McLuhan, known to be a major influence on Heinecken: "Education is ideally civil defense against media fallout."[6]

 Time: 150 Years of Photojournalism is one of many altered magazines that Heinecken produced. His source here is a special issue of *Time* in which the editors attempted to represent the history of photojournalism with a few dozen supposedly iconic images. Heinecken cleverly commented on the absurd notion of compressing 150 years of history into a few pages of images by surgically removing pieces from each page. The formerly "iconic" photographs now have new stories to tell—ones that usually comment on how the media shapes popular beliefs or how corporate advertising (in this case Kodak) sways individual thinking. (FT)

Bringing a Personal Vision to The Hemisphere's Public Events

On the bright streets of Haiti's capital before darkness fell

ALEX WEBB, 1986

Webb has taken the Cartier-Bresson tradition of complex and enigmatic compositions and exploded it into color. This picture is from Port-au-Prince in the hopeful days after Baby Doc Du- *valier fled the island in 1986—and before hopes faded the following year. It describes a mood more than an event, what Webb has called an "epiphanic moment."*

Brazilian grubstakers sift mud for gold

SEBASTIÃO SALGADO, 1986

A former economist, Salgado has been traveling the world to photograph manual laborers. In Serra Pelada, in his native Brazil, he found as many as 50,000 hopeful miners digging for gold along the muddy surface of a man-made hole the size of a football field.

Salvadoran children shield their eyes from the machinery

JAMES NACHTWEY, 1984

Central America became a magnet for photojournalists in the 1980s. While traveling with government troops at the height of the civil war in El Salvador, Nachtwey passed through the town of San *Luis de la Reina. That was he came upon this parado scene, which might stand a allegory for the plight of al caught up in a maelstrom lent events. As a military h*

68

Viet Nam: A War No One Wanted In the Land Nobody Knew

Reaching Out (after taking Hill 484, South Viet Nam)

LARRY BURROWS, 1966

This picture, right, was taken when many Americans still thought the war was winnable. Burrows first learned about color photography as a

16-year-old darkroom assis[tant] in LIFE's photo labs in London. He was k[illed in] a helicopter cra[sh in] Laos in 1971.

And all are backe[d . . .]est support and service in the [. . .]. We are m[. . .]. We are [. . .]aging. For m[. . .]ges that mean [b]usiness, call 1 80[. . .], Ext. 960D.

SHARE

Terror of War: children on [Highway 1 near Trang] Bang

[NICK ("DINH CONG NICK")] UT, 1972

[. . .] inner was [. . .]eral William [. . .] suggested [. . .] was burned [. . .]t."

[. . .]ors and [. . .]on

[. . .]7

[. . .]tation oc- [. . .] from the [. . .] 35,000 [. . .]even hun- [. . .]ested.

Lieut. Colonel Robert Stirm returns home, Travis A.F.B.

SAL VEDER, 1973

An Air Force officer, Stirm had been shot down over North Viet Nam in 1967. Like many of the most striking photos of the Viet Nam War—Burst of Joy won the Pulitzer Prize—the image was not the result of a lengthy essay assignment but a quick "grab" shot by an A.P. photographer

KODAK

The new vision

[. . .] wounded soldiers [. . .] furious cloud, three [. . . ht] dresses shield their [. . .] the dust. "A lyrical mo- [. . .]rutal situation," [. . .]as called it.

New Challenges 1950-1980

63

Today and Tomorrow 1980-

69

TIME/FALL 1989

GEORGE HERMS

(American, b. 1935)

32 Palm Songs, 1967–71

Best known for his distinctive assemblages of materials marked by the processes of time, Southern California artist George Herms has also produced important printed work using a small handpress that he salvaged in Topanga Canyon in the mid-1960s. Dubbing his publishing endeavor "the LOVE Press," Herms devotes it principally to the work of his poet friends, often employing unconventional bindings and keeping the pages loose. *32 Palm Songs* is a rare instance in which Herms created both poetry and imagery for one of his books. It features a round plastic box containing thirty-two circular pages seven inches in diameter, each bearing a poem intended to be sung while held in the palm of the hand. For an exhibition of his work at the Newport Harbor Art Museum in 1979, Herms mounted the pages on three black cardboard sheets, two of which are now held at the Getty Research Institute.

The title of the work celebrates Herms's thirty-second birthday and refers to his family address in Woodland, California, where he was born. His imaginative treatment of the letterpress and woodblock "pages" often requires circular readings, as in the colorful "Solstice 69" and the brown letterpress "It just dawned on me," printed from three different viewpoints. Herms's poems play with puns ("HAVE MERCI"), nonsensical rhymes ("aloof on the roof of your alphabet mouth"), phonic sequences ("swung by sturdy sunbeam"), clichés ("You were made for Love"), and word inversions ("AikavolsohcezC"). The imagery extends beyond words to include the handprint of one of Herms's children, a heat-seared gold plastic page he produced with a waffle iron, and a seven-inch Mylar disc that resembles a 45 RPM record. (NP)

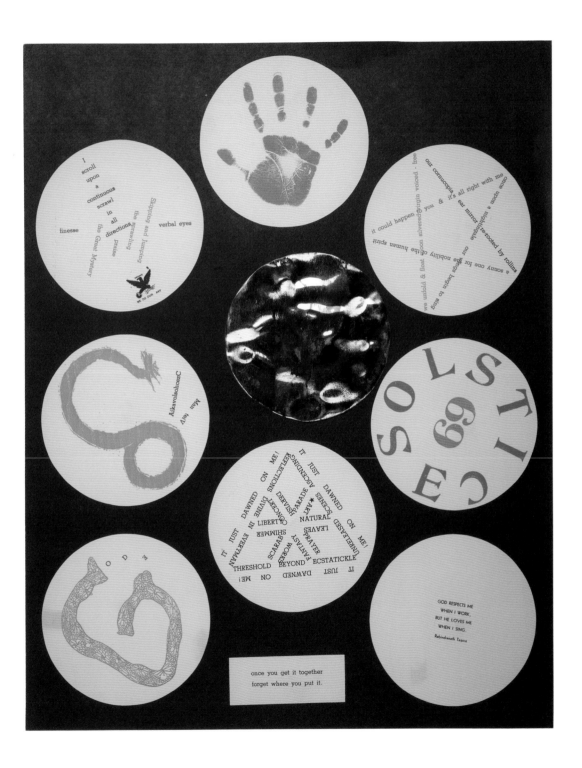

I
scroll
upon
a
continuous
scrawl
in
all
directions
finesse

Skipping and jumping
the sprawling
praise
the Great Mystery

verbal eyes

our cornucopia : free
it's all right with me
echo upon echo
re-rooted by rolling

it could happen to you & silvered virgin voiced
a sunny one for the nobility of the human spirit
we unfold & float upon
drops begin to sing

SOLSTICE
69

GOD RESPECTS ME
WHEN I WORK,
BUT HE LOVES ME
WHEN I SING.
Rabindranath Tagore

once you get it together
forget where you put it.

ANDREW HOYEM

(American, b. 1935)

Flatland: A Romance of Many Dimensions, 1980
Text by Edwin Abbott Abbott (British, 1838–1926)
San Francisco: Arion Press

In *Flatland,* a gentleman named A. Square guides us through his two-dimensional world comprised of geometric figures bound to an elaborate caste system. Lauded as a precursor to science fiction, Abbott's fantastical satire of Victorian life has been in print continuously since its first publication in 1884.

The story is both guidebook and memoir, as Square explains his society and his experiences of other dimensions. Life in two dimensions requires Flatlanders to determine social status through a strange system of seeing and feeling each other's shapes. Adorning one's self with color has been outlawed after lower-class triangles deceptively painted their sides to impersonate well-to-do polygons and circles. In the second half of the novella, Square meets a Sphere from the Land of Three Dimensions who shows him the First Dimension. Throughout these passages, the narrator juggles the difficulties of articulating concepts that are awkwardly physical and experiential, and in the end, the peculiar world of Flatland is alien despite being composed entirely of familiar shapes.

The Arion Press's special accordion-fold edition of the novella leads us through Flatland plane by plane. Printer Andrew Hoyem's die-cut and watercolor illustrations supplement Abbott's original quirky diagrams to help us visualize an existence as flat as the page of a book. Hexagons, triangles, and slits cut into pages show us how a Flatlander with a body as thin as paper casts the slightest of shadows.

In his introduction to this edition, Ray Bradbury claimed *Flatland* as a book for boys—mathematical fun for the understanding and enjoyment of males only. He seems to have missed the point of Abbott's caricature of the Victorian reluctance to educate women. In fact, Abbott was a staunch advocate for women's education and a religious reformer who believed that we are resigned to ignorance when we are limited by a narrowness of vision. Lampooning his society with a tale of unfathomable dimensions was his way of reminding readers of the importance of imagining an existence more evolved than our own. (RL)

of Sight Recognition——" "Oh, I have no patience with
your Sight Recognition," replied she, " 'Feeling
is believing' and 'A Straight Line to
the touch is worth a Circle to the
sight' " — two Proverbs,
very common with
the Frailer

Sex in Flatland.

□ "Well," said I,
for I was afraid of irritating her, "if it must be so,
demand an introduction." Assuming her most gracious
manner, my Wife advanced towards the Stranger, "Permit me,
Madam, to feel and be felt by——" then, suddenly recoiling, "Oh! it is
not a Woman, and there are no angles either, not a trace of one. Can it be that I
have so misbehaved to a perfect Circle?" □ "I am indeed, in a certain sense a Circle,"
replied the Voice, "and a more perfect Circle than any in Flatland; but to speak more accurately,
I am many Circles in one." Then he added more mildly, "I have a message, dear Madam, to your
husband, which I must not deliver in your presence; and, if you would suffer us to retire for a few minutes——"
But my Wife would not listen to the proposal that our august Visitor should so incommode himself, and assuring
the Circle that the hour of her own retirement had long passed, with many reiterated apologies for her recent indiscretion,
she at last retreated to her apartment. □ I glanced at the half-hour glass. The last sands had fallen. The third Millennium had begun.

ALLAN KAPROW

(American, 1927–2006)
Echo-logy, 1975
New York: D'Arc Press

Kaprow's "activity booklets" present performance instructions that can be carried out by small groups of people. Though they can be read, and their photographs document past enactments of the activities, the books are in fact meant to be used as scores, allowing performers to organize their own enactments of the piece.

 Echo-logy—a play on *ecology*—asks participants to visit a stream and carry out a set of activities that alternately follow and defy the natural flow of water. Participants are instructed to use buckets to carry water upstream and to spit water back into the stream to observe it carried back downstream. They are asked to try to silently pass words to one another upstream, like a game of telephone, and to shout words back down. The fumes of a gas-soaked rag slowly evaporate as it is passed upstream; a plastic bag is slowly inflated by participants' breath as it is handed down.

 Though the activities may seem awkward and contrived, when performed in situ they create an experience in which participants cannot help but contemplate the natural world and their place within it: the power of the stream and the traces (saliva, breath, gas fumes) even simple activities leave behind. *Echo-logy* creates a sense of intimacy among participants, with people coming close and mouthing silent words to one other and accumulating their collected breaths in a bag. It also allows for exuberance and assertion, as performers shout their words to one another and into the sky. (GP)

2 sending a mouthed silent word
a distance upstream

person-by-person

saying it aloud to the trees

propelling a shouted word
a distance downstream

person-by-person

mouthing it to the sky

ECHO-LOGY is concerned with natural processes. Water flowing downstream is carried mechanically upstream, is dumped and flows back. Some is lost along the way. More water is transferred downstream mouth-by-mouth, loses oxygen, is mixed with saliva and is given back to the stream to be altered again. A word is silently formed, is recognized from a distance and is passed in that manner upstream, changing its identity, and is spoken to the trees. A word shouted from person to person, so loudly as to be misunderstood, rushes downstream similarly and is silently conveyed to the air. A gas-soaked rag is evaporated in stages on its trip upstream, becoming relatively clean as it gives its fumes to the atmosphere and further chemical change. Human breaths are collected and conducted downstream by hand. Small bits escape. The growing bagful becomes stale and the container is then released to the winds. The movement is simply back and forth.

ECHO-LOGY was carried out by a small group of persons moving in the water of a stream in Far Hills, N.J. on the weekend of May 3rd and 4th, 1975. It was commissioned by the Merriewold West Gallery.

9/74-4/75

ALLAN KAPROW

3 transporting a gas-soaked cloth
a distance upstream
(waving it gently in the air)

person-to-person

waving it gently until dry

carrying a bagged breath
a distance downstream

each adding a breath

opening the bag to the wind

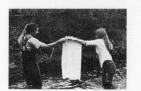

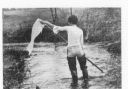

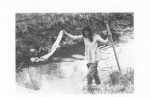

LEANDRO KATZ

(Argentine, b. 1938)

Ñ, 1971

New York: Vanishing Rotating Triangle

The letter Ñ is unique to the Spanish alphabet. Moreover, as Katz points out in this book, most of the words whose initial letter is Ñ are adapted from indigenous languages such as Quechua, Aymara, Mapuche, Toba, and Tehuelche, among others. In this way, Ñ embodies the unique identity of the Ibero-American culture and highlights the influence of pre-Hispanic America on the Spanish language, reversing the common colonizer-colonized relationship.

 With this publication, Katz wanted to pay tribute to the letter and experimented with an offset press purchased by the independent group Vanishing Rotating Triangle, of which he was a member. Katz has long been interested in the nature of language and produced several works related to different alphabets and combining letters and images, such as photographs of phases of the moon, windmills, and tropical snails. For this book, Katz struck an Ñ on a typewriter, photographed it, and enlarged it, a process that distorted the letterform. Then, during the printing process, he layered different colors over his source image. The result is a series of Ñs that seem handmade at the start and end up conveying a vibrating, kinetic Pop quality. In order to emphasize the particularities and history of the Ñ, the artist incorporated into the work information from the *Diccionario de la lengua española de la Real Academia Española* (Dictionary of Spanish language of the Royal Spanish Academy) and *Appleton's New Cuyás English-Spanish and Spanish-English Dictionary.* (IA)

INES VON KETELHODT
(German, b. 1961)
farbwechsel, 2011–13

Can we think of color abstractly, without associating
certain shades with particular objects? Or rather, do
we remember the colors of things in terms of expe-
rience and how we use them? In the six volumes of
farbwechsel (color change)—dense paper chunks of
color—carefully chosen subjects are correlated with
primary hues. Pure color is prioritized over content
that's presented in a supporting role. Green relates
to Virginia Woolf's *To the Lighthouse*. Lipstick red
shows movie-star smooches. White starkly alludes
to recent Japanese fatalities: the Tōhoku earthquake
and tsunami, and the Fukushima nuclear disaster
in 2011. Most of the specific references are spot-on
and thoughtful but also occasionally strange. They
actually work to create new color associations and
to demonstrate how color makes our world. (MR)

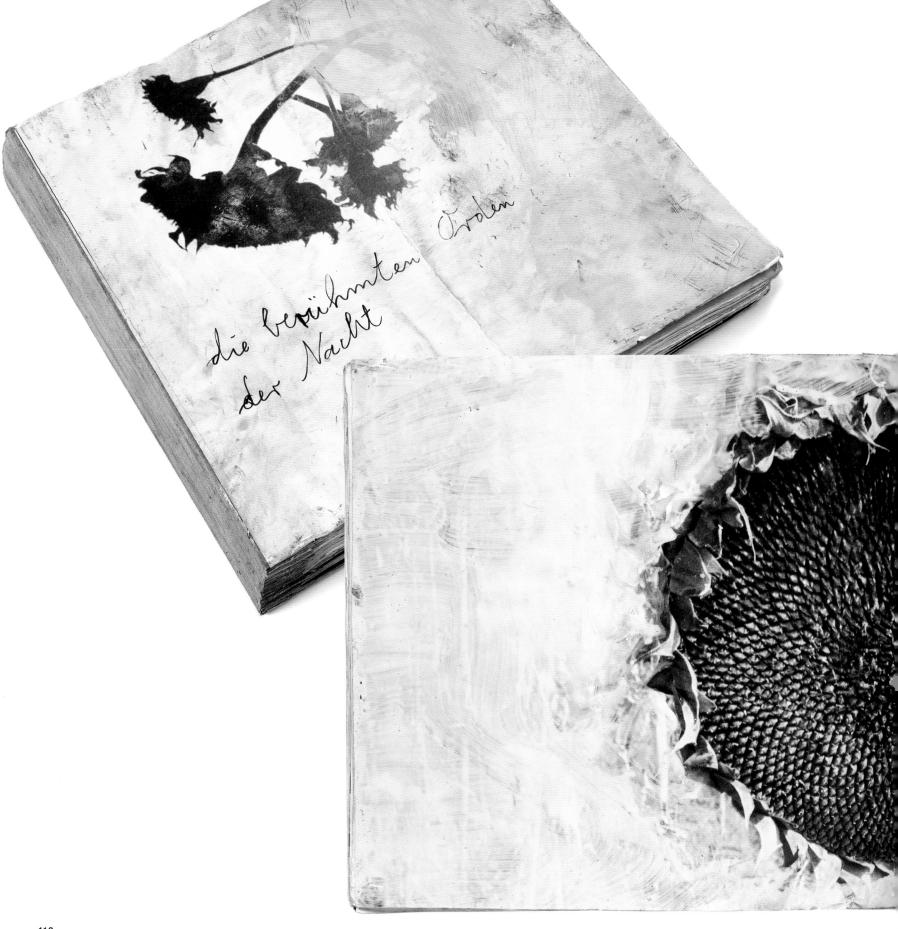

die berühmten Iroten
der Nacht

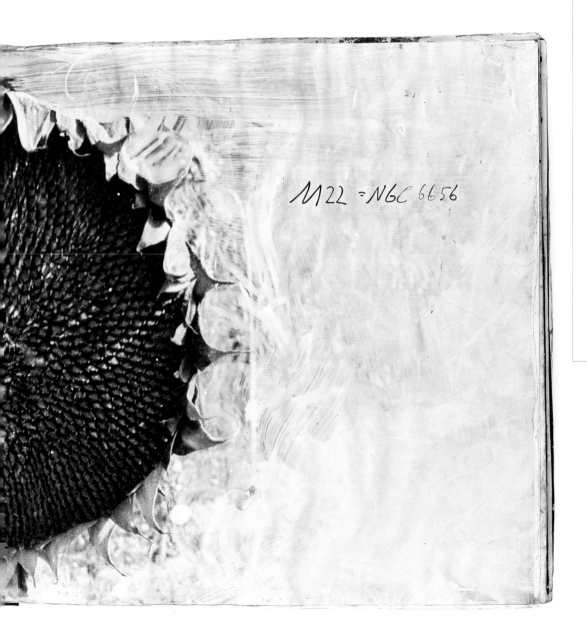

Within the image: M22 = NGC 6656

ANSELM KIEFER
(German, b. 1945)
Die berühmten Orden der Nacht, 1996

Inspired by Ingeborg Bachmann's poem "An die Sonne" (To the sun), Kiefer's *Die berühmten Orden der Nacht* (The celebrated orders of night) is simultaneously microscopic and cosmic. The book begins at ground level, with worm's-eye-view photographs of sunflowers well past their prime. These Kiefer has overpainted and lightly annotated with star names and astronomical coordinates. The focus is on the flowers, with the photos zooming in slowly and enlarging until the final view is a double-page spread of the sunflower's center holding its drying seeds. More than halfway through, the book abruptly shifts focus, from day to night, to heavily encrusted, painted black pages full of stars (p. 22).

When viewing Kiefer's book, it helps to know Bachmann's poem, which recounts the beauty of life under the sun—"much more beautiful than the celebrated orders of night, the moon and the stars"—and notes that "without the sun, even art puts on a veil." For an artist who is known for his monumental works, this book is relatively modest. (There is a larger painting by the same name in the Guggenheim Bilbao.) The austere intensity of the images, sequenced to be read serially, make this unique work disarmingly intimate and forceful. (JT & MR)

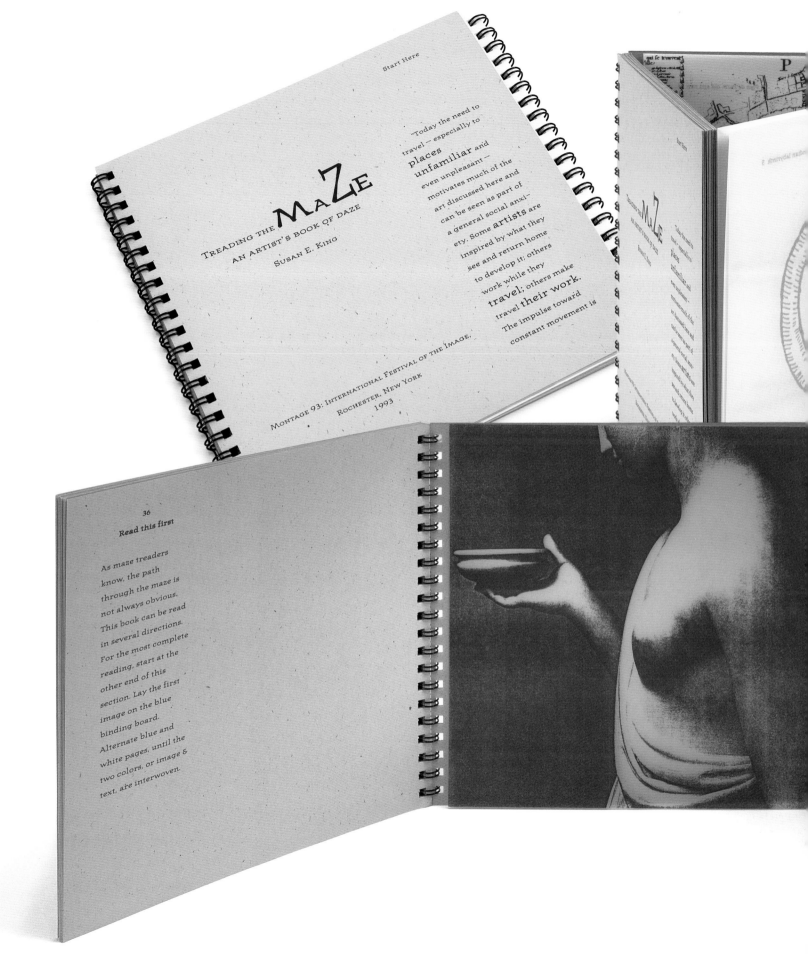

MaZe

TREADING THE

AN ARTIST'S BOOK OF DAZE

SUSAN E. KING

"Today the need to travel — especially to places unfamiliar and even unpleasant — motivates much of the art discussed here and can be seen as part of a general social anxiety. Some artists are inspired by what they see and return home to develop it; others work while they travel; others make travel their work. The impulse toward constant movement is

MONTAGE 93: INTERNATIONAL FESTIVAL OF THE IMAGE, ROCHESTER, NEW YORK
1993

36

Read this first

As maze treaders know, the path through the maze is not always obvious. This book can be read in several directions. For the most complete reading, start at the other end of this section. Lay the first image on the blue binding board. Alternate blue and white pages, until the two colors, or image & text, are interwoven.

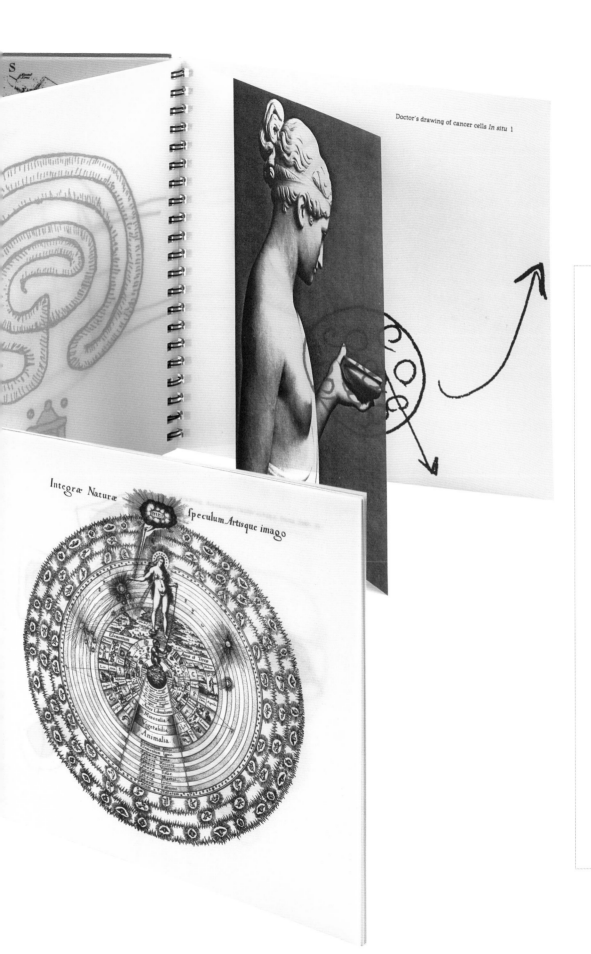

Doctor's drawing of cancer cells *In situ* 1

Integra Naturæ
Speculum Artisque imago

SUSAN E. KING

(American, b. 1947)
Treading the Maze: An Artist's Book of Daze, 1993
Rochester, NY: Visual Studies Workshop Press

Artists' books often encourage readers to take divergent paths through their pages. The title of this work supplies the clue to the purposely uncharted path we find ourselves taking through this book. It combines reproduced and altered photographs with a memoir about the artist's experience of breast cancer. The book is intended to be read from side to side across triple-panel spreads with double spiral bindings, allowing us to meander through unfamiliar spaces. King's journey as a cancer patient is full of such places, and her narrative embraces the metaphor of travel, becoming a kind of postmodern guidebook or surreal travelogue. Her story becomes a quest, a journey to the hospital, a trip to the doctor. We are forced to take different paths and stop to reflect—a Grand Tour through parts of the body and the course of an illness.

The book's cover introduces recurring depictions of the breast with a photograph of an antique sculpture of Hebe, the Greek goddess of youth. Subsequent images echo and rhyme with this one: doctors' sketches of King's breast and their treatment plans, rose windows from Notre-Dame Cathedral, a circular medieval maze, scientific diagrams of the atom used for jewelry, and alchemical images of the universe—all underscoring ideas about corporeal space. Indeed, for King, the conceit is that "the inside story" can be found within the body. *Treading the Maze* is a deep and intimate work that effectively transcends the personal. (MR)

PETER RUTLEDGE KOCH
(American, b. 1943)
ADAM CORNFORD
(British, b. 1950)
JONATHAN GERKEN
(American, b. 1980)
Liber Ignis, 2015
Berkeley, CA: Editions Koch

According to its title, this is a book of fire, but it is actually made of lead, looking charred and irredeemably black. It charts a gloomy history of copper mining in the American West, detailing miners' hellish lives and lethal daily work. Yet the historical documentary photos here are magnetic. They convey a strange beauty, like photographs of war or natural disasters, that you do not forget. You peer into the pages searching for more detail, as if exploring a ruin or an abandoned house. Thus does Koch lure us into a deeper understanding of this dark and wrinkled fold in American history.

Because material makes meaning, the colophon of this work describes every detail of its conception and construction: lead and black-dyed microfiber pages; a binding of soldered copper tubing and linen thread; a cover of copper; photo interventions. Making this book required intense labor, and reading it is work as well—hefting the dark block from its shelf, lifting it from its box, supporting it is an effort. Heavy lead pages sag and bend as they are turned; implicitly they reference the depressing processes and toxic substances of mining. (MR)

RAILROADS, 2

Shadows of the hand's fingers
rail spurs and branch lines
lumber cars from the northern hills
stacked and tied
with amputated forests
ore cars from the pit heads
piled with metal shatter
ready for combustion

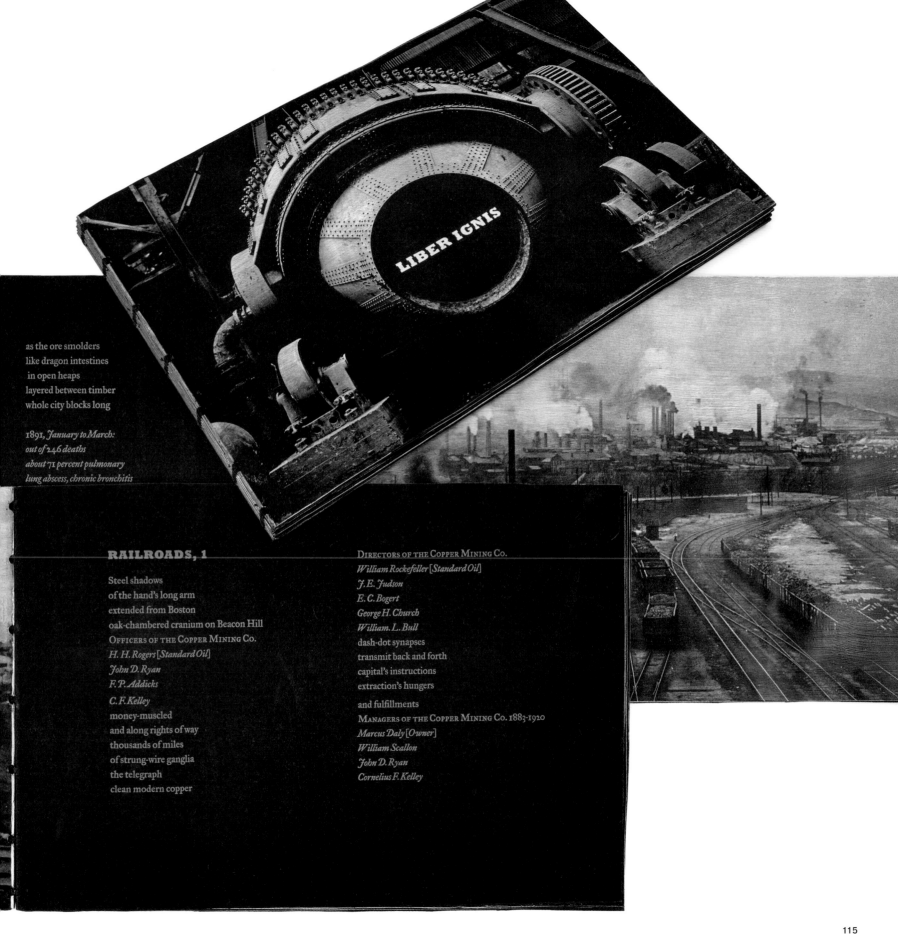

as the ore smolders
like dragon intestines
in open heaps
layered between timber
whole city blocks long

1891, January to March:
out of 246 deaths
about 71 percent pulmonary
lung abscess, chronic bronchitis

LIBER IGNIS

RAILROADS, 1

Steel shadows
of the hand's long arm
extended from Boston
oak-chambered cranium on Beacon Hill
Officers of the Copper Mining Co.
H. H. Rogers [Standard Oil]
John D. Ryan
F. P. Addicks
C. F. Kelley
money-muscled
and along rights of way
thousands of miles
of strung-wire ganglia
the telegraph
clean modern copper

Directors of the Copper Mining Co.
William Rockefeller [Standard Oil]
J. E. Judson
E. C. Bogert
George H. Church
William. L. Bull
dash-dot synapses
transmit back and forth
capital's instructions
extraction's hungers

and fulfillments
Managers of the Copper Mining Co. 1883-1920
Marcus Daly [Owner]
William Scallon
John D. Ryan
Cornelius F. Kelley

MICHAEL KUCH

(American, b. 1965)
*Illuminations: **An Acrostic Martyrology***, 2014
Northampton, MA: Double Elephant Press

Equal parts Blake and Bosch, Michael Kuch updates medieval book arts for a modern sensibility—or perhaps he simply points out that the modern sensibility has been medieval all along. His striking and whimsical figures evoke both the surreal world of *Alice in Wonderland* and the menageries inhabiting the margins of thirteenth-century manuscripts. Here, the artist renders in mezzotint thirteen imaginary martyrs. He brings the art of illumination beyond the Enlightenment with figures that are not being tortured in the arena or burned at the stake but rather "impaled by shafts of ineluctable light" and "tempted by personal demons." Marginalia with roots in the Middle Ages extend their branches into the scientific era, with anatomically correct organs mingling with precisely rendered insect and botanical life—always accompanied, however, by a panoply of more monstrous forms.

Each martyr is viewed through a window in the preceding page, allowing the reader to alternate between the stark black-and-white mezzotints of martyrs and their hand-colored borders—between the lit room and the darkened chamber. Stripped of their decorations, the martyrs are transported out of their neo-Gothic context and take on aspects of Gustave Doré's or Francisco de Goya's tormented figures. Kuch, who generally eschews artistic verisimilitude, offers a twenty-first-century vision of the medieval martyrology, merging the richness of the illuminated codex with allegory and symbolism from a different world. (RK)

Undressing the soul
before one's rest

Some fellow tempted
by personal demons

117

MONIKA KULICKA

(Polish, b. 1963)
Drips Runs and Bleeds, 1999
New York: John Gibson Gallery

Chlorophyll is a favored medium of Monika Kulicka in projects ranging from works on paper to large-scale installations and video. The *New York Times* has described her work as "abandoned science experiments," but rather than suggesting a case of a mad scientist run amok or preaching against the dangers of technology, *Drips Runs and Bleeds* imitates (or mocks?) the technologies so integral to our lives that they are often invisible to us as such: inks, writing, and bookmaking.

While this book has an obvious antecedent in the eighteenth-century technique of nature printing (using natural objects—plants, animals, rocks—to produce an image), a truer comparison might be found in the work of the German chemist F. F. Runge. His 1855 book *Der Bildungstrieb der Stoffe* (The formation of substances; p. 5) consists of a series of chemical "artworks" created by dropping different solutions on blotter paper. To his German Romantic sensibilities, this proved that art was not a human invention but something inherent in the larger chemical universe. In Kulicka's book, chlorophyll—both an ink that stains the page and a stand-in for blood, the life force of our ecosystem—follows its own paths across the page. Like Runge's chromatograms with an irrational twist, this work presents nature as an author/artist and knocks ideas of human technocracy out of kilter. (RK)

LA LIBER AMICORUM, 2012

Graffito is old Italian slang for "little mark," and in ancient Greek the verb *graphein* likely meant "scratch, draw, paint" long before it came to mean "to write." Any daydreaming doodler has experienced the innate human urge to make a mark, to "graph." Graffiti as an artistic expression is rooted in this desire—whether others like it or not.

Conceived and donated by local collectors Ed and Brandy Sweeney, *LA Liber Amicorum* binds together 143 works on paper contributed by more than 150 of Los Angeles's leading graffiti and tattoo artists. The cover [1] was designed by Prime; the works shown at right were created by [2] Blosm and Petal, [3] Elika, and [4] Axis. Many of the works were executed in response to holdings in the Getty Research Institute's collection of early modern books and manuscripts: calligraphy and writing manuals, emblem books, sketchbooks, and virtuoso examples of engraving and pen work applied to ornamental and calligraphic prints and drawings. Indeed, the title of the work, as well as its spirit, was inspired by a genre of manuscript popular in the sixteenth and seventeenth centuries found in the Getty's Special Collections: a *liber amicorum* ("book of friends") was bound with blank leaves that multiple contributors then filled with illuminated coats of arms, watercolors, poetry, and calligraphy as mementos for the owner.

This collection likewise emulates the sketchbooks, or piece books, that street artists often carry with them and inscribe for each other. By gathering diverse approaches to letterforms, handstyles, symbols, and themes into a single book, *LA Liber Amicorum* symbolizes the transformation of the creative output by rival crews of street artists into an LA "book of friends." (DB)

[1]

[2]

[3]

ALL OF MY HEROES HAVE BROKEN THE LAW.

[4]

PATRICIA LAGARDE

(Mexican, b. 1961)
Fantastic Island, 2011
Mexico City: Escabarajo Gris Press

Within a brown box, like nineteenth-century photos found in an attic, this panorama of eight photogravures unfolds to show a shipwreck in the northern latitudes of the Arctic Ocean—86° 13', to be exact, as one of its pages makes clear. This work is inspired by both a sepia-tone image of a ship Lagarde discovered in her grandfather's collection and the story of the Norwegian explorer Fridtjof Nansen, who led a record-breaking expedition to the North Pole during 1893–96—yet it is not a history. With almost no words, it is a vision of the voyage of an improbably small ship with a slightly silly name (*Handkerchief*) as it sets out optimistically for smooth sailing, no clouds in the sky. Subsequent images, based on dioramas that Lagarde constructed and then photographed with an analog camera, seem dreamlike and inexplicable. There are terrifying threats and strange apparitions: gigantic stormy waves, an arcing whale rising out of the water, a blimp in the sky above, and a sea monster. (MR)

by air mail

MIT LUFTPOST
PAR AVION
BY AIR MAIL

hannedarborn
21 hamburg 90
am burgleg 26
yrumelby

to:
David Lamelas
42 Russell Road
London W 14.
ENGLAND

23/8/70
21 hamburg 90
am burgleg 26

dear david lamelas

i got your letter
thank you for the first—
for the second:
i shall not make any
commentary or/
 contribution
to the statements:

1.
2.
3.

you sent me

i am very busy doing
my own work and hope
you will understand

so far today so far
 and so less
 today
best for you / your work
 let me know again
hanne darboven

MUSEE D'ART MODERNE
SECTION LITTERAIRE
DEPARTEMENT DES AIGLES BRUXELLES, LE 31 octobre 1969.

Mon Cher Lamelas,

1. Conceptual artists are more rationalists rather than mystics... etc.............

2. Comme je tiens à défendre un sens de la réalité plutôt que la théorie et
 le rêve...

3. Musée d'Art Moderne. Section Littéraire. Département des Aigles.

4. Dans l'une de mes dernières lettres datée du 25 août 69, placée encore sous
 le signe du XIXème siècle et adressée aux organisateurs d'une exposition
 en cours à Leverkusen, au lieu de... ces chemins, ces mers, ces nuages
 comme ceux d'une liberté et d'une justice. Il faut lire ceci: ... ces chemins,
 ces mers, ces nuages comme ceux d'une répression et d'une absence.

 Parce que la réalité du texte et le texte réel sont bien loin de former un
 seul monde.

5. Qu'est-ce qu'un artiste étranger ?

 Marcel Broodthaers.

ANCIENNE ET NOUVELLE ADRESSE :
30, RUE DE LA PEPINIERE, BRUXELLES 1 (BELGIUM) TELEPHONE (02) 12 09 54

PUBLICATION

David Lamelas

[2]

1. Use of oral and written language as an Art Form.

2. Language can be considered as an Art Form.

3. Language cannot be considered as an Art Form.

These statements were given to the previous list of artists and critics for consideration.
Their responses are published in this book, which constitutes the form of the work, presented first in Nigel Greenwood Inc Ltd London, between the 23rd of November and the 6th of December 1970.
I do not take part in the responses to the statements since, as a receiver of all the contributions, my reference is prejudiced.
My choice of the three statements does not imply agreement or disagreement with any of the three statements.

David Lamelas
September 1970, London

DAVID LAMELAS
(Argentine, b. 1946)
[1] **Letters related to *Publication*,** 1970
[2] ***Publication*,** 1970
London: Nigel Greenwood

A slim booklet with a minimalist cover and interior design features the responses of thirteen artists and critics to statements posed by Lamelas on the use of language in art, a topic that had come to dominate debates about the visual arts in the late 1960s.

Respondents included Robert Barry, Daniel Buren, Victor Burgin, Gilbert & George, Lucy R. Lippard, and Lawrence Weiner, among others. Their contributions range from comical to dryly intellectual. Gilbert & George proclaimed, "Oh art, what are you? You are so strong and powerful, so beautiful and moving," while Barry deadpanned, "I think that artists will be using language to make their art for a long time." Lamelas himself did not take part in the discussion, since, he argued, "as a receiver of all the contributions, my reference is prejudiced."

The GRI holds the archive for *Publication*, including the booklet of thirty-eight unillustrated pages and the original responses from the artists. Despite its visual austerity, Lamelas exhibited *Publication* as an artwork at Nigel Greenwood Inc Ltd in London in late 1970. The notion of a publication as an exhibition had been proposed by the American art dealer Seth Siegelaub the previous year, but Lamelas's project also responds to—and perhaps satirizes—the British Conceptual art group Art & Language, which sought to advance art theory itself as artistic production. The art historian Daniel R. Quiles posited that *Publication* was Lamelas's oblique critique of Conceptual art.[7] (ZG)

SOL LEWITT

(American, 1928–2007)
A Book of Folds, ca. 1978

Sometimes an artist's book requires no type, no binding, no printing, and no photography. LeWitt's *Book of Folds* simply presents a series of pages, each of which has been folded and unfolded to create a creased pattern, that are held together by a piece of knotted twine. This is one of six unique books LeWitt produced for a fund-raiser for the New York nonprofit space Franklin Furnace, one of the foremost organizations to archive and advocate for the importance of artists' books. Other works in the group included *A Book without Six Geometric Figures* (also held by the Getty Research Institute), whose overlapping geometric cutouts become an indistinct shape when viewed together, and *A Book of Tears*, in which each page is torn in a slightly different manner. A pioneer of Conceptual art, LeWitt was known for his wall drawings, which explored complex permutations of simple lines. *A Book of Folds* speaks to a similar process, creating a surprising degree of variety—and perhaps even a narrative—from the basic act of folding and unfolding a page. (GP)

RICHARD LONG

(British, b. 1945)
Papers of River Muds, 1990
Los Angeles: Lapis Press

One of the best-known proponents of Land Art, Richard Long has made projects since the late 1960s that derive from his deep interactions with the natural landscape and often bring natural materials into the gallery. In *Papers of River Muds*, Long incorporated landscape directly into the pages of the book; he mixed mud gathered from fourteen rivers around the world with wood pulp to produce thick handmade paper. The many colors and consistencies of mud produced paper that varies in texture and shade. The book presents no text other than the names of the rivers (some oddly spelled; one unknown): Amazon, Avon, Chitravathri (*sic*), Condamine, Guatiquia, Huang He, Hudson, Indragoodby, Jordan, Murrumbidgee, Mississippi, Nairobi, Nile, Rhine, and Umpqua. Despite this spare format, the book is sensual and surprisingly visual— not only through nuanced differences between the papers but also through the mental journey that we take as we imagine the faraway locales from which these river muds were gathered. (GP)

PAPERS OF RIVER MUDS

THE LAPIS PRESS
LOS ANGELES 1990

EDITOR JERRY SOHN

PAPER TECHNICIAN WALLY DAWES

PAPER MAKER MADELEINE PESTIAUX

TYPOGRAPHY LES FERRISS

SCREEN PRINTER JEFF WASSERMAN

BINDER ULLI ROTZSCHER

SPECIAL THANKS TERESA BJORNSON

PUBLISHER SAM FRANCIS

NAIROBI

GUATIQUIA

CONDAMINE

AVON

MISSISSIPPI

RUSSELL MARET

(American, b. 1971)

***Interstices & Intersections or, An Autodidact Comprehends a Cube: Thirteen Euclidean Propositions**, 2014*

Remember how you felt in high school geometry class? That potentially stultifying subject is given an unforgettable spin in this shamelessly beautiful book. This two-sided accordion book, or *leporello*, is filled with perceptions of pure shapes in living color. It collapses 3-D shapes into 2-D and then depicts them in deeply saturated hues. Red triangles dance. Parallelograms stretch into jagged forms. A cone becomes a funny party hat, and spheres bounce like balls. Some leaves are simply and elegantly ornamental, with repetitive abstract designs filling entire pages and inhabiting your headspace.

Basing his project on Sir Thomas Little Heath's 1908 translation of Euclid's *Elements of Geometry*, Maret added his own commentary focusing on issues of geometry, literature, and letterforms—the latter being a recurring obsession for the artist. His approach to color here follows the nineteenth-century Euclidean commentator Oliver Byrne, who proposed that color enhancement can assist in the presentation of geometry's complex shapes. (MR)

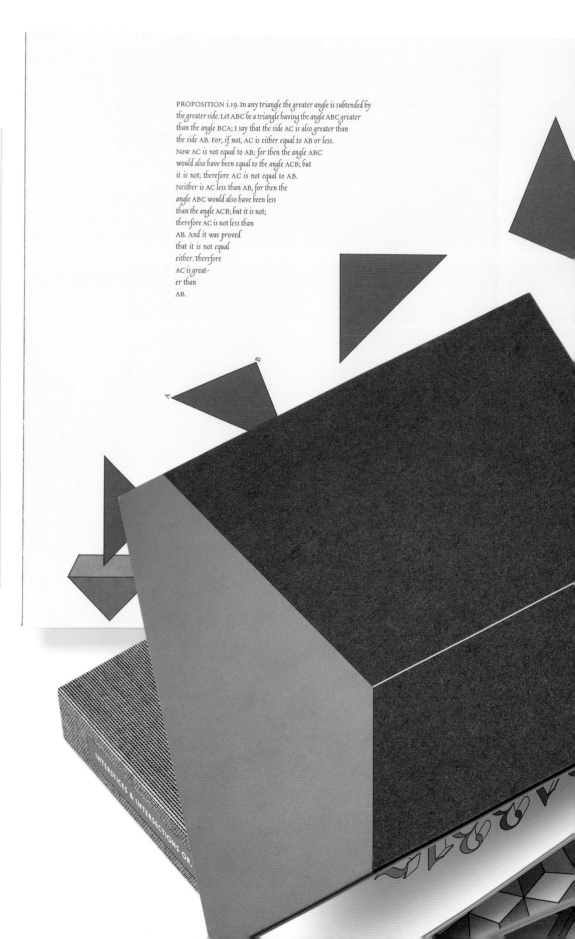

PROPOSITION i.19. In any triangle the greater angle is subtended by the greater side. Let ABC be a triangle having the angle ABC greater than the angle BCA; I say that the side AC is also greater than the side AB. For, if not, AC is either equal to AB or less. Now AC is not equal to AB; for then the angle ABC would also have been equal to the angle ACB; but it is not; therefore AC is not equal to AB. Neither is AC less than AB, for then the angle ABC would also have been less than the angle ACB; but it is not; therefore AC is not less than AB. And it was proved that it is not equal either. Therefore AC is greater than AB.

PROPOSITION viii.15. *If a cube number measure a cube number, the side will also measure the side; and, if the side measure the side, the cube will also measure the cube.*

For let the cube number A measure the cube B, and let C be the side of A and D of B; I say that C measures D. For let C by multiplying itself make E, and let D by multiplying itself make G; further, let C by multiplying D make F, and let C, D by multiplying F make H, K respectively. Now it is manifest that E, F, G and A, H, K, B are continuously proportional in the ratio of C to D. And, since A, H, K, B are continuously proportional, and A measures B, therefore it also measures H. And, as A is to H, so is C to D; therefore C also measures D. Next, let C measure D; I say that A will also measure B. For, with the same construction, we can prove in a similar manner that A, H, continuously proportional in the ratio of C to D. And, since C measures D, is A to H, therefore A also measures H, so that A measures B also.

arating, influencing each other like brush strokes on a canvas. Take a cube number, stuff it inside a different cube and measure it with another, and stack them all up into a disordered obelisk. All that is missing, really, is color, light and shade, and a willingness to career off into pure abstraction. Number as segmented dream, as agent, as engine, brightly colored and inaccessible. But just as Euclid tilts suggestively toward non-representation he swings back on his pendulum into realism, leaving a physical architecture in his wake. ¶Despite his forays into abstraction, numbers, in Euclid's world, are *things*. They are as classifiable as elements, as dimensional as sculpture, with all the multi-tonal potential of thoughts. They *exist* and can therefore be *applied*. Take the number 27, for instance, and regard it as an object. It is a cube whose length, breadth, and height are 3. Turn it over in your hand and notice how light plays on its surface as it rotates. Toss it in the air, spin it like a top, then slather it with glue and stick it onto two progressively larger cubes. 64 and 125 will do. Make seventy-two of these telescoping arms and rotate each five degrees from its neighbor around a common center. Imagine this construction in colored glass letting light through a cathedral wall, cut in marble and arrayed across a floor, or fabricated as tin carriages whirling around a carousel. Number as implied verb, active and available for use. ¶When I read about cube numbers, I want to grab onto one and sink my teeth into it. I want to cut it, bisect it, and reassemble it into something new. The tactility of cube numbers elicits sculptural fantasies that I would never experience if placed before a chunk of rock with a chisel. Despite these fantasies, there is nothing I want to do more with cubes than represent them in two dimensions. A three dimensional cube situated in space is inert and irrefutable. It is what it wants to be, and because of this it does not

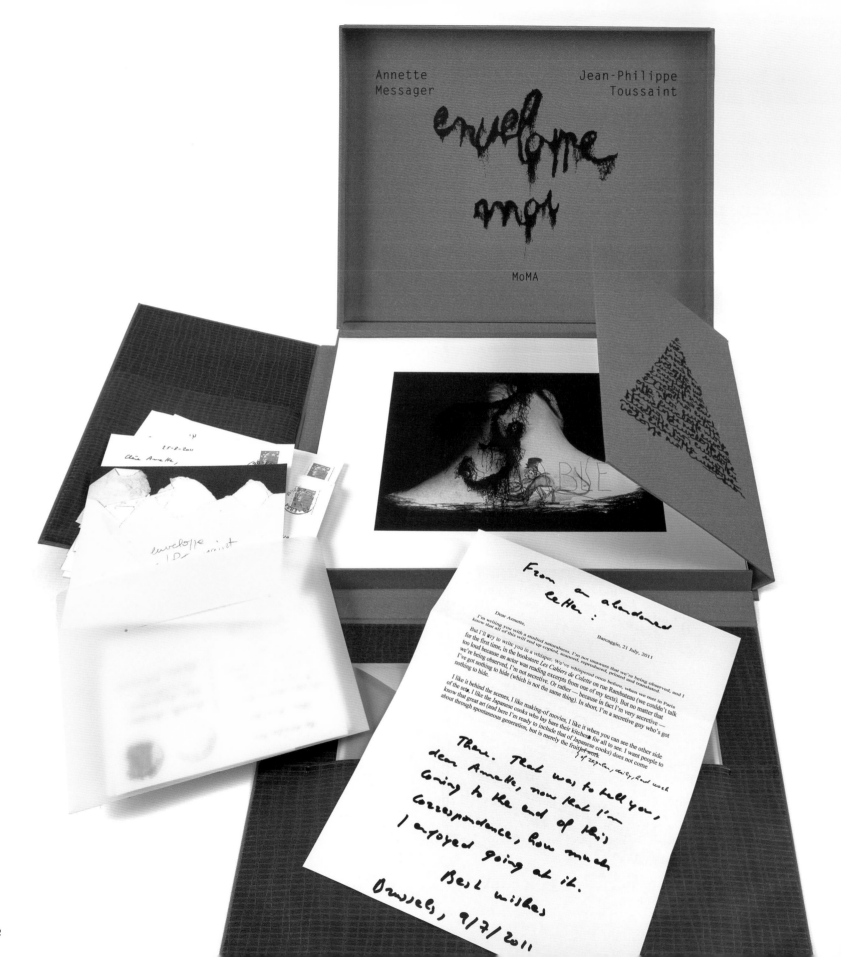

ANNETTE MESSAGER
(French, b. 1943)
JEAN-PHILIPPE TOUSSAINT
(Belgian, b. 1957)
Enveloppe-moi, 2013
New York: Library Council of the
Museum of Modern Art

This enticing, actually exciting, enclosure made for
readers to explore holds envelopes to be opened
and postcards to be read. There is an unsettling
feeling of violating someone's privacy, peeking at
secrets. Indeed, what the viewer does is the reverse
of enveloping; it is unpacking—unfolding, holding,
and reading. Messager sent fifteen postcards,
one by one, to the artist and writer Jean-Philippe
Toussaint. Messager's artwork is on the front of the
cards; Toussaint's replies, on the reverse. In addition
to their surprisingly tame correspondence, the box
includes a "virgin" set of postcards for readers to
send to their own correspondents. (The adjective
used by the artist hints at what could go on.) After
opening this small collection of memories and
art, you might think it more aptly titled *Ecrites-moi*
(Write to me). But instead it is *Enveloppe-moi* (Enve-
lope me), a more intriguing invitation. (MR)

KATHERINE NG

(American, b. 1964)

[1] *Banana Yellow*, 1991
Northridge, CA: Second Story Press

[2] *A Hypothetical Analysis of the Twinkle in Stars (As Told by a Child to a Teacher)*, 1994
Pasadena, CA: Pressious Jade

[3] *Fortune Ate Me*, 1992
Northridge, CA: Second Story Press

Like children's books, Ng's deceptively simple volumes engage by means of their alternative, yet familiar, formats. The experience of materiality—opening, unfolding, flipping pages, refolding, closing—enhances the cerebral intake from her texts, slowing comprehension. To read Ng's books is to remember what it was like to be a child: learning to read, deciphering the words, making them into meaning, quietly and slowly acquiring mature understanding. The books ask and respond to questions. Ng writes that the darkly titled *Fortune Ate Me* was inspired by letters she received from her father while in college. For all the juvenile allusions they may evoke, these are not cute stories but tales of cultural collisions and perspectives gained from experience. (MR)

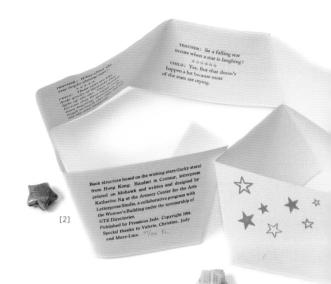

[2]

TEACHER: What makes stars twinkle?
CHILD: Stars twinkle because of their tears… light from the moon… makes them twinkle.
TEACHER: Why do stars have tears?
CHILD: Sometimes… because they're tired, so they yawn.
TEACHER: So a falling star occurs when a star is laughing?
CHILD: Yes. But that doesn't happen a lot because most of the stars are crying.

美国出生中国人

mei
gwok
cheut
sang
jung
gwok
yahn

American Born Chinese

In a derogatory manner, native born Chinese people call me, *ABC* (American Born Chinese). They look down at me for not speaking their language, not knowing their culture, for being born an American.

香蕉黃

Banana Yellow

[1]

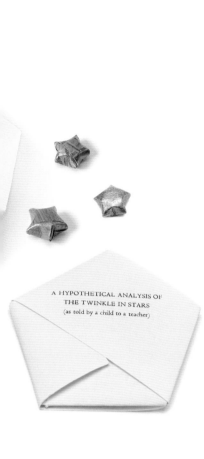

A HYPOTHETICAL ANALYSIS OF
THE TWINKLE IN STARS
(as told by a child to a teacher)

[3]

LAURA OWENS

(American, b. 1970)

Fruits and Nuts, 2011–12

Los Angeles: Ooga Booga

Owens, a major advocate for painting of her generation, has also been one of its most active and inventive publishers of artists' books. Her parallel practice allows Owens to test ideas from one medium against the other. A case in point is *Fruits and Nuts*. The book's title may come from an old zinger about residents of the state of California, but Owens takes the phrase literally, producing an illustrated abecedarium of treats from "avocado" to "jujubes" and "kiwi" to "yantok" (a citrus fruit from the Philippines). There is a childlike simplicity and pleasure to the book, reinforced by the luscious colors of the screen printing and the thick boards of its covers. And yet the use of actual newspapers from the 1960s as the support disturbs any sense of cozy nostalgia, as Owens's foodstuffs are freely painted over reports about mortar attacks in Vietnam or the assassination of Robert Kennedy. Owens has also used enlarged newsprint as the background for her paintings, and the subtle sophistication of her technique maintains a delicate balance of humor and sobriety, on canvas and in print. (JT)

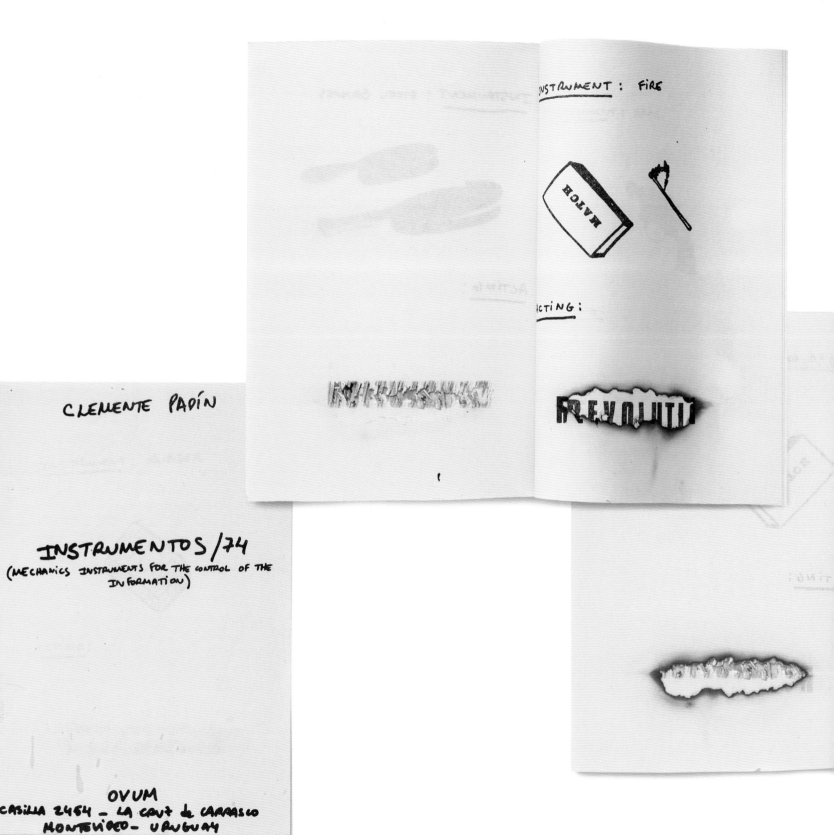

CLEMENTE PADÍN

INSTRUMENTOS/74
(MECHANICS INSTRUMENTS FOR THE CONTROL OF THE
INFORMATION)

OVUM
CASILLA 2454 - LA CRUZ de CARRASCO
MONTEVIDEO - URUGUAY

INSTRUMENT: FIRE

MATCH

ACTING:

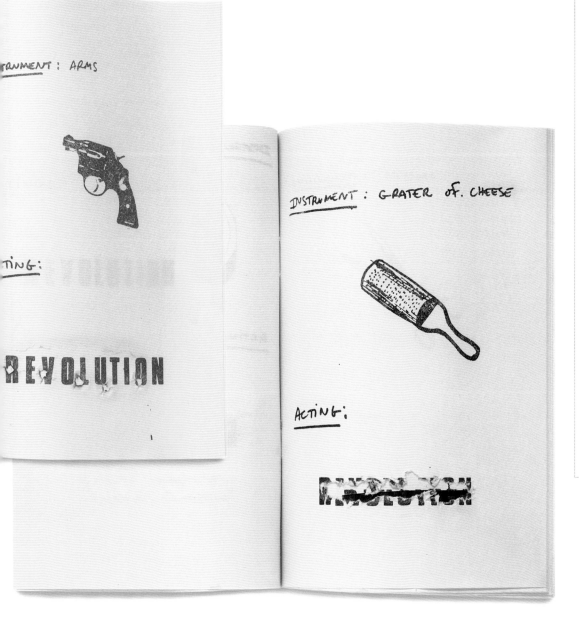

CLEMENTE PADÍN
(Uruguayan, b. 1939)
***Instrumentos/74: Mechanics Instruments
for the Control of the Information***, 1974
Montevideo: Ovum

In the late 1960s Padín produced concrete poetry, using letters as graphic elements meant less to be read than to be seen, and he edited the journal *Ovum*. With the arrival of the Uruguayan dictatorship in 1973, however, Padín's work took an overtly political turn, eventually resulting in the artist's imprisonment and the confiscation and destruction of his work. *Instrumentos/74* was one of the works that drew the government's ire.

It is a simple affair: photocopied pages stacked atop one another and then stapled twice. The primitiveness of its construction, however, belies its power. It presents, as its subtitle makes explicit, a series of *Mechanics Instruments for the Control of the Information*: rubber erasers; hands; acid; correction tape; cheese grater; scissors; brush, pencils, and India ink; steel brushes; fire; arms. The top half of each page contains a simple graphic representation of each tool, while the bottom half bears a literal trace of that instrument's action on the paper (erasure, tearing, dissolving, etc.). As one continues through the publication, it becomes increasingly evident that these erasures are targeting a specific word. Finally, on the last page, when no instruments of control remain, only the word remains: "Revolution."

Instrumentos/74 exemplifies the rapid spread of artistic uses of photocopy technologies across the world as a means of self-publication. It also illustrates the fraught circumstances in which the work was produced—and the very real risks it carried. (JT)

BENJAMIN PATTERSON

(American, 1934–2016)
ABC's, 1962

While working as an artist in Germany and France, Patterson filled the pages of a French children's alphabet coloring book with clippings from magazines and newspapers, pasting in ephemera such as postcards. Historically, it was a ladies' pastime to create these kinds of albums; scrapbooks are one of the oldest genres. But Patterson's album twists its sentimental context; his selection of content and its arrangement is transformative. Lifting pieces of paper formerly part of something else, his assemblages effect a change of identity, but hardly ever like a butterfly emerging from a cocoon. Rather, Patterson's cut-and-pastes are provocative, his suggestive snips serve to disturb decorum.

The scrapbook is encyclopedic in its array of media, stressing disjunction and dislocation throughout. An old postcard—"Bonne Fête," showing a boy holding a large pink bouquet—is pasted on a foldout of the Alps from *Paris Match* and is paired with a poem in German titled "Für Benjamin" dated July 1961. Reuse and revision are core compositional strategies here, and Patterson evaded frivolity by including newspaper clippings that reference current events and culture but stress the disconnects. *M* features a large portrait of Miles Davis, with Mao on the verso. *P* has printed phonetic pronunciations, *pli—pro—piv—pom—pur*. Perfect for double-bass-player Patterson's acoustic propensities, sounds are down on paper. On the leaf for the letter *K*, a photo of Nikita Khrushchev is paired with an enigmatic printed poem:

> Killed cow.
> Wrecked plane.
> Scared me.
> Smith.

(MR)

RAYMOND PETTIBON

(American, b. 1957)

Faster, Jim, 2002

Lithographs by Greg Colson (American, b. 1956), Francesca Gabbiani (Canadian, b. 1965), Scott Grieger (American, b. 1946), Eddie Ruscha (American, b. 1966), and Dani Tull (American, b. 1966); photograph by Todd Squires (American, b. 1973); silkscreens by Victor Gastelum (American, b. 1964)

Venice, CA: Hamilton Press

I don't know how it's going to turn out until it's done.[8]

More than a bookmaker, Pettibon is a born graphic artist, preferring to work in black and white, prizing the effect of black ink strokes on a white background. Echoing the centuries-old formats of block books and broadsides, Pettibon's cosmic comics are insightful bearers of wise ideas. Crafted dramatically on paper made to burn into our memories, characters' thought bubbles can be read aloud; random quotes from an interior voice are intended to make you wonder.

 Most of Pettibon's books are intentionally modest photocopies; he hardly ever works in deluxe modes. This exceptional project was done with a crew of collaborators, which is how Pettibon actually works when he makes his art or does gallery installations. The book's theme is travel, Los Angeles style. The slipcase shows the familiar Goodyear blimp we see cruising over Los Angeles on weekends, only here crashing into a refinery like the one in El Segundo. The edition has a fancy cover of brushed aluminum with Victor Gastelum's stencil of a snazzy Impala. The title page features a hitchhiker's thumb: "Take me for a ride!" (MR)

Faster, Jim

GREG COLSON FRANCESCA GABBIANI DANI TULL
VICTOR GASTELUM SCOTT GRIEGER TODD SQUIRES
RAYMOND PETTIBON EDDIE RUSCHA *R.P.*

ADRIAN PIPER

(American, b. 1948)

Three Untitled Projects [for 0 to 9]:
Some Areas in the New York Area, 1969
New York: 0 to 9 Press

In 1969 Adrian Piper was still an undergraduate at the School of Visual Arts in New York when she staged her first one-person exhibition. The show featured three pieces. The first contained an image of a map of Manhattan accompanied by nineteen sheets of seemingly blank paper that, as Piper described it, were enlargements of a block that had been highlighted on the map. The second presented sets of addresses for each of the five boroughs of New York City with an explanation that the listings were determined by the intersections in the folds of corresponding maps. The third consisted of four sheets of graph paper, each with grids of increasing density, with an explanation that the pages represented systematic enlargements and reductions. In their reliance on text, their employment of seemingly objective systems, and their presentation of documentation, the pieces all bear hallmark characteristics of Conceptual art.

What truly set the exhibition apart—other than the precocious age of the artist—was the fact that it took place not in a gallery but rather as a mail art piece that was published by Vito Acconci and Bernadette Mayer's 0 to 9 Press and sent to a group of 150 individuals in the art world. Piper had surreptitiously obtained their addresses from Seth Siegelaub, the well-known gallerist/impresario identified with Conceptualism who also happened to be the artist's employer at the time. (JT)

ADRIAN PIPER

Barbara Riese, London, Eng.
Yvonne Rainer, New York, N.Y.
Clyde Stats, Chicago, Ill.
Rafael Soyer, New York, N.Y.
Seth Siegelaub, New York, N.Y.
Richard Serra, New York, N.Y.
Robert Smithson, New York, N.Y.
Charles Simonds, Somerset, N.J.
School of Visual Arts, New York, N.Y.
Richard Van Buren, New York, N.Y.
Janice Warner, Bronx, N.Y.
Ian Wilson, New York, N.Y.
Lawrence Weiner, New York, N.Y.
Phillip Zohn, New York, N.Y.
Jill Johnston, New York, N.Y.
Jean Lipman, New York, N.Y.
Peter Walker, Brooklyn, N.Y.
Andrew Ross, Brooklyn, N.Y.
Charles Ross, New York, N.Y.
Michael Kirby, New York, N.Y.
Brice Marden, New York, N.Y.
Kenneth Snelson, New York, N.Y.
Paul Waldman, New York, N.Y.
Bill Bolinger, New York, N.Y.
Peter Gourfain, New York, N.Y.
Jo Baer, New York, N.Y.
Bruce Glaser, New York, N.Y.
Frederick Zuckerman, New York, N.Y.
Eva Hesse, New York, N.Y.

Mr. and Mrs. Alejandro Puentes, N.Y.
Mike Braziller, New York, N.Y.
Susan Perry, New York, N.Y.
Marge Sussman, New York, N.Y.
Marc Landy, New York, N.Y.
K.C. Scott, New York, N.Y.
Dulcy Ganz, New York, N.Y.
Mike Shorr, New York, N.Y.
Paul Jansen, New York, N.Y.
Deborah Hay, New York, N.Y.
Lucinda Childs, New York, N.Y.
Simone Whitman, New York, N.Y.
Rosemary Castoro, New York, N.Y.
William Pettet, Los Angeles, Cal.
Willoughby Sharp, New York, N.Y.
Mr. and Mrs. Robt. Topol, Mamaroneck, N.
Alan Power, London, England
Ron Cooper, Los Angeles, Cal.
Alan Ruppersburg, London, England
Christine Kozloff, London, Eng.
Mr. and Mrs. James Butler, Los Angeles
Arthur Rose, New York, N.Y.
Raymond Dirks, New York, N.Y.
Mr. and Mrs. Dennis Holt, New York, N.Y.
Joseph Rafael, New York, N.Y.
Peter and Amy Lang, New York, N.Y.
Mr. and Mrs. Wm. Oursley, Oxford, Ohio
Barry Flanagan, London, England
Mr. and Mrs. Jay Siegelaub, New York, N.

One block was randomly selected from a map of the New York area,
scale: ¼ = 500' (see map).

p.1: The area of the block measures 1/16 x 3/16" on the map and 125 x
375' in actual size, and is enlarged in a proportion of 1 : 3 to a
rectangular area measuring 11 x 33", after which:

p.2: 1/3 the area of the block measuring 1/48 x 3/48" on the map and
41'8" x 125' in actual size is enlarged to a rectangular area of
11 x 33".

p.3: 1/9 the area of the block measuring 1/144 x 3/144" on the map and
13'10 2/3" x 41'8" in actual size is enlarged to a rectangular area of
11 x 33".

p.4: 1/27 the area of the block measuring 1/432 x 3/432" on the map
and 4'8" x 13'10 2/3" in actual size is enlarged to a rectangular area
of 11 x 33".

p.5: 1/81 the area of the block measuring 1/1296 x 3/1296" on the map
and 1'6 2/3" x 4'8" in actual size is enlarged to a rectangular area
of 11 x 33".

p.6: 1/243 the area of the block measuring 1/3888 x 3/3888" on the
map and 6 1/3" x 1'6 2/3" in actual size is enlarged to a rectangular
area of 11 x 33".

p.7: 1/729 the area of the block measuring 1/11664 x 3/11664" on the
map and 2 1/9" x 6 1/3" in actual size is enlarged to a rectangular
area of 11 x 33".

p.8: 1/2187 the area of the block measuring 1/34992 x 3/34992" on the
map and 19/27" x 2 1/9" in actual size is enlarged to a rectangular
area of 11 x 33".

p.9: 1/6561 the area of the block measuring 1/104976 x 3/104976" on
the map and 19/81" x 19/27" in actual size is enlarged to a rectangu-
lar area of 11 x 33".

p.10: 1/19683 the area of the block measuring 1/314928 x 3/314928" on
the map and 19/243 x 19/81" in actual size is enlarged to a rectangu-
lar area of 11 x 33".

p.11: 1/59049 the area of the block measuring 1/954784 x 3/954784" on
the map and 19/729 x 19/243" in actual size is enlarged to a rectangu-
lar area of 11 x 33".

p.12: 1/177147 the area of the block measuring 1/2864352 x 3/2864352"
on the map and 19/2187 x 19/729" in actual size is enlarged to a rec-
tangular area of 11 x 33".

p.13: 1/531541 the area of the block measuring 1/8593056 x 3/8593056"
on the map and 19/6561 x 19/2187" in actual size is enlarged to a
rectangular area of 11 x 33".

p.14: 1/1594623 the area of the block measuring 1/25779168 x
3/25779168" on the map and 19/19684 x 19/6561" in actual size is en-
larged to a rectangular area of 11 x 33".

p.15: 1/4783869 the area of the block measuring 1/77337504 x
3/77337504" on the map and 19/59049 x 19/19683" in actual size is en-
larged to a rectangular area of 11 x 33".

p.16: 1/14351607 the area of the block measuring 1/231002512 x
3/231001512" on the map and 19/177147 x 19/59049" in actual size is
enlarged to a rectangular area of 11 x 33".

p.17: 1/43054821 the area of the block measuring 1/603007536 x
3/693007536" on the map and 19/531541 x 19/177147" in actual size is
enlarged to a rectangular area of 11 x 33".

p.18: 1/129164463 the area of the block measuring 1/2079022608 x
3/2079022608" on the map and 19/1594623 x 19/531541" in actual size
is enlarged to a rectangular area of 11 x 33".

p.19: 1/387493389 the area of the block measuring 1/6228067824 x
3/6228067824" on the map and 19/4783869 x 19/1594623" in actual size
is enlarged to a rectangular area of 11 x 33".

The 8½ x 11" areas shown represent 2/5 of the total enlargement.

0 TO 9 Books
102 Christopher Street
New York, N.Y. 10014

MARKUS RAETZ

(Swiss, b. 1941)

Notizbüchlein, 1972

Lucerne: Toni Gerber und P. B. Stähli

Flipping through this small spiral-bound book, you could be forgiven for feeling that you have stumbled upon an original sketchbook rather than a published edition. The basis for this exquisitely produced fac-simile was, in fact, Raetz's own sketchbook, made during a three-week period in Amsterdam in 1971. The little book has been replicated perfectly, leaving few clues as to its status aside from a small block of publishing information at the back.

Artists use sketchbooks to test and record ideas, and as such, there is no need for them to present a cohesive narrative or advance a finished set of concepts. Yet sketchbooks are fascinating for precisely this reason, allowing us to witness an art-ist's thoughts taking shape as they happen. Raetz's sketchbook is filled with a variety of drawings and doodles, from the highly finished to the barely there, and includes scenes of high surrealism, abstraction, and absurd comedy: a breast-headed elephant soars through the air; dots coalesce to form cathedrals of light; a naked man on ice skates whizzes by, as a caption (in German) reads: "Thinking as ice skating, and vice versa." This book celebrates the freedom of the creative mind left to glide, allowing us a glimpse into the daily life of an artist at work. (GP)

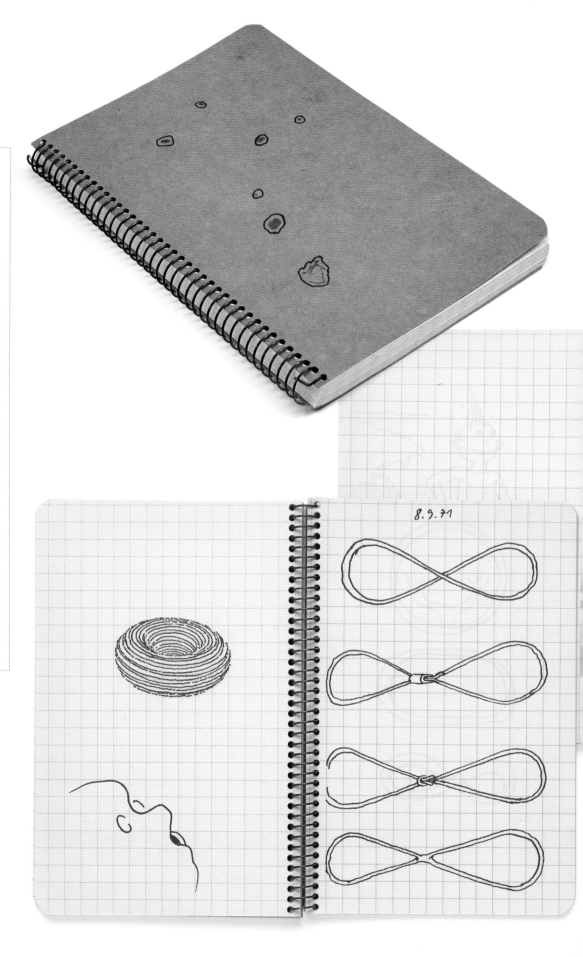

HARRY REESE
(American, b. 1946)
SANDRA LIDDELL REESE
(American, b. 1947)
Heart Island & Other Epigrams, 1995
Text by James Laughlin (American, 1914–1997)
Isla Vista, CA: Turkey Press

Stop searching stop weeping
she has gone to Heart Island

where the Truth People live
eating fern-shoots & berries

where there is no fighting
no sin no greed no sorrow

A selection of short love poems—dreams and realities—by the renowned New Directions editor James Laughlin was designed, printed, and bound by his good friends Harry Reese and his wife, Sandra Liddell Reese, at their Turkey Press. Laughlin's seemingly innocent poems are wittily paired with weird hybrid, half-human creatures reproduced from early nineteenth-century French wood engravings in an "infernal dictionary." Such modest small press books can be marvelously approachable; they invite you to hold them, to open them, and to read them quietly, as opposed to feeling like the book is going to bury you. As enterprises frequently run by artists, small presses bring together circles of friends to relish and record shared tastes. Such collaborations demonstrate the personal and informal social roles that books can play, like family members telling beloved, familiar stories. The simple formats of these alternatives to trade editions lend them-selves especially well to poetry. Printed on carefully selected papers, lightly bound to allow pleasurable browsing, and enhanced with very strange pictures to ponder, *Heart Island & Other Epigrams* offers poetry for thoughtful rumination, like small plates of good food. (MR)

THE TWO OF THEM

One kept his stomach full.
The other nourished his imagination.
It was a perfect arrangement
Until some confusion arose
As to which one should do which.

THE FIRST NIGHT

we spent together was like
school each was trying to

teach the other what was
liked or not liked the de-

tails are irrelevant what
mattered was that love was

becoming a real thing be-
tween us without regard to

this or that preference.

SUE ANN ROBINSON

(American, b. 1946)
Chisolm Hours, 1988
Rochester, NY: Visual Studies Workshop

Bringing together Southwestern ranch decor and
cowboy paraphernalia (barbed wire, bridles, raw-
hide, and fringe) and featuring standard elements
from medieval and Renaissance books of hours,
Robinson's improbable (and funny) book should
be seen as distinctly "American" (pronounced
with a Texas twang). Indeed, it is a cowboy-style
meditation. Like illuminated manuscripts made for
distinguished patrons, such as the fifteenth-century
Hours of Catherine of Cleves, this book is inten-
tionally showy, though in a rodeo or Western flea
market style. Stitched on synthetic rawhide, which
substitutes for parchment or vellum, the embel-
lished pages flop and jangle like leather chaps and
reins, giving a rolling cadence to reading, like riding
on horseback. (MR)

RACHEL ROSENTHAL
(American, b. France, 1926–2015)
DANIEL J. MARTINEZ
(American, b. 1957)
Soldier of Fortune, 1981
Los Angeles: Paradise Press

Artists often create books to memorialize them-selves, wrapping themselves like mummies between the covers. This portfolio by the feminist perfor-mance artist Rosenthal captures her unconventional response to a personal crisis. Texts taken from a diary the artist kept in January 1981 reveal that she felt suicidal after discovering that her investment banker had embezzled all her assets. She further recalled that her father had a similar experience when he lost a fortune in the Crash of 1929, though his reaction was more philosophical: after revealing the financial disaster to the family, he said, "We'll discuss it after my nap." In another entry Rosenthal describes seeing a starving coyote, empathizing with it, and feeling guilty for not saving its life.

A Beverly Hills portrait that lampoons the lifestyles of the city, taking them with a grain of salt, Rosenthal's book juxtaposes personal texts with photographs by Daniel J. Martinez of her high-concept appearances in Los Angeles restaurants with her pet rat, Tattie Wattles. The book's dining scenes recall the Rococo flavor of Jean-Baptiste Oudry's illustration of La Fontaine's fable "The City Rat and the Country Rat," in which the rats dine on leftovers on an elegantly appointed table. Lest the rat, who often traveled astride Rosenthal's shoulder, seem to be an incidental player, he is the featured character in *Tattie Wattles: A Love Story* (Santa Monica, CA, 1996), finely illustrated by Rosenthal. (MR)

Saturday

Michael's

Les Fromages -- ce qu'il faut
A portion of assorted Cheeses with
Strawberries and Blackberries on the side

I hate this world. I hate the way things are. I hate my past, my body, my Fa-ther and Mother. I hate the chain of life. I hate what creatures do to creatures, what people do to animals, what people do to people. In the name of science, art, love, morality, patriotism, idealism, ignorance, stupidity, cupidity, cruelty and hate. I hate being part of it. I punish myself with food. I don't even taste what I stuff myself with. I am part of a hideous conspiracy. I can't pray or become part of God Consciousness because I hate the manifestations of God. I think I am a Gnostic. Believe that all creation is of the Devil. God is the uncreated. But where is God since even consciousness has an electric field? That's the Nagual I guess. But what good is it, or even is it at all? Every-thing manifest is made of killing, death, eating, destroying, competing, greed. The symbiotic relationships are only for survival. There is no love except in books. I feel abandoned and conned into collaborating. I want to shave my head like they shaved the collaborationist women — those who slept with Germans.

DIETER ROTH

(Swiss, 1930–1998)
[1] *Poetrie*, 1967
Stuttgart: Edition Hans Jörg Mayer
[2] *Poemetrie*, 1968
Cologne: Diter Rot u. Rudolf Rieser

Dare we call these funky volumes books when there is no paper? The "pages" of *Poemetrie* consist of twenty-one envelopes of clear vinyl on which are printed the texts of poems. These envelopes contain urine, now desiccated and yellow green, that retains its characteristic repellent odor, which is possibly getting stronger with age. The pouches in the "Luxury Edition" of *Poetrie* are filled with a flesh-colored pudding-like substance; Roth called these *Käsewolke* (cheese clouds). Did Roth foresee that these shiny pages, printed with deliberately antipoetic, scatological verse, would wrinkle and cloud with age? Fifty years after their publication, the pungent materiality of these works makes them unforgettable.

The artist's name strikingly echoes that of the Enlightenment philosopher, writer, and editor Diderot (p. 47). What would that eighteenth-century luminary make of these books? Perhaps they exemplify the mid-twentieth century, just as Diderot's *Encyclopédie* epitomized the intellectual culture of his time. Somehow in these arresting works, the charmless morphs into the memorable. (MR)

[1]

BRIAN ROUTH

(British, b. 1948)

Harry + Harry Kipper in Eh Pet, 1976

The comic book stylings of Brian Routh's *Eh Pet* present an expansion of the fantasies explored in museums and nightclubs by the performance art duo the Kipper Kids (aka Harry Kipper and Harry Kipper), the personae that Routh and Martin von Haselberg assumed onstage. The Kipper Kids' unique style of performance drew freely from a multitude of genres that had rarely mixed before, blending art world elements of Conceptualism, body art, and Vienna Actionism with raucous nods to cabaret, vaudeville, and slapstick. Harry Kipper was a sort of hypermasculine cockney buffoon, a nightmarish reversal of the buttoned-up gentility of Gilbert & George, the leading British performance artists of the day. The Kipper Kids were all about id, suggestive of society's more barbaric traits bubbling just under the surface.

Eh Pet draws heavily from the Kipper Kids' performances, mimicking the overall appearance, costumes, and rough language of the duo. In Routh's hand-drawn renditions here, the Kipper Kids traipse through a narrative that spans air, land, and sea and allows them to exercise in front of the Great Pyramids, fly fighter jets, proliferate as robots, fight bad guys, do a bit of naked boxing, capture army deserters, visit a dungeon, go fishing, and eventually be eaten alive before bursting forth unharmed and ready for more. The book presents a humorous and somewhat startling transposition of the antic energy of the Kipper Kids' performances into the unrestrained imaginativeness of superhero comics. (GP)

ED RUSCHA

(American, b. 1937)
[1] *Hard Light*, 1978, with Lawrence Weiner
(American, b. 1942)
[2] *On the Road*, 2009
[3] *Dutch Details*, 1971
[4] *Various Small Fires and Milk*, 1964
[5] *Thirtyfour Parking Lots in Los Angeles*, 1967
[6] *Every Building on the Sunset Strip*, 1966
[7] *A Few Palm Trees*, 1971
[8] *Twentysix Gasoline Stations*, 1967
[9] *Nine Swimming Pools and a Broken Glass*, 1968
[10] *Some Los Angeles Apartments*, 1965
[11] *Records*, 1971
[12] *Then + Now: Hollywood Boulevard 1973-2004*, 2005
[13] *Real Estate Opportunities*, 1970
[14] *Business Cards*, 1968, with Billy Al Bengston
(American, b. 1934)
[15] *Royal Road Test*, 1967, with Mason Williams
(American, b. 1938) and Patrick Blackwell
(American, b. 1935)
[16] *Babycakes with Weights*, 1970
[17] *Colored People*, 1972
[18] *Crackers*, 1969, with Mason Williams

"The Henry Ford of book making." That's how Ed Ruscha described his aspirations in a 1969 interview with the *National Observer.* In holding up as an exemplar the inventor of the Model T and popularizer of assembly-line production, the artist was expressing his desire to make artists' books affordable and accessible to the general public. Until Ruscha, the world of artists' publications had been dominated by the model of the *livre d'artiste*, small, numbered editions, made artisanally, and priced accordingly. Ruscha's books were printed inexpensively by commercial printers in increasingly large editions. Four hundred copies were made for the first editions of *Twentysix Gasoline Stations* and *Various Small Fires and Milk,* and a thousand copies of *Every Building on the Sunset Strip,* with each subsequent edition increasing in quantity by several thousand, an unprecedented scale in the world of artists' books.

It was not just their relative economy and mass production that differentiated Ruscha's books; they were also distinctive in their unusual deployment of photography. Ruscha disregarded many of the medium's aesthetic criteria, such as pleasing composition, technique, or even interesting subject matter. He presented photography at its most flatfooted, often haphazardly composed and at times out of focus, portraying commonplace elements of postwar suburban life that most people overlooked: gas stations, cheap apartment buildings, parking lots, swimming pools, and commercial buildings for sale. While widely imitated today as classics, at the time the seemingly arbitrary compilations (note the recurrence of quantitative titles: *Thirtyfour…, Some…, Nine…*) elicited much head scratching—and even rejection from the Library of Congress, which declined the copies Ruscha as publisher dutifully had sent of *Twentysix Gasoline Stations.* This rejection did not deter the artist, whose sense of mission is reflected in the similar formats of his publications from the 1960s, many of which are the same size and sport the same modern serif font on an otherwise blank cover. While the works printed after 1970, especially the more recent *Then + Now* and *On the Road* (an adaptation of Jack Kerouac's novel), diverge from this classic mold and even find Ruscha experimenting with limited luxury editions, he remains an artist fascinated by everyday pleasures. (JT)

HARD LIGHT

go with the music box, that we barely could hear. Everybody held his breath to listen. "Tick . . . tack . . . tick-tick . . . tack-tack," Dean cupped a hand over his ear; his mouth hung open; he said, "Ah! Whee!"

Carlo watched this silly madness with slitted eyes. Finally he slapped his knee and said, "I have an announcement to make."

"Yes? Yes?"

"What is the meaning of this voyage to New York? What kind of sordid business are you on now? I mean, man, whither goest thou? Whither goest thou, America, in thy shiny car in the night?"

"Whither goest thou?" echoed Dean with his mouth open. We sat and didn't know what to say; there was nothing to talk about any more. The only thing to do was go. Dean leaped up and said we were ready to go back to Virginia. He took a shower, I cooked up a big platter of rice with all that was left in the house, Marylou sewed his socks, and we were ready to go. Dean and Carlo and I zoomed into New York. We promised to see Carlo in thirty hours, in time for New Year's Eve. It was night. We left him at Times Square and went back through the expensive tunnel and into New Jersey and on the road. Taking turns at the wheel, Dean and I made Virginia in ten hours.

"Now this is the first time we've been alone and in a position to talk for years," said Dean. And he talked all night. As in a dream, we were zooming back through sleeping Washington and back in the Virginia wilds, crossing the Appomattox River at daybreak, pulling up at my brother's door at eight A.M. And all this time Dean was tremendously excited about everything he saw, everything he talked about, every detail of every moment that passed. He was out of his mind with real belief. "And of course now no one can tell us that there is no God. We've passed through all forms. You remember, Sal, when I first came to New York and I wanted Chad King to teach me about Nietzsche. You see how long ago? Everything is fine, God exists, we know time. Everything since the Greeks has been predicated wrong. You can't make it

98

with geometry and geometrical systems of thinking. It's all *this!*" He wrapped his finger in his fist; the car hugged the line straight and true. "And not only that but we both understand that I couldn't have time to explain why I know and you know God exists." At one point I moaned about life's troubles—how poor my family was, how much I wanted to help Lucille, who was also poor and had a daughter. "Troubles, you see, is the generalization-word for what God exists in. The thing is not to get hung-up. My head rings!" he cried, clasping his head. He rushed out of the car like Groucho Marx to get cigarettes—that furious, ground-hugging walk with the coattails flying, except that he had no coattails. "Since Denver, Sal, a lot of things—Oh, the things—I've thought and thought. I used to be in reform school all the time, I was a young punk, asserting myself—stealing cars a psychological expression of my position, hincty to show. All my jail-problems are pretty straight now. As far as I know I shall never be in jail again. The rest is not my fault." We passed a little kid who was throwing stones at the cars in the road. "Think of it," said Dean. "One day he'll put a stone through a man's windshield and the man will crash and die—all on account of that little kid. You see what I mean? God exists without qualms. As we roll along this way I am positive beyond doubt that everything will be taken care of for us—that even you, as you drive, fearful of the wheel" (I hated to drive and drove carefully)—"the thing will go along of itself and you won't go off the road and I can sleep. Furthermore we know America, we're at home; I can go anywhere in America and get what I want because it's the same in every corner, I know the people, I know what they do. We give and take and go in the incredibly complicated sweetness zigzagging every side." There was nothing clear about the things he said, but what he meant to say was somehow made pure and clear. He used the word "pure" a great deal. I had never dreamed Dean would become a mystic. These were the first days of his mysticism, which would lead to the strange, ragged W. C. Fields saintliness of his later days.

VARIOUS

SMALL

FIRES
VARIOUS SMALL FIRES
AND MILK

EDWARD RUSCHA

1 9 6 4

[4]

THE SUNSET STRIP

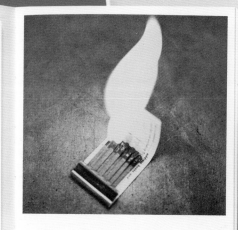

N.W. corner of Canon Dr. & Park Way

THIRTYFOUR

PARKING

LOTS

Parking Square underground lot, 5th & Hill

[5]

[9]

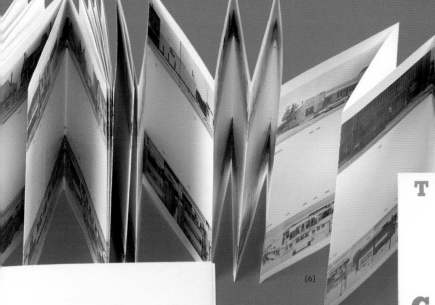

[6]

TWENTYSIX

GASOLINE

STATIONS

BOB'S SERVICE, LOS ANGELES, CALIFORNIA

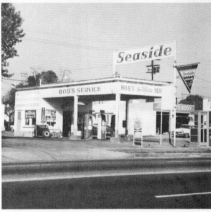

A FEW
PALM
TREES

EDWARD RUSCHA

1971

[7]

[8]

SOME

LOS ANGELES

APARTMENTS

6565 FOUNTAIN AVE.

[10]

Records

[11]

Sunset Plaza Drive

ENDING WEST, SOUTH SIDE, SUNSET PLAZA DRIVE JULY 8, 1973

ENDING WEST, SOUTH SIDE, SUNSET PLAZA DRIVE JUNE 5, 2004

TRAVELING EAST, NORTH SIDE, SUNSET PLAZA DRIVE JUNE 5, 2004

Sunset Plaza Drive

TRAVELING EAST, NORTH SIDE, SUNSET PLAZA DRIVE JULY 8, 1973

[12]

5800 W. Cazaux Dr., Hollywood

[13]

[14]

BUSINESS CARDS

BY
BILLY AL BENGSTON
AND
EDWARD RUSCHA

1 9 6 8

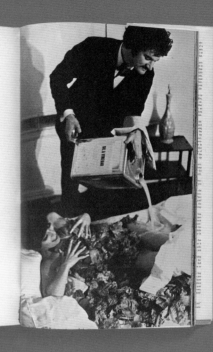

[18]

[17]

© COPYRIGHT 1972 BY EDWARD RUSCHA

[15]

ROYAL
ROAD TEST

Between 2886 & 2922 Hollyridge Dr., Hollywood

[18]

BABYCAKES

[16]

CHRISTOPHER RUSSELL

(American, b. 1974)

GRFALWKV, 2013

Careening between images of impossible beauty and others of abject decay, *GRFALWKV* presents a meditation on ambition, mortality, and the precarious balance of everyday life. The text and images are meticulously handmade and hand drawn. The work is organized into five stylistically distinct sections. "The Antichrist" (subtitled "A Cinematic Genre Jumbled in Memory") presents a poem compiling imagery from Hollywood films such as *The Omen* against a background of silhouetted wild animals and proliferating leaves. "The Sublime," set against a hazy spray-painted void, imagines apocalypse as the ultimate aesthetic achievement: "the awe of art appreciation, faculties fading against a wave of heat and a golden hue." "World War Three" imagines gruesome scenes from a nuclear wasteland presented alongside shadowy outlines of castles pierced by angular collaged intrusions in gold. The book's longest chapter, "Dead Art Star," tells a dystopian story of art world success, with the antihero staging his own demise as a final perfect picture. Ornate floral designs reminiscent of William Morris wallpaper run throughout this section, as do Rorschach-style collisions of textual fragments and their mirror images.

The book's (anti)climax, "Some Places," presents textual descriptions of four tattered landscapes, gritty settings for real or potential trauma. The texts here sit within jagged fields of white that rupture an otherwise uniform black-and-white floral pattern. An epilogue presents a text on bodily decomposition that notes: "In the mechanics of decay, science insists on fate, the predictable progress of decomposition. Rot is just destiny absent of spiritual resolve." Despite the assertively Gothic tendencies of Russell's text, the book grapples with beauty, evident in its handmade details and abundance of decorative imagery. Text and image form counterpointing extremes, leaving us to search for balance within a world bounded by impermanence, death, and decay. (GP)

GRFALWKV

Dead
Art
Star

BETYE SAAR

(American, b. 1926)

Hand Book, 1967

Text by Beverly Gleaves, David Ossman, and
Pat Ryan; Xerox work by Gail Gehring

Ideas about the power of hands flow from and
amplify the simple title of this work. Saar, who
began her artistic career as a printmaker, under-
stands the importance of applying pressure to
create an image; she likewise knows the significance
of extending a hand, pressing the flesh. Her ocher-
brown book is illustrated with hands that display
gestures signaling friendship, peace, and curses
across cultures—the language of fingers raised
or curled into the palm. Hands are scrutinized by
fortune-tellers, who use them to describe personal-
ity types and talents and forecast the future. Books
are read by holding them in our hands; indeed,
the meaning of *manual,* as in a handbook or guide,
comes from *manus*, "hand" in Latin. While neatly
encompassing the complex relationship of body
and book, this *Hand Book* does not bear an entirely
positive message: the final hand here is depicted
with a raised middle finger around which is coiled
a snake. (MR)

CRY:
pox pox pox
a curse on you!

HAND:
gesturing, quivering,
two fingers outstretched,
pointing, jabbing.

THEN:
a witches brew
seal a fate,
end taboo.

Beverly Gleaves

The Palm of Love

Betye Saar

CAROLEE SCHNEEMANN

(American, b. 1939)
Parts of a Body House Book, 1972
Cullompton, UK: Beau Geste Press

Parts of a Body House Book shuns a rigid structure. It includes an eclectic mix of notes, sketches, rubber stamps, stencils, and photographs. The index consists of overprinted images to be found within its pages, and the book's contents must be deciphered from a cacophony of visual information.

The book collects material related to works produced by Schneemann in the 1960s and early 1970s, when she became known for her transgressive performance and body art. There are sketches for the 1965 silent film *Fuses*, which contains scenes of lovemaking between the artist and her partner at the time, the composer James Tenney, observed by their cat Kitsch. A sheet of tissue paper with a drop of menstrual blood is a reference to her 1972 *Blood Works Diary*, which recorded the totality of one menstrual cycle. The artist's *Sexual Parameters Survey* documents women's experiences with their sexual partners.

Parts of a Body House Book was printed while Schneemann was living in London. The artist took regular trips to Devon to work with the Beau Geste Press, an experimental artists' printing community founded by Martha Hellion, David Mayor, and Felipe Ehrenberg (p. 80), among others. Schneemann described the experience of being at the press:

> Upstairs in the old farmhouse, Felipe churning Beau Geste. Rain streaming wind from the sea emerald green grass doesn't snow in winter gulls flying cows mooing not enough paraffin heaters cold sorting turning pages typing proof reading painting drawing rolling cigarettes coffee in Dundee marmalade jars the cats smiling rain Chris cuts minute stencils Madeleine typing "Missing Gender" Martha cooking tamales David Mayor collating Anthony making his events book. This house reminds me (& Kitsch) of another country house. Felipe says, we spend our lives trying to find a place like this we can miss later.

(ZG)

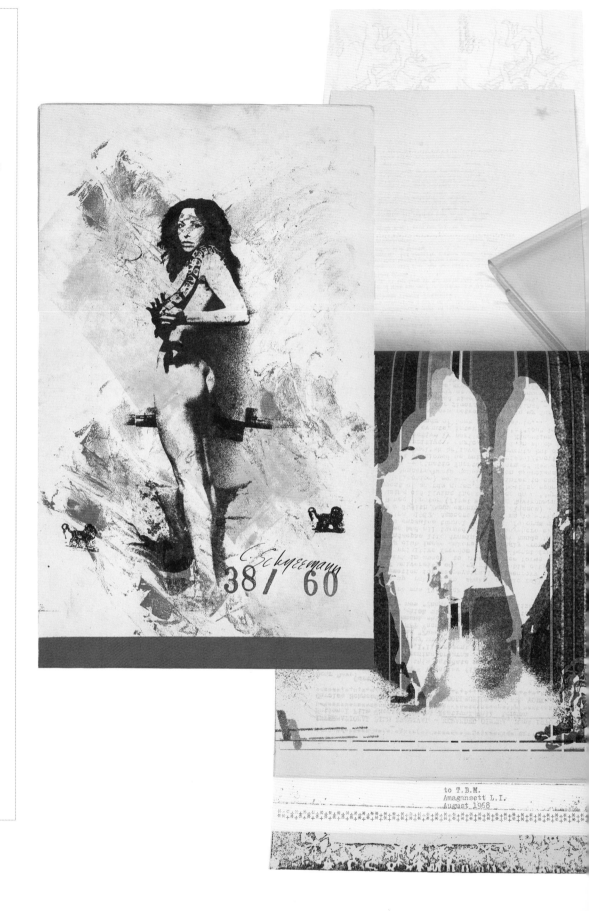

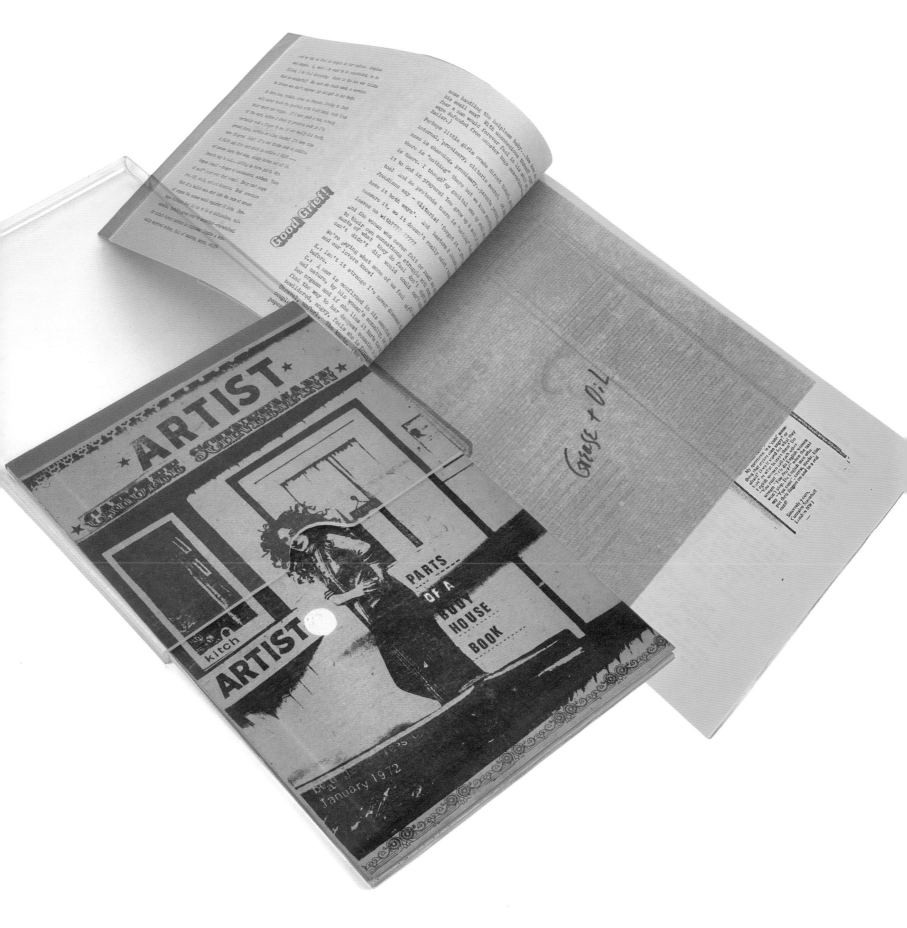

THAMOTHARAMPILLAI SHANAATHANAN

(Sri Lankan, b. 1969)
The Incomplete Thombu, 2011
London: Raking Leaves

In his introduction to this work, Shanaathanan states:

> The contents of this file provide records of properties and lands belonging to Tamil-speaking citizens prior to single or multiple displacements from their homes. The enclosed documents (1–80) are made up of three related elements: ground plans of houses drawn from memory by displaced civilians (with interview notes on reverse), architectural renderings of collected ground plans, and dry pastel drawings made in response to all of the above. Those interviewed were displaced from Jaffna and the surrounding area during the civil conflict in Sri Lanka between 1983 and 2009.... Winslow's Tamil dictionary, also called the Maanippaay dictionary, defines Thombu (Thoampu) as a public register of lands. The word Thombu is derived from the Greek word *tomos*, meaning a section, most likely of papyrus, which gave rise to the Latin word tome or large book.

(GP)

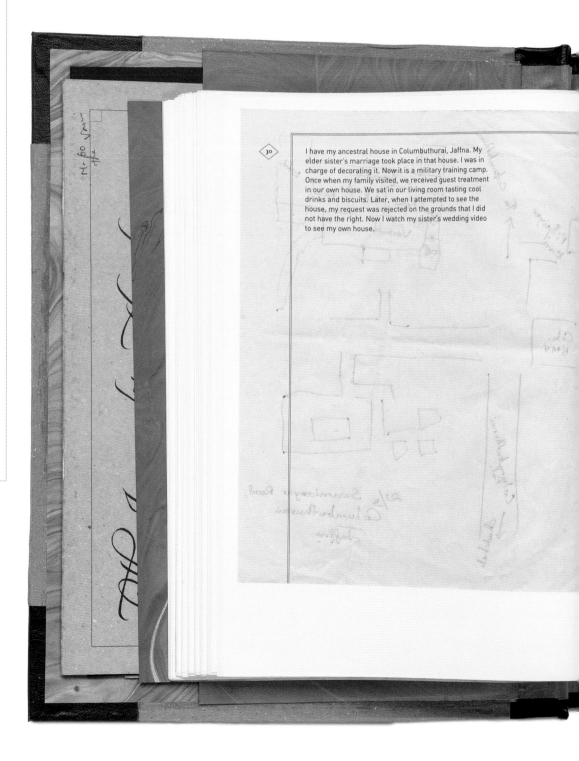

30 I have my ancestral house in Columbuthurai, Jaffna. My elder sister's marriage took place in that house. I was in charge of decorating it. Now it is a military training camp. Once when my family visited, we received guest treatment in our own house. We sat in our living room tasting cool drinks and biscuits. Later, when I attempted to see the house, my request was rejected on the grounds that I did not have the right. Now I watch my sister's wedding video to see my own house.

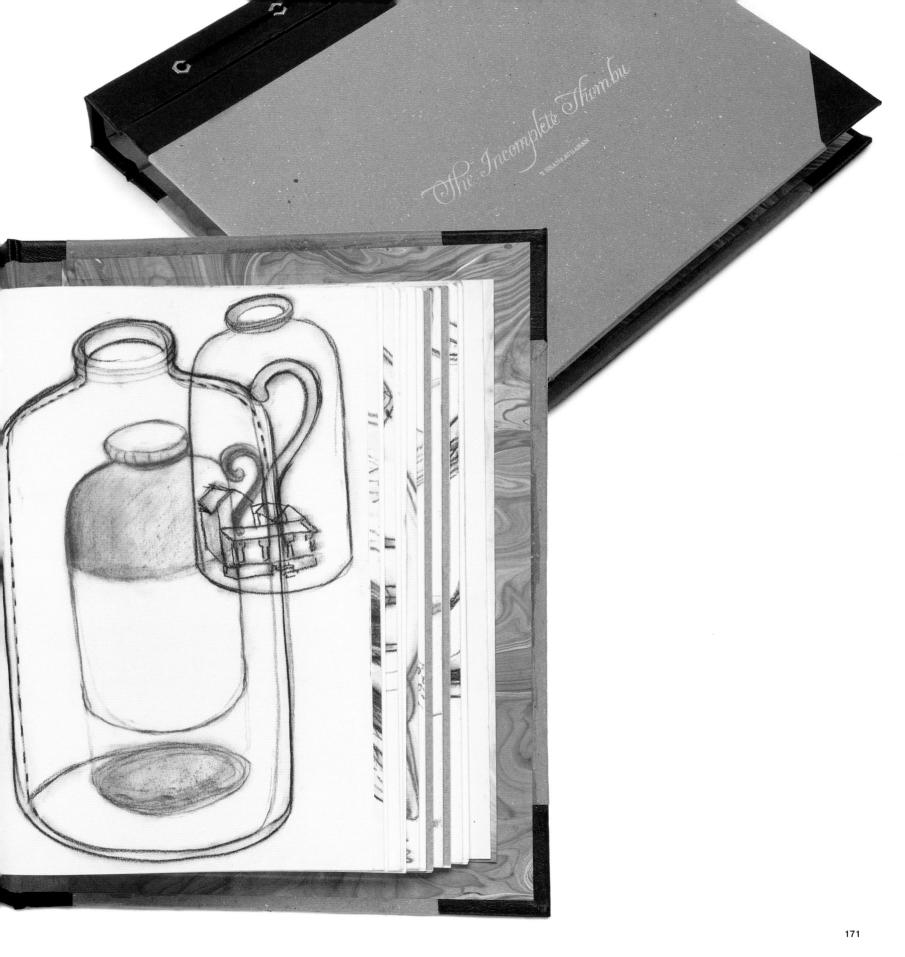

ALEXIS SMITH

(American, b. 1949)

Untitled book on the theme of Sherlock Holmes, 1971

Given her attention to the mysteries and minutia of everyday life, it is no surprise that Alexis Smith makes books from the same mundane sources she draws on for her larger pieces and installations, assembling and collaging them into possible narratives. Putting a little drama into the mix, this work is like a dossier; it holds an enclosure with a photograph—an original film still from a 1932 movie—and is filled with individual loose sheets that include excerpts of texts by Arthur Conan Doyle. Instead of a composed piece, Smith gives us clues to assemble. Indeed, these pieces of evidence are like those from which we construct our own personal narratives, some boring, some strange and tantalizing, most extremely enigmatic—like those used by the famous crime solver Sherlock Holmes. (MR)

June 6, 1932

Japanese readers who hope and trust that TIME readers will show every respect to His Majesty have made the following request: let copies of the present issue lie face upward on all tables; let no object be placed upon the likeness of the Emperor, shown in his sacred enthronement regalia.

BARBARA T. SMITH

(American, b. 1931)

[1] *Coffin: Hokusai's Wave*, 1965–66
[2] *Coffin: Time Piece, Pink Rose*, 1965–66
[3] *Coffin: Printed Matter*, 1965–66

Smith's thirty-two-volume Coffin series documents the artist's innovative experimentation with photocopying in the early years of the technology. After being "politely rejected" by a printer in Los Angeles when she wished to make a lithograph, Smith leased a Xerox 914 and installed it in her dining room. She placed a range of objects—fabric, photographs, found objects, drawings—on the glass plate of the Xerox machine, finding ways to narrate stories by manipulating, repeating, and distorting her images. Smith's use of her own body to explore the roles of women in visual culture and motherhood are particularly arresting. She played with different papers and acetate sheets and experimented with die cutting and perforation.

Formats of the collected Coffin books vary from a bureaucratic-looking spiral binding to the accordion folds of the book called *Hokusai's Wave*, which allow for the gradual revelation of the many blue paper "waves" and nod to one of the masters of the ukiyo-e print and to Japanese screens. *Oh! Those Leopard Skin Bikinis* is an accordion-fold book upholstered with plush black vellum, suggestive of a folding screen one might find in a dressing room—an intentional play on issues of publishing and privacy. While photocopying is usually associated with proliferation, Smith's Coffin series exists in an edition of one, suggesting the volumes were produced as personal works and not for public distribution. (ZG)

[1]

[2]

KEITH A. SMITH

(American, b. 1938)
Book 91, 1982
Barrytown, NY: Space Heater Multiples

In contrast to those casting their artists as star per-
formers, some books are enigmatic to the point of
anonymity, offering no clues as to author or subject.
A string book produced in an edition of 50, *Book 91*
deals with its material and structure in the purest
fashion. This is a book about the activity of read-
ing, although without text or images; it is all form,
producing a beguiling awkwardness that beckons,
then disorients. What could be frustrating in fact
becomes calming as we leaf through the pages.
The book's structure enforces slow progress through
the pages; we experience the added sensory com-
ponent of noisiness, the sound of cord grating as
pages are turned. There is a bit of deliberate trouble
as the strings stick. By placing the cords in unex-
pected places—not sewn into the binding but run-
ning through holes in the pages—Smith teaches us
implicitly about the structure of books. It is as if we
have been ensnared by the book, like a difficult but
beloved friend. What makes the viewer respectful
and attentive is the elegance of the book's sculp-
tural quality—nothing more, nothing else to distract
or detract from our appreciation of the physical
book. (MR)

"I love my love with a capital T. My love is Tender and True.
I'll love my love in the barley fields when the thunder cloud is blue.
My body crumbles beneath the ground but the hairs of my head will grow.
I'll love my love with the hairs of my head. I'll never, never let go.
Ha! Ha!
I'll never, never let go."

The hair sang soft, and the hair sang high, singing of loves that drown
Till he took his scythe by the light of the moon, and he scythed that sin
Every hair laughed a lilting laugh, and shrilled as his scythe swept thr
"I love my love with a capital T. My love is Tender and True.
Ha! Ha!
Tender, Tender, and True."

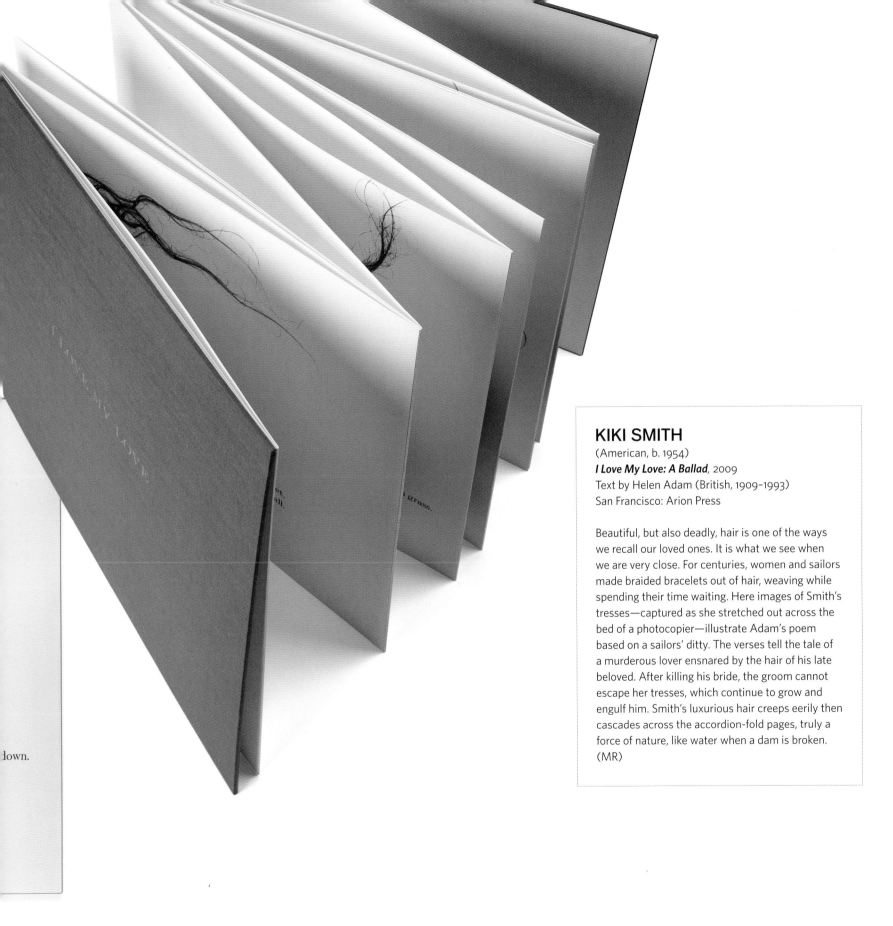

KIKI SMITH
(American, b. 1954)
I Love My Love: A Ballad, 2009
Text by Helen Adam (British, 1909–1993)
San Francisco: Arion Press

Beautiful, but also deadly, hair is one of the ways
we recall our loved ones. It is what we see when
we are very close. For centuries, women and sailors
made braided bracelets out of hair, weaving while
spending their time waiting. Here images of Smith's
tresses—captured as she stretched out across the
bed of a photocopier—illustrate Adam's poem
based on a sailors' ditty. The verses tell the tale of
a murderous lover ensnared by the hair of his late
beloved. After killing his bride, the groom cannot
escape her tresses, which continue to grow and
engulf him. Smith's luxurious hair creeps eerily then
cascades across the accordion-fold pages, truly a
force of nature, like water when a dam is broken.
(MR)

BUZZ SPECTOR

(American, b. 1948)

[1] *Page 39, for Jean Brown*, 1985
[2] *Marcel Broodthaers*, 1990

Violence done to books is difficult to defend, but it is also a highly effective attention-getting device—especially if the victim is a revered cultural object. Ripped and slashed pages and obscuring applications of paint are some of Spector's signature techniques in creating his altered volumes. His book-objects play on and often deny our impulses to enjoy browsing and settling down to read. While Spector has written wonderfully insightful essays about artists' books and reading, many of his projects belie a love/hate relationship with books and the audience of readers and viewers.

With its sheared, oblique wedge of pages, Spector's *Page 39* beckons seductively: an elegantly sculpted work of paper. Created for the collector Jean Brown, Spector methodically tore off the pages of John Cage's *Silence: Lectures and Writings*[9] to form an illegible work on paper.

For *Marcel Broodthaers,* Spector took a copy of an exhibition catalogue (published in 1990 by the Walker Art Center in Minneapolis) on the titular artist and coated its torn pages with gesso—the material painters have used for centuries to prime their canvases. Impossible to read, the result is a beautiful ruin of a book on the life and works of Broodthaers. (MR)

[1]

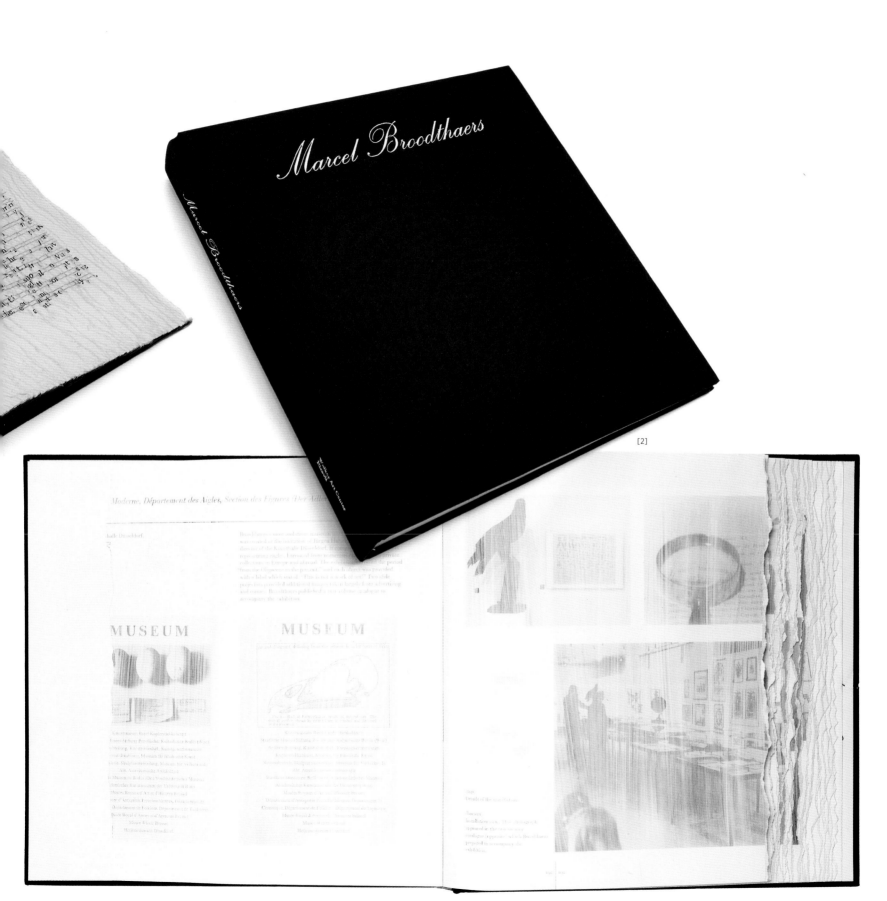

[2]

MIKA TAJIMA

(American, b. 1975)
Negative Entropy, 2015
Paris: Three Star Books

A book can begin with a word or an image, but Mika Tajima's *Negative Entropy* originated with a sound— or, to be more precise, with a whole set of sounds: machines clanging, vats opening and closing, looms weaving, spools of thread winding and unwinding. These are the noises you might hear in industrial textile production of the sort that became one of the principal drivers of the Industrial Revolution. Tajima made audio recordings in a number of textile factories in Pennsylvania, holdouts against globalization and the export of manufacturing to other parts of the world. The recordings were translated into digital spectrograms, which were in turn used as designs for weavings produced on Jacquard looms, which cover the slipcases of these books.

The recursiveness of the project continues with the contents of the first four volumes of this set, each of which portrays a textile site, with color photographs of the factories and their machines. Meanwhile, the last volume represents the New York University Data Center, a descendant of the industrial automation developed in textile mills— especially Jacquard looms, early precursors of computer programming that operate via punch cards. Because no photography is allowed at the center, it is represented by Jacquard-card translations of digital photographs and by color spectrograms derived from audio recordings made at the Data Center—the same type of patterns found on the slipcase fabric (and also in Tajima's series of paintings of the same title). In this way Tajima highlights the threads running from the industrial past to the digital present. (JT)

BETH THIELEN

(American, b. 1953)

[1] *Sentences... Words Spoken in Prison to an Artist: A Mono-Print Pop-Up Book Sculpture*, 1990
[2] *Why the Revolving Door: The Neighborhood, the Prisons*, 1992

Filled with looming angels and nightmarish creatures, these apocalyptic pop-up books contain vignettes of desolate characters abandoned to life on the street or, even more sadly, wasting away in prison. Arresting and not easily forgotten, Thielen's disturbing book-sculptures, fashioned from cut paper and depicting corporeal and emotional damage, could almost be seen as representations of splits in the social fabric. The pop-up, a source of wonder in children's books, here depicts the world of homelessness in jagged shapes that rise up from the page and lead us to question why we do not see these people and their forlorn predicaments more clearly in our own streets.

Describing her work with women in prison, Thielen wrote of her desire to explore the implication of scars, both real and figurative. This led to an interest in gravity and in fear, physics and psychology. Gravity presses in from the outside—settling on shoulders, slowing walking, pulling lines down around the eyes and mouth. Paralleling these effects, Thielen's pages pull and drag as you move from one scene of fragmentary figures and ruined landscapes to another. The weight of fate closes off positive possibility, hope dissolving like Thielen's pop-up figures collapsing back into the page as they close, recoiling from her captions and the weary pathos of her images. (MR)

[1]

184

Inmate: "My mother died when I was ... holic, and my brother sexually abused me.... that sort of thing is ... ny of us here."

[2]

Officer: "I just look through them."

RICHARD TUTTLE

(American, b. 1941)
Early Auden, 1991
Text by W. H. Auden (British, 1907–1973)
San Francisco: Hine Editions

This is a book that transmits color and poetry, a gallery hung with miniatures illuminated by beautiful words. Ten accordion-fold pages unfurl in successive waves of color on fragile paper stock that doesn't actually support itself. Sugar-lift aquatint and hardground etchings by Tuttle are interspersed with small white windows that frame excerpts from poems written by Auden between 1929 and 1935 and selected by the artist. The crisp presentations of letterpress verse are small performances, inset amid a wash of luxurious colors and abstract patterns made by Tuttle's art—a perfect foil for Auden's crystalline language. (MR)

The doors swung back at last: success had been complete.
The formulae essential to salvation
Were found for ever, and the true relation
Of Agape to Eros finally defined:
The burghers hung out flags in celebration,
The peasants danced and roasted oxen in the street.

The new books upon the morning table, the lawns and the
 afternoon terraces!
Here are the playing-fields where he may forget his ignorance
To operate within a gentleman's agreement: twenty-two sins
 have here a certain license.

hostile capture
er's spring at corner;
e,
se where days are counted
t protect,

FISSURE

Photographs by Ian van Coller, Iceland 2014

IAN VAN COLLER

(South African, b. 1970)
Fissure: Iceland 2015, 2015
Bozeman, MT: Doring Press

Monumental glacial masses are the subject of this appropriately massive elephant folio, which becomes a kind of monument itself. Of this magnificent visual treatise van Coller writes: "Fissures are the dark, deep, narrow openings within a body, a separation of substance or belief that was once an integrated whole. These clefts expose intimate, subterranean layers that were previously concealed from view, and seem to promise to reveal secret interiors and greater truths within." The artist has allowed the sheer presence and immediacy of Iceland's glaciers to speak for themselves, his subtly colored images mapping the surface qualities of these icy clefts. The book's simple, elegant design—with its riveting full-bleed photographs perfectly printed on floppy, oversize sheets of paper—presents the beauties and fragilities of the earth's surface as well as a subtle moral: ice is still alive and well in Iceland as long as it's not disturbed by human presence. (MR)

ERICA VAN HORN
(American, b. 1954)
Envelope Interiors, 1996
Norfolk, UK: Coracle Press

Van Horn comes from a feminist tradition that stresses the possibilities and intrinsic beauty of everyday materials. *Envelope Interiors* is a paper gallery of snippets of envelope linings (about to become a forgotten genre), which was crafted from an idea that Van Horn credits to the British artist David Bellingham. Van Horn drew the black frames first, noting that "I will be filling the spaces as I find the envelopes. I will stay inside the lines." Within their frames, the liners display varied patterns in determinedly pleasant hues. A startling number could be seen as Op Art. A rubber stamp notes the period—"Begun 29 Feb 1996…Finished 08 Jun 1996"—in which the artist extracted these small doses of visual stimulation from the quotidian activity of opening the mail. Van Horn notes that this work belongs as much to the worlds of scrapbooking, trainspotting, or stamp collecting as to the world of art. (MR)

CECILIA VICUÑA

(Chilean, b. 1947)
Sabor a mí, 1973
Cullompton, UK: Beau Geste Press

This collection of words and images was intended to celebrate the Popular Unity government of Salvador Allende in Chile (1970–73). In the light of later events, it became a reflection on a time of political crisis. The artist recalled: "A few days before we were to print the book the coup happened. Within two weeks I changed the book's contents so it would be a testimony of the Chilean tragedy."[10] The book's dual status—as celebration and testimony—was bracketed by two momentous events: a failed military coup against Allende's government in June 1973 and the successful coup of that September, which led to the death of the celebrated socialist leader. Mimeographed at the Beau Geste Press, it contains a foreword by Felipe Ehrenberg, one of the press's founders (p. 80), which characterizes *Sabor a mí* (Taste of me) as "the very first howl of pain to emerge from the rubble under which Chile's conscience lies stunned."

 Throughout the book, fragile-looking objects are reproduced alongside writings that refer to the political situation. These *precarios*, as the artist calls them, are assembled from organic materials or trash, such as feathers, string, cloth, wood, or plastic. Texts load the ghostly images with meaning: "This is the blood of the workers assassinated by the fascists of 'Fatherland & Freedom.' It's in carbon paper so that their pain is multiplied…so that all can surge in indignation against sedition." (ZG)

SABOR A MI
cecilia vicuña

BILINGUAL EDITION
EDICION BILINGUE

BEAU GESTE PRESS
England – Latin America

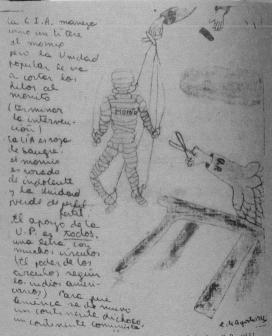

The CIA pulls the strings of the puppet (mummie), but U.P. will cut the strings. The CIA is red (blood) the mummie pink (indole nce) and Unidad Popular is green (fertile). 2 de Agosto 73

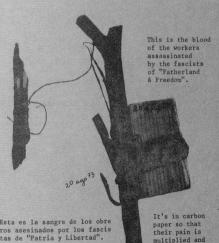

This is the blood of the workers assassinated by the fascists of "Fatherland & Freedom".

Esta es la sangre de los obre ros asesinados por los fascis tas de "Patria y Libertad". Están en papel calco para que su dolor se multiplique en lo s demas y cada uno lo sienta como su propio dolor, levanta ndose así en indignación cont ra la sedición.

It's in carbon paper so that their pain is multiplied and everybody can feel it as their own pain, so that all can surge in indig nation against se dition.

KARA WALKER

(American, b. 1969)

Freedom: A Fable, 1997

Pasadena, CA: Peter Norton Family
Christmas Projects

In the eighteenth and nineteenth centuries, silhouettes of cutout paper were created as keepsakes; often framed, they were treasured along with locks of hair and baby clothes as tokens of remembrance. Employing this seemingly simple and crafty medium, Walker draws our attention to unusual details, and we suddenly see troubling elements—less cut and composed than hacked and horrid. History is almost always her subject, often a received narrative that takes a U-turn.

Subtitled "A Curious Interpretation of the Wit of a Negress in Troubled Times," this pop-up book was commissioned and sent out as a Christmas present by the Peter Norton Family in 1997. Evoking eighteenth-century paper theaters that reduced figures and landscapes to two dimensions, Walker's book, with its receding layers of paper, plays with perspective, distance, and activity. Staging content across the spreads, she allows us to turn the pages to make figures move, like paper dolls or a game; the scenes appear and disappear theatrically. Histories unfold, then go back on the shelf for another day. In a final twist we remember that in contemporary usage the silhouette is not only a paper craft but also, when appearing as a full-size figure, used for target practice. (MR)

"This ship, with its uncertain destination is much like this woman's sex," she begins, pointing to a spot just below her navel. "For, wherein lies the potential for many things, and yet they are all conjecture, fantastic ideals for our new future set up by right-thinking men and their well-meaning wives. But this sex, despite all outside expectations, no matter the damage done to it previous or present, has quite the will of its own, creating juices where at first there were none and creating ease and vitality from the same brew.

"This woman's body is like our history, starting from places of darkest mystery and capable of bringing to light New Worlds. The place between," her hands drifted down and merge into a V pulling curled calico taut over her thighs, "our ancestors filled with the murky slime of death.

"And our history is now like the death of the father, whose death we fear more than our uncertain lives. Our father, that peculiar institution, has left us here to rebirth our own bodies without benefit of conflict, love or land.

"Is this a rebirth, or is this is a slow death for which one can only seek life's blood - although we know not whose? This woman's ship-shaped sex casts a wide net, to incriminate or absolve all that inhibits our rebirth. This ship will swallow us and regurgitate our remains in some new form. We shall don Liberty's black charms, our bodies are reborn at the hour of our demise."

...ato

New World.

In it she knows she need not fear an insurrection. "Why, surely my people understand that my knowledge of people in opposition and their operation in America will make me great."

She thinks.

She has taken to referring to these unknown Africans as her people. She would like to claim ownership, such-like, but with undying devotion that then I'll work on the White people as well!"

Preface

The pages of this book are highly inflammable
and constitute a fire hazard. The book has a shelf
life of approximately four years after which time
it is subject to spontaneous combustion.

This warning serves to release artist and
publisher from any liability arising from hazards
contained herein.

Preface

The pages of this book are soluble in water.
After being dissolved, the solution may be used to
extinguish any fire generated by Volume I.

ROBERT WATTS
(American, 1923–1988)
S.O.S., 1976

Watts's *S.O.S.* consists of two slim bound volumes
that are entirely blank save for a preface in each:
"The pages of this book are highly inflammable and
constitute a fire hazard. The book has a shelf life
of approximately four years after which time it is
subject to spontaneous combustion" (Volume I);
and "The pages of this book are soluble in water.
After being dissolved, the solution may be used to
extinguish any fire generated by Volume I" (Volume
II). Taken as a whole, *S.O.S.* is perhaps not so much
an artist's book as it is an invitation to participate
in an act of faith. If we take Watts at his word, then
Volume I is a time bomb, ready to burst into flames
(after 1980, apparently) and destroy the library in
which it sits. In this scenario, Volume II's supposedly
water-soluble contents provide little comfort, as one
rarely fights fire by waiting for books to dissolve in
water. Yet these volumes also propose a system of
opposing elements and counterbalancing opinions,
and in this sense they point toward the essence
of what books can do. After all, ideas have been
known to spread like wildfire, and books are often
the containers for those ideas. Yet even the most
combustible ideas have been known to be calmed
by alternative viewpoints and opposing modes of
logic. This is the eternal drama of discourse that lies
in wait in every library—preserved, one hopes, in a
room that is both cool and dry. (GP)

WILLIAM WEGMAN

(American, b. 1943)
Field Guide to North America and to Other Regions,
1993
Venice, CA: Lapis Press

Not one of those old-fashioned guidebooks that tell you where to go and what to see, this work is more like a souvenir pillow filled with pine needles to remind you of the forest after you've returned from vacation. One of the last books published by Lapis Press, established by the California artist Sam Francis, this box of photographs, maps, and drawings is ostensibly about camping in the forests of Maine. Wegman's sincere and sensitive Weimaraners make an appearance here, wandering through the woods wearing L. L. Bean outfits that match the book's blanket-like inner wrap in the classic buffalo-check wool of Maine Guide shirts. The seemingly goofy imagery actually makes an important point about how we take our culture with us when we return to nature—and how we sometimes take so much nature with us when we leave that nothing is left. On one of the pages of this collection Wegman wrote: "Man is doing all he can at an alarming rate to destroy the environment. In his vain attempt in making products that will make her life more comfortable he is rapidly using up her natural resources." (MR)

BOY
1 OLD FASHIONED TENNIS RACQUET

2 AN OAR
LITTLE

3 NUT

AGAIN 4 WISH
guitar

5 OLD WOODEN WHEEL

6 WOOD PLANE

7 THIS PART OF SAW

WAS
8 BUCKET

9 SIGN
I

THEN 10 BOX

11 WOULD BE HAPPY
1 INCH PLYWOOD

12

LAWRENCE WEINER

(American, b. 1942)

And/Or: Green as Well as Blue as Well as Red, 1972

London: Jack Wendler

From a distance one might mistake Weiner's Conceptual art book for a more famous "little red book," *Quotations from Chairman Mao Tse-Tung* (1964), which was widely distributed by the Chinese Communist Party until Mao's death in 1976. Though Weiner has never explicitly acknowledged the connection, *And/Or: Green as Well as Blue as Well as Red* nonetheless has a clear egalitarian intent, aiming to subvert the elitism of the art world with a complete work of art that could be cheaply produced and widely distributed without the need for collectors, galleries, or museums. The book consists of a series of simple phrases or propositions for artworks that we may complete in our mind. For example, one page says, "green as well as blue as well as red," which is not only a list of colors but also a prescription for an image: you might envision a red barn on a green field against a blue sky, or you might picture the most fantastical abstraction that has ever been imagined. Other prescriptions—"red over and above green over and above blue" or "unrelated to red; unrelated to blue; unrelated to green"—allow you to imagine increasingly complex scenarios. Even though the book itself contains no illustrations whatsoever, nor even any color aside from the gleaming red of its cover, it engages us in the deepest forms of aesthetic and philosophical contemplation. (GP)

GREEN AS WELL AS BLUE AS WELL AS RED

LAWRENCE WEINER

NOT BLUE AS WELL AS GREEN

(OF) GREEN IN RELATION TO RED

NOT BLUE AS WELL AS GREEN

4. IN RELATION TO

OF GREEN IN RELATION TO RED

XU BING

(Chinese, b. 1955)

An Introduction to Square Word Calligraphy,
1994–96

Xu Bing is well known for his installations, but the essence of his complex thinking about how words, books, and scrolls express culture can be found in this apparently simple and quite funny book. His wittily crafted "square word calligraphy" introduces Westerners to visual reading and demonstrates how Chinese characters forgo the awkwardness of building words from letterforms and then defining what they mean. In place of this laborious process, viewers immediately see what his words mean. Combining elements of the two writing systems, square word calligraphy redesigns the English alphabet in such a way that it seems like we can read Chinese.

This work points out that Chinese pictograms accommodate ideas and present them in ways that Western alphabetical schemes do not. Where Western languages see text and image as separate categories of knowledge, text *is* image in Chinese. In the calligraphy traditions of China, personal styles of presentation further refine expressiveness and meaning. A favorite example of the subtleties of Chinese language is friends in conversation writing a character in order to clarify their meaning. Xu Bing politely does this for us in this mock manual, which includes practice sheets and emphasizes the physicality and performative nature of Chinese characters for those who do not know Chinese. His made-up characters help us to recognize that the embedded meanings in letterforms, word shapes, and their presentation are as essential to understanding artworks as reading the characters on scrolls. (MR)

NOTES TO PLATE ENTRIES

1.	Filippo Marinetti and Tullio D'Albisola, *Parole in libertà futuriste: olfattive tattili termiche* (Rome: Edizioni futuriste di Poesia, 1932); and Tullio D'Albisola, *L'anguria lirica: lungo poema passionale,* preface by Filippo Marinetti, illustrations by Bruno Munari, commentary by V. Orazi (Rome: Edizioni futuriste di Poesia, 1933). Both books are held in the Getty Research Institute.

2.	Marta Werner and Jen Bervin, eds., *The Gorgeous Nothings: Emily Dickinson's Envelope Poems* (New York: Christine Burgin/New Directions in association with Granary Books), 2013.

3.	Dan Chiasson, "Out of Print: The Scrap Poetry of Emily Dickinson," *New Yorker* 92, no. 40 (December 5, 2016): 79.

4.	Ian Hamilton Finlay to Emmett Williams (1925–2007), ca. 1963, Jean Brown Papers, Getty Research Institute, 890164.

5.	Lewis Hyde, *The Gift: Imagination and the Erotic Life of Property* (New York: Vintage/Random House, 1983), xvii.

6.	Marshall McLuhan, *Understanding Media: The Extensions of Man* (New York: Macmillan, 1964), 208.

7.	Daniel R. Quiles, "My Reference is Prejudiced: David Lamelas's Publication," *ArtMargins,* Fall 2013, 31–62.

8.	From an interview with Mike Kelley, "By way of Norman Greenbaum: Raymond Pettibon interviewed by Mike Kelley," *Raymond Pettibon* (NY: Rizzoli, Regen Projects, 2013), 166.

9.	John Cage, *Silence: Lectures and Writings* (Middleton, CT: Wesleyan University Press, 1961).

10.	Paulina Varas Alarcón, Lucy Lippard, and Cecilia Vicuña, *Artists for Democracy: El Archivo de Cecilia Vicuña* (Santiago: Museo de la Memoria y Derechos Humanos, 2014).

LIST OF PLATES

All dimensions given as height by width by depth unless otherwise noted.

Dennis Adams (American, b. 1948)
Recovered—10 on 10, Adams on Garanger, 1993
Photograph by Marc Garanger (French, b. 1935)
Gelatin silver print, silk screen
25½ × 25½ in. (64.77 × 64.77 cm)
Brussels: Maîtres de forme contemporains
Edition of 10
GRI 2802-005
© Dennis Adams

Nobuyoshi Araki (Japanese, b. 1940)
Xerox Photoalbums (ゼロックス写真帖),
volume 1, 1970
Xerox print
8⅞ × 6 in. (22.54 × 15.24 cm)
Edition of 70
GRI 2831-530, vol. 1
© Nobuyoshi Araki

Lisa Anne Auerbach (American, B. 1967)
American Megazine #2: The Age of Aquarius,
2014
Inkjet
60 × 39 in. (152.4 × 99.06 cm)
Edition of 5
GRI 2018-S19
© Lisa Anne Auerbach

Tauba Auerbach (American, b. 1981)
Stab/Ghost, 2013
Four-color silk screen on Lexan, light-box table, Plexiglas hood, display "wave"
15¾ × 11⅞ in. (40 × 30.16 cm)
Paris: Three Star Books
Edition of 10
GRI 2016.M.18
© Tauba Auerbach. Courtesy Paula Cooper Gallery, New York

John Baldessari (American, b. 1931)
Throwing Three Balls in the Air to Get a Straight Line (Best of Thirty-Six Attempts), 1973
Offset photolithograph
Each print 9½ × 12¼ in. (24.13 × 31.12 cm)
Milan: Giampaolo Prearo/Galleria Toselli
Edition of 2000
GRI 93-B5447
Courtesy of John Baldessari

Mirosław Bałka (Polish, b. 1958)
Entering Paradise, 2003
Etching, letterpress
15⅞ × 15⅛ in. (40.32 × 38.42 cm)
Santa Monica, CA: Edition Jacob Samuel
Edition of 20
GRI 2636-450
© 2003 Mirosław Bałka

Ana Dias Batista (Brazilian, b. 1978)
Livro das escalas, 2015
Gridded paper and paper printed with stone pattern
10½ × 7½ in. (26.67 × 19.05 cm), three-dimensional element 5 × 5 in. (12.7 × 12.7 cm)
Edition of 18
GRI 2017-B132
© 2016 Ana Dias Batista

Mirella Bentivoglio (Italian, 1922–2017)
Litolattine, 1975
Eight flattened tin cans, steel, bottle cap
5½ × 4 in. (13.97 × 10.16 cm)
Edition of 2
GRI 2014-B1
Gift of Frances Pohl
© 1998 Mirella Bentivoglio

Jen Bervin (American, b. 1972)
The Dickinson Composites, 2010
Textile samples, color print
Each print and fabric sheet 11¼ × 15 in. (28.58 × 38.1 cm), booklet 11 × 8½ in. (27.94 × 21.59 cm), box 12 × 15½ × 1½ in. (30.48 × 39.37 × 3.81 cm)
New York: Granary Books
Edition of 50
GRI 2900-698
© Jen Bervin and Granary Books, 2010

Sandow Birk (American, b. 1962)
American Qur'an, 2005–14
Ink and gouache on paper
Each sheet 16 × 24 in. (40.64 × 60.96 cm)
Unique
GRI 2865-711
Promised gift of Strawn Bovee
Courtesy of the artist and Catharine Clark Gallery

Ken Botnick (American, b. 1954)
Diderot Project, 2015
Letterpress, photopolymer print
11½ × 7⅝ in. (29.21 × 19.37 cm)
St. Louis: emdash
Edition of 70
GRI 2015-B2
© Ken Botnick

Andrea Bowers (American, b. 1965)
Labor Is Entitled to All It Creates, 2012
Flyers and printed ephemera,
Colby poster stock
18 × 15 × 8 in. (45.72 × 38.1 × 20.32 cm)
Los Angeles: Susanne Vielmetter Los Angeles Projects
Edition of 2
GRI 3023-849
© Andrea Bowers

Terry Braunstein (American, b. 1942)
Shorthanded, 1995
Altered book, collage, mixed media
6⅞ × 5⅞ in. (17.46 × 14.92 cm)
Edition of 25
GRI 2016-B255
© Terry Braunstein

Terry Braunstein (American, b. 1942)
Shorted, 1996
Altered book, collage, mixed media
6⅞ × 5¼ in. (17.46 × 13.34 cm)
Edition of 25
GRI 2016-256
© Terry Braunstein

Terry Braunstein (American, b. 1942)
Shortsighted, 1996
Altered book, collage, mixed media
6⅞ × 5⅞ in. (17.46 × 14.92 cm)
Edition of 25
GRI 2016-B257
© Terry Braunstein

Marcel Broodthaers (Belgian, 1924–1976)
Un jardin d'hiver, 1974
Offset lithograph
6⅞ × 5⅞ in. (17.46 × 14.92 cm)
London: Petersburg Press; Brussels: Société des Expositions
Edition of 120
GRI 88-B3950
© 2018 The Estate of Marcel Broodthaers/ Artists Rights Society (ARS), New York/ SABAM, Brussels

Nancy Buchanan (American, b. 1946)
Fallout from the Nuclear Family, 1980
Paper ephemera, photographs
Each volume 11⅜ × 8⅞ in. (28.89 × 22.54 cm)
Unique
GRI 2011.M.14
Courtesy of the artist

Chris Burden (American, 1946–2015)
Coyote Stories, 2005
Etching, aquatint, digital prints
Each sheet 15 × 12½ in. (38.1 × 31.75 cm), box 16⅛ × 14⅛ in. (40.96 × 35.88 cm)
Santa Monica, CA: Edition Jacob Samuel
Edition of 18
GRI 2691-214
© Chris Burden/licensed by The Chris Burden Estate and Artists Rights Society (ARS), New York

Michele Burgess (American, b. 1960) and
Bill Kelly (American, b. 1948)
Repair, 2006
Letterpress, photo intaglio
10 × 7½ in. (25.4 × 19.05 cm)
San Diego: Brighton Press
Edition of 30
GRI 2857-852
© Brighton Press

James Lee Byars (American, 1932–1997)
Gold Dust Is My Ex Libris, 1983
Offset lithograph
6½ × 6½ in. (16.51 × 16.51 cm)
Eindhoven, Netherlands: Stedelijk
Van Abbemuseum
Edition of 500
GRI 1363-155
© The Estate of the Artist

James Lee Byars (American, 1932–1997)
The One Page Book, 1972
Offset lithograph
11½ × 8½ in. (29.21 × 21.59 cm)
Cologne: Michael Werner
Edition of 50
GRI 94-B10578
© The Estate of the Artist

James Lee Byars (American, 1932–1997)
TH FI TO IN PH, 1977
Gold cardboard box, crumpled black tissue
paper with gold printing
Approximately 8 × 6¼ × 3¼ in.
(20.32 × 15.88 × 8.25 cm)
Mönchengladbach, Germany:
Städtisches Museum
Edition of 330
GRI 90-B13573
© The Estate of the Artist

John Cage (American, 1912–1992)
Mushroom Book, 1972
Lithographs by Lois Long (American, 1918–2015)
Text by Alexander H. Smith
(American, 1904–1986)
Lithographs on opaque paper, letterpress on
translucent paper, denim-covered portfolio
Each sheet 22 × 15 in. (55.88 × 38.1 cm),
box 23 × 15¾ in. (58.42 × 40.01 cm)
New York: Hollanders Workshop
Edition of 75
GRI 95-B4036
© John Cage Trust

Sophie Calle (French, b. 1953)
La fille du docteur, 1991
Black-and-white photographs, calling cards
in glassine envelopes, imitation leopard skin
11⅜ × 8⅜ in. (28.89 × 21.27 cm)
New York: T. Westreich
Edition of 230
GRI 94-B2274
© Sophie Calle/ADAGP, Paris and ARS, New
York, 2018

Carolee Campbell (American, b. 1936)
The Persephones, 2009
Text by Nathaniel Tarn (American, b. 1928)
Sumi ink and salt, letterpress, goat parchment
Each sheet 14 × 9 in. (35.56 × 22.86 cm),
cover 14½ × 9⅝ in. (36.83 × 24.45 cm)
Sherman Oaks, CA: Ninja Press
Edition of 85
GRI 2874-300
© Carolee Campbell, Ninja Press

Ken Campbell (British, b. 1939)
Tilt: The Black-Flagged Streets, 1988
Letterpress, linocut, zinc, metallic dusting
Approximately 11½ × 8¾ in. (29.21 × 22.22 cm)
Edition of 80
GRI 91-B28967
© Ken Campbell

Augusto de Campos (Brazilian, b. 1931)
Colidouescapo, 1971
Planographic print
5¼ × 5¼ in. (13.34 × 13.34 cm)
São Paulo: Edições Invenção
GRI 92-B21562
© Augusto de Campos 1970

Ulises Carrión (Mexican, 1941–1989)
Arguments, 1973
Letterpress on colored paper
8⅞ × 6 in. (22.54 × 15.24 cm)
Cullompton, UK: Beau Geste Press
Edition of 200
GRI 91-B32329
© Juan J. Agius

Anne Carson (Canadian, b. 1950) and
Kim Anno (American, b. 1958)
The Mirror of Simple Souls, 2003
Letterpress, red walnut dye
St. Joseph, MN: One Crow Press (Literary
Arts Institute of the College of St. Benedict)
Edition of 5
GRI 2709-123
©Anne Carson and Kim Anno

Michael Cherney (American, b. 1969)
Twilight Cranes, 2008
Photographic print with chine collé, rosewood box
Box 10⅞ × 7⅜ × 5⅝ in. (27.62 × 18.73 × 14.29 cm)
Edition of 9
GRI 2789-113
Gift of the GRI Council
© Michael Cherney

Simon Cutts (British, b. 1944)
Fo(u)ndlings, 1978
Fifty exhibition checklist cards, twine,
cardboard box
1¾ × 1⅜ in. (4.45 × 3.49 cm), box 3⅝ × 2⅛ in.
(9.21 × 5.40 cm)
London: Coracle Press
Edition of 300
GRI 1367-840
© Coracle

Felipe Ehrenberg (Mexican, 1943–2017)
Pussywillow: A Journal of Conditions, 1973
Offset print on wrapping paper, corrugated
cardboard
8¾ × 6 in. (22.22 × 15.24 cm)
Cullompton, UK: Beau Geste Press
GRI 93-B2489
© 1973 Felipe Ehrenberg

Olafur Eliasson (Danish, b. 1967)
Your House, 2006
Laser-cut paper, cardboard box
10⅞ × 17 × 4¼ in. (27.62 × 43.18 × 10.80 cm),
box 11½ × 17¾ × 4½ in. (29.21 × 45.09 × 11.43 cm)
New York: Library Council of the Museum of
Modern Art
Edition of 225
GRI 2771-207
© Olafur Eliasson

Timothy C. Ely (American, b. 1949)
Hollow House, 2015
Drawing, watercolor, painted and gilded paper,
wood, embossed leather, wax
12⅜ × 9 in. (31.43 × 22.86 cm)
Unique
GRI 2017-B122
© Timothy C. Ely

Barbara Fahrner (German, b. 1940)
The Philosopher's Stone, 1992
Cardboard, steel pins, colored ink, pencil,
watercolor
Approximately 6 × 8 × 6 in.
(15.24 × 20.32 × 15.24 cm)
Unique
GRI 94-B18918
© Barbara Fahrner and Daniel E. Kelm

Hans-Peter Feldmann (German, b. 1941)
1 Bild, 1970
Offset lithograph
5½ × 3⅞ in. (13.97 × 9.84 cm)
GRI Harald Szeemann Papers, 2011.M.30,
series II, box 1178, folder 35
© 2018 Artists Rights Society (ARS),
New York/VG Bild-Kunst, Bonn

Hans-Peter Feldmann (German, b. 1941)
11 Bilder, 1969
Offset lithograph
3¾ × 3⅞ in. (9.53 × 9.84 cm)
GRI Harald Szeemann Papers, 2011.M.30,
series II, box 1178, folder 35
© 2018 Artists Rights Society (ARS),
New York/VG Bild-Kunst, Bonn

Hans-Peter Feldmann (German, b. 1941)
14 Bilder, 1971
Offset lithograph
4 × 5¾ in. (10.16 × 14.6 cm)
GRI Harald Szeemann Papers, 2011.M.30,
series II, box 1178, folder 35
© 2018 Artists Rights Society (ARS),
New York/VG Bild-Kunst, Bonn

Hans-Peter Feldmann (German, b. 1941)
45 Bilder, 1971
Offset lithograph
8⅛ × 8⅛ in. (20.64 × 20.64 cm)
GRI Harald Szeemann Papers, 2011.M.30,
series II, box 1178, folder 35
© 2018 Artists Rights Society (ARS),
New York/VG Bild-Kunst, Bonn

Ian Hamilton Finlay (Scottish, 1925–2006)
Poem with 3 Stripes, ca. 1963
Collage
8¾ × 8⅛ in. (22.23 × 20.64 cm)
Dunsyre, UK: Wild Hawthorn Press
Unique
GRI 2016-B265
Courtesy of the Estate of Ian Hamilton Finlay

Max Gimblett (New Zealander, b. 1935)
The Gift, 1992
Drawing, red linen clamshell box with pink
and orange ribbon closure
Each sheet 6⅛ × 4¼ in. (15.56 × 10.80 cm),
box 6¼ × 5¼ in. (15.88 × 13.34 cm)
Unique
GRI 94-B6529
Gift of the artist
© Max Gimblett

Guillermo Gómez-Peña (Mexican, b. 1955)
and Felicia Rice (American, b. 1954)
*DOC/UNDOC: Documentado/Undocumented:
Ars Shamánica Performática*, 2014
Video by Gustavo Vazquez (Mexican, b. 1954),
text by Jennifer A. González (American, b.
1965), sound by Zachary James Watkins
(American, 1980)
Relief print, letterpress, DVD, compact disc,
clamshell box, aluminum case, mirror, electric
lights, wrestling mask, headphones, various
objects
Book 17⅞ × 11 in. (45.4 × 27.94 cm) closed
Santa Cruz, CA: Moving Parts Press
Edition of 65
GRI 2015-B6
© 2018 Felicia Rice and Moving Parts Press

Walter Hamady (American, b. 1940)
*Hunkering: the last gæbberjabb[296] number eight
and ix/xviths or aleatory annexations or odd bond-
ings or fortuitous encounters with incompatible
realities or love, anguish, wonder: an engagement
or a partial timeline of sorts or bait and switch or
finally, a pedagogical rememberance[27]*, 2005
Letterpress, marbled endpapers, collage,
rubber stamp
10⅜ × 7⅛ in. (26.35 × 18.10 cm)
Mount Horeb, WI: The Perishable Press
Edition of 108
GRI 2714-062
© MMV The Perishable Press Limited

Robert Heinecken (American, 1931–2006)
Time: 150 Years of Photojournalism, 1990
Altered magazine
10¾ × 8⅛ in. (27.31 × 20.64 cm)
Edition of 8
GRI 2915-341
© Robert Heinecken Trust

George Herms (American, b. 1935)
32 Palm Songs, 1967–71
Letterpress, plastic, cardboard
Each sheet 11 × 8½ in. (27.94 × 21.59 cm)
Edition of 32
GRI George Herms Papers, 2009.M.20, box 80,
flat file 6
© George Herms

Andrew Hoyem (American, b. 1935)
Flatland: A Romance of Many Dimensions, 1980
Text by Edwin Abbott Abbott (British,
1838–1926), introduction by Ray Bradbury
(American, 1920–2012)
Letterpress, watercolor, aluminum
14 × 7 × 392 in. (35.56 × 17.78 ×
995.68 cm) open
San Francisco: Arion Press
Edition of 275
GRI 1358-449
© 1980 Arion Press

Allan Kaprow (American, 1927–2006)
Echo-logy, 1975
Offset lithograph
12 × 8½ in. (30.48 × 21.59 cm)
New York: D'Arc Press
GRI Allan Kaprow Papers, 980063, box 26,
folder 9
Photos © Lizbeth Marano

Leandro Katz (Argentine, b. 1938)
Ñ, 1971
Offset lithograph
11 × 8½ in. (27.94 × 21.59 cm)
New York: Vanishing Rotating Triangle
Edition of 150
GRI 91-B26501
© 1970 Leandro Katz

Ines von Ketelhodt (German, b. 1961)
farbwechsel, 2011–13
Letterpress, photopolymer print, cellophane
16½ × 11½ in. (41.91 × 29.21 cm)
Edition of 33
GRI 2016-B234
© Ines von Ketelhodt

Anselm Kiefer (German, b. 1945)
Die berühmten Orden der Nacht, 1996
Gelatin silver print, cardstock, canvas, paint, ink
11¾ × 12⅜ × 2 in. (29.85 × 31.43 × 5.08 cm)
Unique
GRI 2818-250
© Anselm Kiefer

Susan E. King (American, b. 1947)
Treading the Maze: An Artist's Book of Daze, 1993
Spiral binding, photocopy, plastic, sticker
7⅜ × 8¼ in. (18.73 × 20.96 cm)
Rochester, NY: Visual Studies Workshop Press
Edition of 800
GRI 93-B15131
© Susan E. King

Peter Rutledge Koch (American, b. 1943),
Adam Cornford (British, b. 1950), and
Jonathan Gerkin (American, b. 1980)
Liber Ignis, 2015
Lead sheets, photogravure, letterpress, copper,
felt, linen thread
18 × 12 in. (45.72 × 30.48 cm), box 13⅞ ×
21⅜ × 2 in. (35.24 × 54.29 × 5.08 cm)
Berkeley, CA: Editions Koch
Edition of 25
GRI 2016-B66
© Peter Rutledge Koch

Michael Kuch (American, b. 1965)
Illuminations: An Acrostic Martyrology, 2014
Mezzotint, etching, watercolor
11⅜ × 9½ in. (28.89 × 24.13 cm), box 12⅜ ×
10⅛ × 1⅝ in. (31.43 × 25.72 × 4.13 cm)
Northampton, MA: Double Elephant Press
Edition of 40
GRI 2015-B5
© 2014 Michael Kuch

Monika Kulicka (Polish, b. 1963)
Drips Runs and Bleeds, 1999
Chlorophyll
13½ × 15⅜ in. (34.29 × 39.05 cm)
New York: John Gibson Gallery
Edition of 30
GRI 3023-893
© 1999 Monika Kulicka

LA Liber Amicorum, 2012
Mixed media
12½ × 19¼ in. (31.75 × 48.9 cm)
Unique
GRI 2013.M.8
Gift of Ed and Brandy Sweeney
Works shown on p. 120 by Prime; Blosm and
Petal: © Bretado and Zar Bejuane; Elika; and
Axis: © Axis 2012

Patricia Lagarde (Mexican, b. 1961)
Fantastic Island, 2011
Photogravure, cloth-covered board, wooden box
9⅝ × 14⅝ in. (24.45 × 37.15 cm),
box 10⅞ × 15⅝ in. (27.62 × 39.69 cm)
Mexico City: Escabarajo Gris Press
Edition of 5
GRI 2013-B3
© Patricia Lagarde

David Lamelas (Argentine, b. 1946)
Publication, 1970
Offset lithograph
8⅛ × 5⅞ in. (20.64 × 14.92 cm)
London: Nigel Greenwood
Edition of 1000
GRI 93-B4292
© David Lamelas

David Lamelas (Argentine, b. 1946)
Material relating to *Publication*, 1970
Holograph and typescript manuscripts,
some printed matter
Various dimensions
GRI 890233
Broodthaers: © 2018 Artists Rights Society
(ARS), New York/UG Bild-Kunst, Bonn
Darboven: © 2018 Artists Rights Society (ARS),
New York/UG Bild-Kunst, Bonn

Sol LeWitt (American, 1928–2007)
A Book of Folds, ca. 1978
Folded paper, ink, twine
6 × 5⅝ in. (15.24 × 14.29 cm)
Unique
GRI 87-B4320
© 2018 The LeWitt Esate/Artists Rights Society
(ARS), New York

Richard Long (British, b. 1945)
Papers of River Muds, 1990
Handmade paper with mud, poster,
board slipcase
14 × 11¾ in. (35.56 × 29.85 cm)
Los Angeles: Lapis Press
Edition of 88
GRI 90-B40114
© 2018 Richard Long. All rights reserved, DACS,
London/ARS, New York

Russell Maret (American, b. 1971)
*Interstices & Intersections or, An Autodidact
Comprehends a Cube: Thirteen Euclidean
Propositions*, 2014
Letterpress, goatskin, paper-covered boards,
cloth-covered clamshell box
13⅝ × 11 in. (34.61 × 27.94 cm) closed
Edition of 75
GRI 2015-B3
© Russell Maret

Annette Messager (French, b. 1943) and
Jean-Philippe Toussaint (Belgian, b. 1957)
Enveloppe-moi, 2013
Fifteen postcards, one photograph, ten pigment
prints, silk-screened cloth-covered box
Each print 14 × 11 in. (35.56 × 27.94 cm),
box 11¾ × 14⅝ in. (29.85 × 37.15 cm)
New York: Library Council of the Museum
of Modern Art
Edition of 100
GRI 2015-B1
Artwork © Annette Messager 2013
Text © Jean-Phillippe Toussaint 2013
Compilation © The Museum of Modern Art,
New York, 2013

Katherine Ng (American, b. 1964)
Banana Yellow, 1991
Photoengraving, cardboard
4 × 5 in. (10.16 × 12.7 cm)
Northridge, CA: Second Story Press
Edition of 25
GRI 91-B35776
© Katherine Ng

Katherine Ng (American, b. 1964)
Fortune Ate Me, 1992
Letterpress, cardboard, folded paper
Each cookie 1¾ × 3 in. (4.45 × 7.62 cm),
box 5 × 7 × 1½ in. (12.7 × 17.78 × 3.81 cm)
Northridge, CA: Second Story Press
Edition of 100
GRI 92-B26152
© Katherine Ng

Katherine Ng (American, b. 1964)
*A Hypothetical Analysis of the Twinkle in Stars:
(As Told by a Child to a Teacher)*, 1994
Folded and cut paper
3¼ × 3½ in. (8.26 × 8.89 cm) closed
Pasadena, CA: Pressious Jade
Edition of 100
GRI 1363-909
© Katherine Ng

Laura Owens (American, b. 1970)
Fruits and Nuts, 2011–12
Screen printing ink on newspaper
10½ × 7 in. (26.67 × 17.78 cm)
Los Angeles: Ooga Booga
Edition of 100
GRI 2997-959
© 2011–12 Laura Owens
Courtesy the artist; Gavin Brown's enterprise,
New York, Rome; Sadie Coles HQ, London; and
Galerie Gisela Capitain, Cologne

Clemente Padín (Uruguayan, b. 1939)
*Instrumentos/74: Mechanics Instruments
for the Control of the Information*, 1974
Photocopies, staples
6 × 4¼ in. (15.24 × 10.80 cm)
Montevideo: Ovum
GRI Jean Brown Papers, 890164, series 1,
Box 39
© 1974 Clemente Padín

Benjamin Patterson (American, 1934–2016)
ABC's, 1962
Collage
Approximately 12½ × 9½ in. (31.75 × 24.13 cm)
Unique
GRI Jean Brown Papers, 890164, series 1,
folder 40
© 1962 Benjamin Patterson

Raymond Pettibon (American, b. 1957)
Faster, Jim, 2002
Lithographs by Greg Colson (American, b. 1956), Francesca Gabbiani (Canadian, b. 1965), Scott Grieger (American, b. 1946), Eddie Ruscha (American, b. 1968), and Dani Tull (American, b. 1966); photograph by Todd Squires (American, b. 1973); silkscreens by Victor Gastelum (American, b. 1964)
Lithograph, silk screen, digital photographic print, paint on aluminum
18¼ × 15¼ in. (46.36 × 38.74 cm)
Venice, CA: Hamilton Press
Edition of 27
GRI 2608-310
© Raymond Pettibon
Courtesy Regen Projects, Los Angeles and David Zwirner, New York

Adrian Piper (American, b. 1948)
Three Untitled Projects [for 0 to 9]: Some Areas in the New York Area, 1969
Carbon typescript
3 vols., each 11 × 8½ in. (27.94 × 21.50 cm)
New York: 0 to 9 Press
GRI Lawrence Alloway Papers, 2003.M.46, box 13, folder 6
© Adrian Piper Research Archive Foundation Berlin

Markus Raetz (Swiss, b. 1941)
Notizbüchlein, 1972
Offset lithograph, spiral-bound notebook
4¼ × 3¼ in. (10.8 × 8.26 cm)
Lucerne: Toni Gerber und P.B. Stähli
Edition of 1500
GRI 2700-736
© 2018 Artists Rights Society (ARS), New York/ProLitteris, Zurich

Harry Reese (American, b. 1946) and Sandra Liddell Reese (American, b. 1947)
Heart Island & Other Epigrams, 1995
Text by James Laughlin (American, 1914–1997), wood engravings compiled by Jacques Collin de Plancy for the 1863 edition of *Dictionnaire Infernal*
Photopolymer print, letterpress
8⅜ × 5 in. (21.27 × 12.7 cm)
Isla Vista, CA: Turkey Press
Edition of 200
GRI 1372-890
© Harry Reese and Sandra Reese

Sue Ann Robinson (American, b. 1946)
Chisolm Hours, 1988
Mixed media
Approximately 14½ × 12 in. (36.83 × 30.48 cm), plus two prints each 15 × 11½ in. (38.1 × 29.2 cm)
Rochester, NY: Visual Studies Workshop
Limited edition
GRI 91-B35779
© Sue Ann Robinson and Visual Studies Workshop, 1987

Rachel Rosenthal (American, b. France, 1926–2015) and Daniel J. Martinez (American, b. 1957)
Soldier of Fortune, 1981
Silver gelatin print, letterpress, embroidered linen, portfolio with camouflage print
Each sheet 14 × 11 in. (35.56 × 27.94 cm), box 14½ × 12 in. (36.83 × 30.48 cm)
Los Angeles: Paradise Press
Edition of 25
GRI 95-B989
© Rachel Rosenthal Lifetime Trust

Dieter Roth (Swiss, 1930–1998)
Poemetrie, 1968
Clear plastic envelopes, dried substance (urine), plastic tubing, colored marker, particle-board box with metal brackets
10 × 6¼ in. (25.4 × 15.88 cm), box 11⅛ × 7⅝ × 7 in. (28.26 × 19.37 × 17.78 cm)
Cologne: Diter Rot u. Rudolf Rieser
Edition of 30
GRI 94-B19053
© Dieter Roth Estate
Courtesy Hauser & Wirth

Dieter Roth (Swiss, 1930–1998)
Poetrie, 1967
Clear plastic envelopes, Plexiglas, metal screws, substance (possibly cheese)
9⅝ × 5¾ × 3¼ in. (24.45 × 14.61 × 8.26 cm)
Edition of 7
GRI 94-B19053
Stuttgart: Edition Hansjörg Mayer
© Dieter Roth Estate
Courtesy Hauser & Wirth

Brian Routh (British, b. 1948)
Harry + Harry Kipper in Eh Pet, 1976
Construction paper, ink, watercolor
12¾ × 10¼ in. (32.39 × 26.04 cm)
Unique
GRI 2016.M.25
© 1976 Brian Routh

Ed Ruscha (American, b. 1937)
See Appendix p. 208

Christopher Russell (American, b. 1974)
GRFALWKV, 2013
Ink, spray paint, pressure-sensitive adhesive
23⅜ × 18½ in. (59.37 × 46.99 cm)
Unique
GRI 2016.M.7
© Christopher Russell

Betye Saar (American, b. 1926)
Hand Book, 1967
Text by Beverly Gleaves, David Ossman, and Pat Ryan, Xerox work by Gail Gehring
Relief print, Xerox print, hand-carved bookmark
10⅞ × 8⅛ in. (27.62 × 20.64 cm)
Edition of 300
GRI 2015-B7
© Betye Saar
Courtesy of the artist and Roberts Projects, Los Angeles

Carolee Schneemann (American, b. 1939)
Parts of a Body House Book, 1972
Designed by Felipe Ehrenberg (Mexican, 1943–2017)
Hand-cut stencil, heat stencil, electronic stencil, photocopy, photographs, 35mm film, plastic
13 × 8 in. (33.02 × 20.32 cm), box 13¼ × 8½ in. (33.66 × 21.59 cm)
Cullompton, UK: Beau Geste Press
Edition of 60
GRI 1381-613
© Carolee Schneemann
Courtesy Carolee Schneemann, Galerie Lelong & Co., and P.P.O.W., New York

Thamotharampillai Shanaathanan (Sri Lankan, b. 1969)
The Incomplete Thombu, 2011
Offset lithograph
12⅝ × 14 in. (32.07 × 35.56 cm)
London: Raking Leaves
Edition of 25
GRI 2018.B27
Courtesy of the artist and Raking Leaves

Alexis Smith (American, b. 1949)
Untitled book on the theme of Sherlock Holmes, 1971
Film still, collage
Each print 12 × 6 in. (30.48 × 15.24 cm)
Unique
GRI 2013-B12
© Alexis Smith

Barbara T. Smith (American, b. 1931)
Coffin: Hokusai's Wave, 1965–66
Xerox print, hand-embossed cover
9½ × 11¾ in. (24.13 × 29.85 cm)
Unique
GRI 2013.M.23
© Barbara T. Smith

Barbara T. Smith (American, b. 1931)
Coffin: Time Piece, Pink Rose, 1965–66
Xerox print, hand-embossed cover
9½ × 14¼ in. (24.13 × 36.19 cm)
Unique
GRI 2013.M.23
© Barbara T. Smith

Barbara T. Smith (American, b. 1931)
Coffin: Printed Matter, 1965–66
Xerox print, Plexiglass, Mylar
12½ × 10 × 1⅛ in. (31.75 × 21.4 × 2.84 cm)
Unique
GRI 2013.M.23
© Barbara T. Smith

Keith A. Smith (American, b. 1938)
Book 91, 1982
Linen cords, embossing
9⅞ × 14⅛ in. (25.08 × 35.88 cm)
Barrytown, NY: Space Heater Multiples
Edition of 50
GRI 94-B1617
© Keith Smith
Courtesy Bruce Silverstein Gallery, New York

Kiki Smith (American, b. 1954)
I Love My Love: A Ballad, 2009
Text by Helen Adam (British, 1909–1993)
Letterpress, offset lithograph
14 × 14 in. (35.56 × 35.56 cm) closed
San Francisco: Arion Press
Edition of 75
GRI 2931-044
© Kiki Smith
Courtesy Pace Gallery

Buzz Spector (American, b. 1948)
Page 39, for Jean Brown, 1985
Altered book
9½ × 7⅞ in. (24.13 × 20 cm)
Unique
GRI 92-B16536
© 1985 Buzz Spector

Buzz Spector (American, b. 1948)
Marcel Broodthaers, 1990
Altered book
10⅛ × 10⅛ in. (25.72 × 25.72 cm)
Edition of 10
GRI 93-B14739
© 1989 Buzz Spector

Mika Tajima (American, b. 1975)
Negative Entropy, 2015
Five volumes, digital Jacquard weaving, spiral binding
Each volume 13⅜ × 10¼ in. (33.97 × 26.04 cm), box 14 × 10½ × 5⅞ in. (35.56 × 26.67 × 14.92 cm)
Paris: Three Star Books
Edition of 12
GRI 2016-B243
© Mika Tajima

Beth Thielen (American, b. 1953)
Sentences… Words Spoken in Prison to an Artist: A Mono-Print Pop-Up Book Sculpture, 1990
Monoprint
12⅜ × 7⅞ in. (31.43 × 20 cm)
Edition of 10
GRI 92-B23667
© 1990 Beth Thielen

Beth Thielen (American, b. 1953)
Why the Revolving Door: The Neighborhood, the Prisons, 1992
Monoprint, pencil
11¼ × 8½ in. (28.58 × 21.59 cm)
Edition of 20
GRI 95-B116
© 1992 Beth Thielen

Richard Tuttle (American, b. 1941)
Early Auden, 1991
Text by W. H. Auden (British, 1907–1973)
Aquatint on translucent paper
12½ × 9 in. (31.75 × 22.86 cm)
San Francisco: Hine Editions
Edition of 80
GRI 91-B36406
© Richard Tuttle
Courtesy Pace Gallery

Ian van Coller (South African, b. 1970)
Fissure: Iceland 2015, 2015
Photobook
25⅝ × 19⅛ in. (65.09 × 48.58 cm)
Bozeman, MT: Doring Press
Edition of 5
GRI 2016-B384
© 2015 Ian van Coller

Erica Van Horn (American, b. 1954)
Envelope Interiors, 1996
Collaged envelopes
6 × 6⅛ in. (15.24 × 15.56 cm)
Norfolk, UK: Coracle Press
Edition of 9
GRI 1385-848
© Erica Van Horn

Cecilia Vicuña (Chilean, b. 1947)
Sabor a mí, 1973
Offset lithograph, mimeograph
7⅞ × 6⅜ in. (20 × 16.19 cm), plus one print
12¾ × 8¼ in. (32.39 × 20.96 cm)
Cullompton, UK: Beau Geste Press
Edition of 250
GRI 93-B15553
© Cecilia Vicuña
Courtesy of the artist and Lehmann Maupin,
New York and Hong Kong

Kara Walker (American, b. 1969)
Freedom: A Fable, 1997
Pop-up book
9⅜ × 8¼ in. (23.81 × 20.96 cm)
Pasadena, CA: Peter Norton Family
Christmas Projects
Edition of 4000
GRI 1475-792
Artwork © Kara Walker
Courtesy Sikkema Jenkins & Co., New York

Robert Watts (American, 1923–1988)
S.O.S., 1976
Planographic print
Two volumes, each 8⅜ × 8⅛ in.
(21.27 × 20.64 cm)
GRI Jean Brown Papers, 890164, series VI,
box 235
© Robert Watts Estate, New York

William Wegman (American, b. 1943)
*Field Guide to North America and to
Other Regions*, 1993
Drawing, painting, collage, photograph,
wool, mixed media
Each sheet 20 × 16 in. (50.8 × 40.64 cm),
box 23⅛ × 18 in. (58.74 × 45.72 cm)
Venice, CA: Lapis Press
Edition of 20
GRI 93-B11694
© 1993 William Wegman

Lawrence Weiner (American, b. 1942)
*And/Or: Green as Well as Blue
as Well as Red*, 1972
Offset lithograph
6¾ × 4¾ in. (17.15 × 12.07 cm)
London: Jack Wendler
Edition of 1000
GRI 91-B13537
© 2018 Lawrence Weiner/Artists Rights
Society (ARS), New York

Xu Bing (Chinese, b. 1955)
An Introduction to Square Word Calligraphy,
1994–96
Offset halftone, relief print
Two volumes, each 16¼ × 10⅞ in.
(41.28 × 27.62 cm)
Edition of 100
GRI 2590-620
© Xu Bing Studio

APPENDIX: ED RUSCHA
(AMERICAN, B. 1937)

1.
Hard Light, 1978
With Lawrence Weiner (American, b. 1942)
Offset lithograph
7 × 5 in. (17.78 × 12.7 cm)
Edition of 3560
GRI 89-B23616
© Ed Ruscha and Lawrence Weiner/Artists
Rights Society (ARS)

2.
On the Road, 2009
Drawing and text by Jack Kerouac (American,
1922–1969), photographs by Gary Regester
(American, b. 1951)
Letterpress, hand-tipped photographic plates
14⅛ × 18⅜ in. (35.9 × 46.7 cm)
New York: Gagosian Gallery; Göttingen, Ger-
many: Steidl
Edition of 350
GRI 2874-047
© Ed Ruscha

3.
Dutch Details, 1971
Offset lithograph
4⅜ × 15 in. (11.11 × 38.1 cm) closed,
4⅜ × 30 in. (11.11 × 76.2 cm) open
Deventer, Netherlands: Stichting Octopus
GRI 92-B20813
© Ed Ruscha

4.
Various Small Fires and Milk, 1964
Offset lithograph
7 × 5½ in. (17.78 × 13.97 cm)
Edition of 400
GRI 2861-071
© Ed Ruscha

5.
Thirtyfour Parking Lots in Los Angeles, 1967
Offset lithograph
10 × 8 in. (25.4 × 20.32 cm)
Edition of 2413
GRI 2016-B391
© Ed Ruscha

6.
Every Building on the Sunset Strip, 1966
Offset lithograph
7 × 5⅝ in. (17.78 × 14.29 cm) closed
Edition of 1000
GRI 86-B19486
© Ed Ruscha

7.
A Few Palm Trees, 1971
Offset lithograph
7 × 5⅝ in. (17.78 × 14.28 cm)
Hollywood: Heavy Industry Publications
Edition of 3900
GRI 86-B19478
© Ed Ruscha

8.
Twentysix Gasoline Stations, 1967
Offset lithograph
7 × 5½ in. (17.78 × 13.97 cm)
Alhambra, CA: Cunningham Press
Edition of 500
GRI 91-B10185
© Ed Ruscha

9.
Nine Swimming Pools and a Broken Glass, 1968
Offset lithograph
7 × 5⅝ in. (17.78 × 14.28 cm)
Edition of 2400
GRI 91-B6641
© Ed Ruscha

10.
Some Los Angeles Apartments, 1965
Offset lithograph
7 × 5½ in. (17.78 × 13.97 cm)
Edition of 700
GRI 2861-034
© Ed Ruscha

11.
Records, 1971
Offset lithograph
7 × 5½ in. (17.78 × 13.97 cm)
Hollywood: Heavy Industry Publications
Edition of 2000
GRI 86-B19481
© Ed Ruscha

12.
Then & Now: Hollywood Boulevard 1973–2004,
2005
Chromogenic print
Each print 27½ × 39⅜ in. (69.85 × 100.01 cm),
box 29½ × 41¼ × 2¾ in. (75 × 104.77 × 7 cm)
Göttingen, Germany: Steidl
Edition of 10
GRI 2012.M.1, series II.B, box 50
© Ed Ruscha

13.
Real Estate Opportunities, 1970
Offset lithograph
7 × 5⅝ in. (17.78 × 14.28 cm)
Edition of 4000
GRI 86-B19480
© Ed Ruscha

14.
Business Cards, 1968
With Billy Al Bengston (American, b. 1934)
Photograph, business cards
8¾ × 5⅝ in. (22.23 × 14.29 cm)
Edition of 1000
GRI 89-B22756
© Ed Ruscha
Courtesy Billy Al Bengston

15.
Royal Road Test, 1967
With Mason Williams (American, b. 1938) and
Patrick Blackwell (American, b. 1935)
9⅜ × 6½ in. (23.81 × 16.51 cm)
Offset lithograph
Edition of 1000
GRI 89-B22186
© Ed Ruscha, Mason Williams, and
Patrick Blackwell

16.
Babycakes with Weights, 1970
Offset lithograph
7½ × 6 in. (19.05 × 15.24 cm)
Edition of 200
GRI 1376-316
© Ed Ruscha

17.
Colored People, 1972
Offset lithograph
7 × 5⅝ in. (17.78 × 14.28 cm)
Edition of 4065
GRI 86-B19476
© Ed Ruscha

18.
Crackers, 1969
With Mason Williams (American, b. 1938)
Offset lithograph
8⅞ × 9 in. (22.54 × 22.86 cm)
Hollywood: Heavy Industry Publications
Edition of 5000
GRI 86-B19477
© Ed Ruscha and Mason Williams

ACKNOWLEDGMENTS

One of the pleasures of the Getty Research Institute is its intense atmosphere of research deeply informed by art and books; our daily work is with colleagues who appreciate these equally, but in strikingly different ways. For years it has been both invigorating and revealing to look at the works in Special Collections together, particularly the artists' books. Like all books, they evoke different responses, that is, variant readings. Books differ from archives, manuscripts, or photographs because, in most cases, they are meant to circulate and to communicate. Our experience of shared readings and responses, varied tastes and preferences, is the genesis of this volume, in addition to the desire to make the significance of the genre and the stunning or startling nature of artists' engagements with books better known.

We thank Thomas Gaehtgens and Gail Feigenbaum for their votes of confidence in this catalogue of one of the GRI's most stellar but also possibly least-known collections.

We thank our editor Elizabeth Nicholson, designer Catherine Lorenz, and production coordinator Suzanne Watson for their stalwart and dedicated support for this project, keeping it on track even when its creative approach threatened derailment or, even worse, a crack-up! Through a plethora of choices (more than six thousand artists' books in the vaults) for inclusion, they gave us the confidence to do a book of stunning selections and curatorial choices, not seeking to designate prizewinners but to locate interesting books to point out to our fellow art lovers and readers. Our thanks also go to copyeditor Tom Fredrickson and project assistant Zoe Goldman for their unflagging attention to every detail of word and image within these covers.

We are grateful to all our contributors, who selected books they wanted to recommend "for your consideration." They wrote engaging comments, with different voices, sharing their reactions, occasionally tidbits from research, and most importantly, diverse perspectives on the books. Although artists' books do get reviewed sometimes, our opinion is that it is not enough, because they merit intelligent, informed discussion. Nothing is more appropriate to books and art than viewing them together and then talking about responses. We hope the process of making this book and its publication will contribute to further comments.

We are especially thankful to research assistants Rhiannon Knol, Daniel Spaulding, and Audrey Young, who did admirably diligent jobs tracking down information on the makers and the books. Thanks to Nina Damavandi and Moira Day for their help with rights and permissions, and to Amandine Nabarra-Piomelli, who generously volunteered many hours to assist with photo requests and measurements. With more than one hundred volumes, they put great energy and substantial patience into organizing accurate publishing information and shepherding the photography, working with the GRI's talented photographers John Kiffe and Christine Nguyen, and with Special Collections reading room staff, especially Ted Walbye, Daniel Powazek, Mahsa Hatam, and Erica Wofford. For their work on the exhibition of the same name that accompanies this book, we thank Christina Aube, Jennifer Park, and Samantha Gregg. For all her attention to arrangements and scheduling, which made this book possible, our thanks to Maira Hernandez-Andrade.

Last, and not least but rather most important, we thank all the artists, writers, and printers who make books. It is they without whom this book would not be. Artists' books demonstrate the importance of books, in myriad formats, and the significance of reading—both textual and visual—to cultural communication and the presentation of ideas in the contemporary era.

Marcia Reed
Glenn Phillips

CONTRIBUTORS

MARCIA REED is chief curator and associate director of the Getty Research Institute. Among the exhibitions she has curated are *The Edible Monument: The Art of Food for Festivals* (2015), *Cave Temples of Dunhuang: Buddhist Art on the Silk Road* (2016), and *China on Paper: European and Chinese Works from the Sixteenth to the Early Nineteenth Centuries* (2007). Works in progress include a publication and exhibition on the Jean Brown collection of avant-garde and Fluxus works.

GLENN PHILLIPS is curator and head of Modern and Contemporary Collections at the Getty Research Institute. His recent projects include *Video Art in Latin America* (2017), a thematic survey of media art from twenty-one countries, and *Harald Szeemann: Museum of Obsessions* (2018), a retrospective on the influential Swiss curator.

IDURRE ALONSO is associate curator of Latin American Collections at the Getty Research Institute. Among her publications are *Customizing Language* (2016), *Photography in Argentina, 1850–2010: Contradiction and Continuity* (2017), and *The Metropolis in Latin America (1830–1930)* (2018).

CHRISTINA AUBE is the Getty Research Institute's exhibitions coordinator. Her research interests include early modern printmaking and the history of collecting.

STRAWN BOVEE is an art collector and writer who for more than twenty years created and produced radio programs that addressed religion, ritual, and mindset. She is currently completing a collaborative book with the artist Steve DeGroodt.

DAVID BRAFMAN is associate curator of rare books at the Getty Research Institute. His research projects in process are Facing East: Early Modern Western Views of Islam and The Art of Memory.

DORIS CHON is a research specialist at the Getty Research Institute. She is currently working on a monograph about fictive museums in contemporary art.

LINDA CONZE is a historian and photo curator who was the 2017 Alfried Krupp von Bohlen und Halbach Fellow at the Getty Research Institute. She is currently finishing her PhD (on the role of photography in processes of community building in Weimar and Nazi Germany) at Humboldt-Universität, Berlin.

ZANNA GILBERT is a research specialist at the Getty Research Institute, where she leads the research projects "Concrete Art in Argentina and Brazil" and "Art and Xerography."

RHIANNON KNOL is a specialist in the Books and Manuscripts Department at Christie's, New York. She was previously a curatorial research assistant at the Getty Research Institute.

RYAN LIEU is the Getty Research Institute's collections management coordinator and has worked closely with many artists' books in Special Collections. Trained in studio arts, he studies disappearing craftsmanship and collects obsolete tools.

NANCY PERLOFF is curator of Modern and Contemporary Collections at the Getty Research Institute. She curated the exhibition *Concrete Poetry: Words and Sounds in Graphic Space* (2017) and continues to pursue scholarship on concrete poetry.

ISOTTA POGGI is assistant curator of photographs at the Getty Research Institute. She cocurated the exhibition *Promote, Tolerate, Ban: Art and Culture in Cold War Hungary*, which will be shown at the Wende Museum in Culver City, CA, in 2018, and she coedited the accompanying publication.

JOHN TAIN was formerly assistant curator of Modern and Contemporary Collections at the Getty Research Institute. He is presently director of research at the Asia Art Archive.

FRANCES TERPAK is curator and head of the Getty Research Institute's Photographs and Optical Device Collection. Her book *Robert Mapplethorpe: The Archive* was shortlisted for the 2016 Aperture Book Award. In 2017 she cocurated the Getty's first online exhibition, *The Legacy of Ancient Palmyra*.

INDEX OF ARTISTS AND WORKS